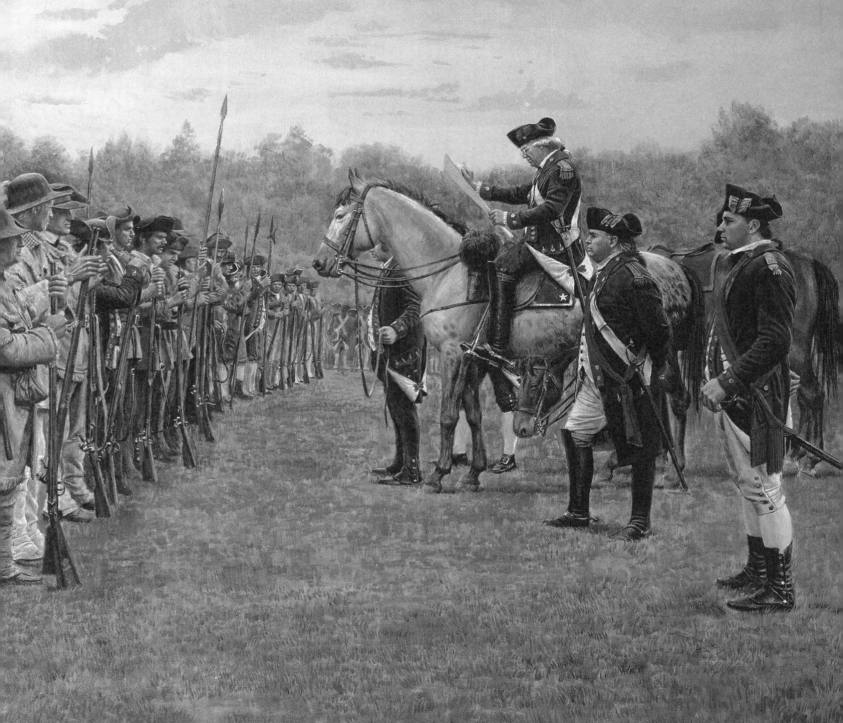

The New Nation

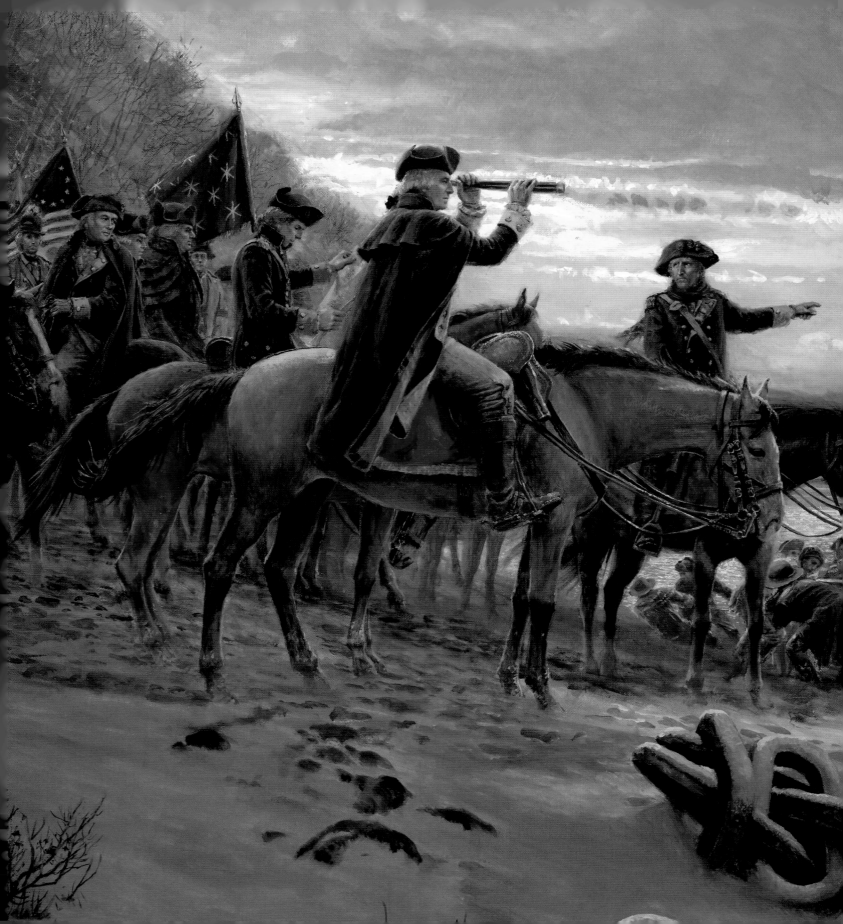

The NEW NATION

THE CREATION *of the* UNITED STATES *in* PAINTINGS *and* EYEWITNESS ACCOUNTS

The Art of
Mort Künstler

Text by EDWARD G. LENGEL ❧ *Foreword by* DAVID HACKETT FISCHER

STERLING
New York

STERLING
New York

An Imprint of Sterling Publishing
387 Park Avenue South
New York, NY 10016

ISBN 978-1-4549-0773-2

Distributed in Canada by Sterling Publishing
c/o Canadian Manda Group, 165 Dufferin Street
Toronto, Ontario, Canada M6K 3H6
Distributed in the United Kingdom by GMC Distribution Services
Castle Place, 166 High Street, Lewes, East Sussex, England BN7 1XU
Distributed in Australia by Capricorn Link (Australia) Pty. Ltd.
P.O. Box 704, Windsor, NSW 2756, Australia

For information about custom editions, special sales, and premium and corporate purchases, please contact Sterling Special Sales at 800-805-5489 or specialsales@sterlingpublishing.com.

Manufactured in China

2 4 6 8 10 9 7 5 3 1

www.sterlingpublishing.com

FRONTISPIECE: Detail, *Washington's "Watch Chain"—West Point, New York, November 30, 1779*

Especially for my beloved Deborah,
my partner in every way

— MKünstler

"[May] your union and brotherly affection may be perpetual; that the free Constitution, which is the work of your hands, may be sacredly maintained; that its administration in every department may be stamped with wisdom and virtue; that, in fine, the happiness of the people of these States, under the auspices of liberty, may be made complete by so careful a preservation and so prudent a use of this blessing as will acquire to them the glory of recommending it to the applause, the affection, and adoption of every nation which is yet a stranger to it."

—— GEORGE WASHINGTON, FAREWELL ADDRESS, 1796

ALSO BY MORT KÜNSTLER

The Civil War Paintings of Mort Künstler, Vols. 1–4
The Civil War Art of Mort Künstler
Mort Künstler's Old West—Cowboys
Mort Künstler's Old West—Indians
Mort Künstler's Civil War—The North
Mort Künstler's Civil War—The South
Images of the Old West—The Paintings of Mort Künstler, text by Dee Brown
Gettysburg—The Paintings of Mort Künstler, text by James M. McPherson
Images of the Civil War—The Paintings of Mort Künstler, text by James M. McPherson
The American Spirit—The Paintings of Mort Künstler, text by Henry Steele Commager
Epic Paintings of America—The Paintings of Mort Künstler, text by Henry Steele Commager

BY MORT KÜNSTLER WITH TEXT BY JAMES I. ROBERTSON JR.

For Us the Living: The Civil War in Paintings and Eyewitness Accounts
Gods and Generals—The Paintings of Mort Künstler
The Confederate Spirit—The Paintings of Mort Künstler
Jackson and Lee—Legends in Gray

ALSO BY EDWARD G. LENGEL

This Glorious Struggle: George Washington's Revolutionary War Letters
General George Washington: A Military Life
Inventing George Washington: America's Founder, in Myth and Memory
A Companion to George Washington

The Guns of Monmouth

Contents

FOREWORD

EVEN BEFORE THE WAR OF INDEPENDENCE was over, some of the soldiers who served with George Washington exchanged a warrior's weapons for an artist's paintbrush, and began to create enduring images of the history they had made. Two men in particular, Colonel John Trumbull and Captain Charles Willson Peale, made this task their life's work. They painted many scenes of the American Revolution and the new republic. Some of their images took on a life of their own and had an extraordinary power to move minds and hearts. These two artists deepened the meaning of history, for their contemporaries and for their posterity.

A striking example is John Trumbull's painting *The Death of General Warren at the Battle of Bunker Hill* (1786). It is small by the measure of history painting in its own time, barely 25 by 37 inches. But it had a great impact on the emotions of those who saw it. Abigail Adams wrote to her sister in 1786, "I can only say that in looking at it, my whole frame contracted, my Blood Shiverd and I felt a faintness at my Heart." The next generation was also moved, but in a different way. Her daughter, Abigail Adams II, wrote of the same painting, "It is enough make one's hair stand on end . . . the scene, is dreadfully beautiful, or rather dreadfully expressive."[1] This power and effect led the dean of British artists, Sir Joshua Reynolds, to observe in 1778 that history painting was art in its highest form.[2]

From his era to our time, many new genres of painting have been invented. But artists have continued to return to historical projects, and in the United States to the great scenes of American history. Some of their visual images have done more to shape our understanding of the subject than all the many words that have been written through the years.

No American painter in our generation has been more successful in that work than Mort Künstler. He could have taken his talent in many directions, but chose to become a painter of history. He is best known in the United States for his superb work on the Civil War. Historian James Robertson Jr. has written that Mort Künstler "is the foremost Civil War artist of our time (if not of all time)."[3] Künstler has also ranged widely through the full span of American history, from the first encounters of European explorers and North American Indians to scenes of American space exploration.

In recent years, he has turned increasingly to the era of the American Revolution and to the Early Republic. Like the art of the soldier-painters in the revolutionary era, his work derives its power from the interplay of opposites: simplicity in a central idea and complexity in its development; meticulous accuracy and soaring flights of imagination. Künstler's paintings represent large historical processes, major events, and great leaders. But he combines those great subjects with close attention to individual people of every condition—rich and poor, young and old, male and female. He paints them with high respect for their individuality and for their creative acts and thoughts. Great leaders and ordinary people both appear in his work not as the objects of history, but as its agents. An example in this book is his painting *Fox Hollow Farm* (pages 18–19), as an image of the westward movement. Others are *Reading the Declaration of Independence to the Troops* (pages 58–59), which gives more attention to the rank and file of the American army than to its officers; and *The First Amendment* (pages 142–43),

in which James Madison is surrounded by a mixed crowd of many Americans in the moment when the first printing of the Bill of Rights passes into their hands.

Another characteristic of Mort Künstler's work appears in its combination of a closely disciplined attention to historical fact and a highly developed concern for the expressive possibilities of his art. Many of his paintings are designed to evoke strong emotional responses to their universal themes and small details. Some of the most powerful examples are also the most subtle and understated. An example is *First Rhode Island* (page 50), a deeply moving image of former slaves in New England fighting for their liberty in the Revolutionary War. The expressive elements gain strength as we reflect upon their meaning. A major school of artists in the twentieth century created works centered on an ideal of "abstract expressionism." Künstler's art has a quality that might be called "concrete expressionism." Through his work we can begin to perceive the infinite possibilities of this great genre.

Yet another combination of elements is also very striking in Mort Künstler's work. Most of his history paintings are about what Thomas Jefferson called "the course of human events." At the same time, Künstler also creates images of environmental and material conditions, not merely as the context of human events, but also as causal elements of critical importance. Many of his compositions give central attention to climate and weather, day and night, light and darkness. They also represent economic conditions and material processes. These various elements are interlocked in thoughtful and creative ways. A case in point is the painting *Rogers' Rangers* (page 26), which juxtaposes the small boat against a representation of the immense wilderness of eighteenth-century America. Another example is an image of George Washington, straining to study the magnitude of his task through the small circumference of his spyglass (*Washington's Spyglass*, page 70). A third is a set of nocturnal scenes that combine an expanse of darkness with small points of light: "*The Regulars Are Coming Out!*" (pages 36–37) and *Two If by Sea* (page 38). We can also observe all of these elements at work within a single painting: *Washington's Crossing* (pages 64–65) is one of Künstler's most recent works, first shown to a large public in 2011. It combines the strengths of his earlier painting with bold new experiments. Mort Künstler's talent continues to grow! He has created a radically new version of one of the most familiar images in American history. When they think of this historic event, many Americans see in their mind's eye a vision of Emanuel Leutze's *Washington Crossing the Delaware* (1851), a truly great history painting of extraordinary power, enduring importance, and dubious accuracy in some of its details. Mort Künstler carefully studied the subject and created another image. Here again he combines simplicity and complexity, which together are fundamental to many important works of art. We see a dark river covered with sheets of ice, and a winter storm with high wind and driving snow. In the distance we see the shadowy outline of the Durham boats that carried some of Washington's troops that night. The painting centers on a big cable-guided flatboat ferry that Washington may well have used. It is crowded with soldiers. At first glance they are a dim, compendious mass. We look again and find that the mass is composed of many individual men of different units, regions, ranks, and conditions. In the foreground is a heavy field gun, and in the background a pair of restless horses. The dominant figure is George Washington, a figure of driving strength, deep resolve, and also stoic calm. Beside him is a young boy, wearing the uniform coat of Continental artillery and a red stocking cap with the motto "Liberty or Death." He holds a lantern that illuminates the figure of Washington himself. Together these elements link the conduct of the War of Independence to the values of the American Revolution. In this powerful image, Mort Künstler adds depth to our understanding of American history. We have many things to learn from his art.

~DAVID HACKETT FISCHER

INTRODUCTION

THE STORY OF THE FOUNDING OF THE United States of America is the story of us. The men and women who explored, settled, built, and expanded the new nation—as well as the Native Americans who both aided and resisted them—were not superhuman; they were everyday people. These people came from many races and backgrounds, and shared a unique combination of qualities. Sometimes they struggled against the elements. Often they struggled with each other. Always they struggled to rise above their own weaknesses and mistakes. What they shared in common was a determination to overcome all obstacles, as well as a vision of a better world for themselves and their children.

Before the first European settlers arrived, Old World cartographers typically depicted North America as an open, blank space. That of course was not the case. Native Americans—whose ancestors are believed to have crossed a land bridge from North Asia to what is now Alaska thousands of years ago—established vital societies across North America. Their conflict with European explorers and settlers is one of the greatest dramas in history. There were heroes and villains on both sides. And despite the larger catastrophe resulting from the collapse of native civilizations, the contest of settlers and natives was not without episodes of both honor and glory.

None of the men and women who sailed across the Atlantic Ocean in the sixteenth and seventeenth centuries to settle North America thought of unifying the continent under a single, let alone a democratic government. They were more concerned just to establish self-sufficient colonies, and endure from one season to the next. For many of the colonists, however, vague notions of liberty were always simmering under the surface. This might mean liberty from political or religious persecution, or even just from the oppressive hand of war. The first colonial governments at Jamestown and Plymouth Colony embodied some concept of liberty, even if they were not always successful in putting it into effect.

As the North American colonies grew larger and more prosperous, the concept of liberty began to loom not just as an ideal but as an objective that was within the grasp of every man and woman. The French and Indian War of 1754–63 stirred the colonists' feelings that as Americans they were not just British subjects but deserved to stand on their own right as equals in a world dominated by great empires. By 1775, these popular currents for liberty and equality had merged to create a revolution such as the world had never seen.

The Revolutionary War not only created but defined the United States. The war for independence from Great Britain was a contest of both elites and common people, fought at all levels of society. No one was unaffected by it. At the top, great men like George Washington, Thomas Jefferson, Benjamin Franklin, and John Adams provided the ideas and leadership to inspire and guide the revolution. But victory would have been impossible without the active participation of the people who fired the muskets, baked the bread, and sewed stars on the flags.

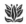

ONE MAN EMBODIED THE NATION'S GENIUS: George Washington. When the war began, he forged an army and provided a strategic vision. As the war progressed, he exercised the leadership his men needed to achieve victory. In the war's waning days, he reached out his powerful arms to close the gap between soldiers and civilians and save the country from military government. He recognized the weakness of the Articles of Confederation, presided over the Constitutional Convention of 1787, and worked tirelessly for ratification. As president, he gave the fledgling U.S. government both strength and form.

Ultimately, however, it was the little people who founded the United States of America. People like Experience Michell, the first colonial tanner in America; Daniel Boone, who forged the Wilderness Trail; Rebecca Brewton Motte, who supplied the arrows that allowed Francis Marion and "Light-Horse Harry" Lee to set her house afire and help rout the British from South Carolina; and a young poet named Francis Scott Key, who observed the British bombardment of Fort McHenry in 1814 and penned "The Star-Spangled Banner." Their examples live on to inspire Americans today through the art of Mort Künstler.

Any historical artist worth his salt will capture the drama inherent in the events he depicts, and strive to do so with scrupulous accuracy. None has achieved these goals more completely than Mort Künstler. He begins by choosing his subjects carefully and well. His focus is both on grand, symbolic events, and on the humble day-to-day episodes that expose the genius of the American character. Through his talent we do not just see an event as it happened; we also understand the emotions of the moment. To view a Künstler painting is to feel history come alive.

Appreciating the history of the United States is about much more than reading textbooks. Our increasingly visual culture demands not just to know, but to see and feel as well. Mort Künstler makes it possible to experience how George and Martha Washington must have felt as they embraced on their Christmas Eve reunion in 1783, or how Lewis and Clark must have felt upon seeing the Pacific Ocean for the first time. Moments such as these knit the fabric of the grand tapestry that is the history of the founding of the New Nation.

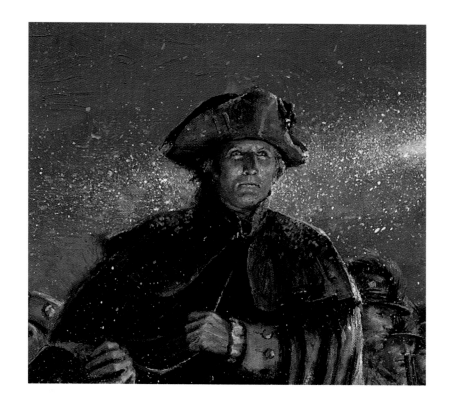

Detail of *Washington's Crossing*

PART ONE

Settlement

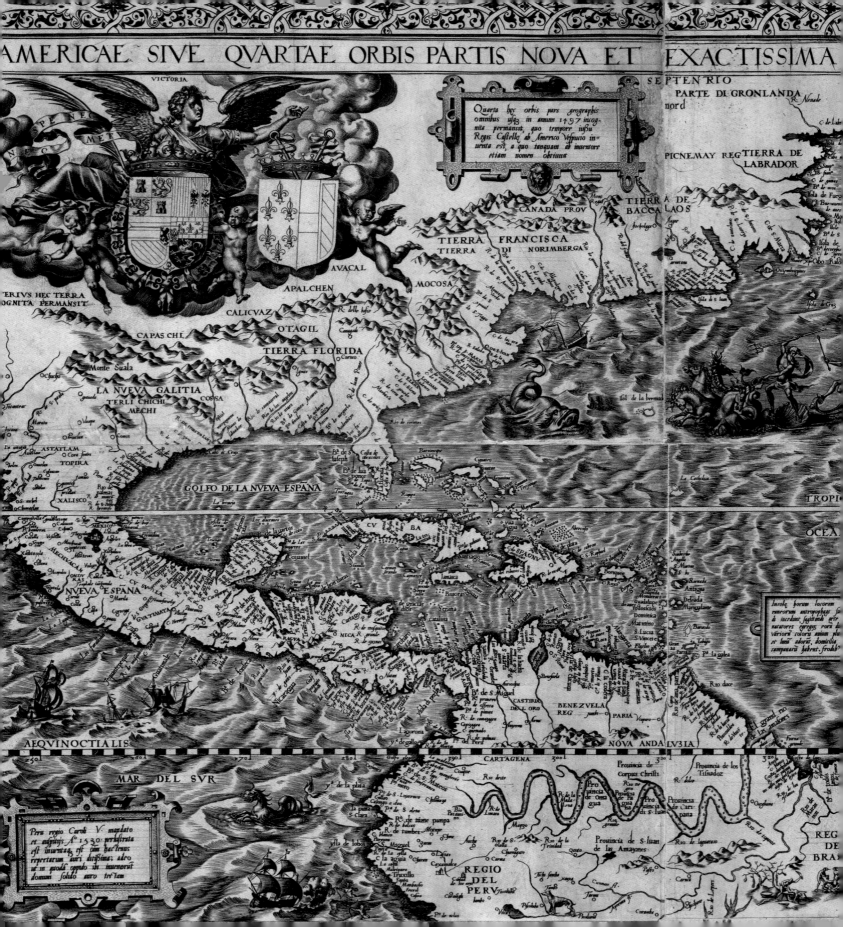

AMERICAE SIVE QVARTAE ORBIS PARTIS NOVA ET EXACTISSIMA

VICTORIA

Quarta hec orbis pars geographis omnibus vsq; in annum 1497 incognita permansit, quo tempore iussu Regis Castelle ab Americo Vespucio inuenta est, a quo tanquam ab inuentore etiam nomen obtinuit

SEPTENTRIO
PARTE DI GRONLANDA
nord

PICNEMAY REG TIERRA DE LABRADOR

TIERRA DE BACCALAOS

CANADA PROV

TIERRA FRANCISCA
TIERRA DI NORIMBERGA

MOCOSA

AVACAL

APALCHEN

CALICVAZ

OTAGIL

CAPAS CHI

TIERRA FLORIDA

Monte Suala

LA NVEVA GALITIA
TERLI CHICHI
MECHI

COSSA

ASTATLAM
TOPIRA

XALISCO

GOLFO DE LA NVEVA ESPAÑA

CV BA

SPAGNA

OCEA

MEXICO

MECHUACAN

NVEVA ESPAÑA

GVATIMALA

NICA

BENEZVELA REG

PARIA

NOVA ANDALVZIA

AEQVINOCTIALIS

CARTAGENA

Prouincia de Corpus Christi

Prouincia de los Tiinadoz

MAR DEL SVR

Prouincia de Omagua

Prouincia di S. Iuan

Prouincia de Cartapana

REG DE BRA

Prouincia de S. Iuan de las Amazones

REGIO DEL PERV

Peru regio Caroli V. mandato et auspicijs A° 1530 perlustrata est inuenta, est olim hac tenus repertarum auri diuissimis; adeo ut in quodă oppido in inuentorū dominū solido auro tri tam

Insule horum locorum incolarum antropophagi sunt, incedunt, sagittandi arte natatores egregij, rorū di varioru colorū auium plu er lună adorāt, domicilia campenarū habent, frondb

THE NEW WORLD "DISCOVERED" BY CHRISTOPHER Columbus in 1492 had been inhabited by human beings for roughly fifteen thousand years. Probably crossing by a land bridge from North Asia across the Bering Strait, people had spread into North, Central, and South America and developed complex societies. By the second millennium A.D., these ranged from settled empires in Central and South America to great population centers in North America, such as the ancient Mississippian city of Cahokia and the Pueblo cities of the Southwest. They included all varieties of subsistence and hunter-gatherer societies in the forests, swamps, mountains, and plains of North America. They were vigorous people, who ejected a feeble Viking attempt at settlement in around the eleventh century and warred constantly among themselves.

Nothing could have prepared them for the devastating impact of European settlement following Columbus's landfall in what is now the Bahamas in 1492. Within the space of a few generations, small bands of hardy adventurers, missionaries, and settlers from Iberia confronted and overthrew societies and empires that had endured for thousands of years; it was literally one of the most world-shaking upheavals in history.

As old empires crumbled, such as that of the Aztecs, new ones evolved. Although the Spanish and Portuguese built the first large colonial empires, the English, French, Dutch, and even Swedes were not far behind. Old World rivalries rekindled on a new stage as the Europeans vied for wealth and influence. The European afflictions of war and religious persecution drove settlers to seek freedom to farm and worship as they pleased. By the seventeenth century, North America had become the fulcrum of a grand new drama that would, in time, transform the face of the earth.

Americae Sive Quartae Orbis Partis Nova et Exactissima Descriptio . . . [1562], by Hieronymus Cock of Antwerp; a detail from a map of the New World based on the charts of sixteenth-century Spanish cartographer Diego Gutiérrez.

CHAPTER ONE

Jamestown to Plymouth Rock

"The six and twentieth day of April . . . we descried the land of Virginia; the same day we entered into the Bay of Chesupioc we could find nothing worth the speaking of but fair meadows and goodly tall trees, with such fresh waters running through the woods as I was almost ravished at the first sight thereof."

— GEORGE PERCY, UPON ARRIVING IN THE NEW WORLD, 1607

THE SPANISH AND PORTUGUESE CONQUEST of much of the New World—and especially the gold and silver-laden galleons that plied the passage back to Europe—inspired other European explorers to try their luck. Like the Conquistadores, many of them were pirates and freebooters. In North America, they hoped to find gold, silver, or perhaps the legendary Northwest Passage to the riches of Asia. Other explorers thought more idealistically, hoping to found new societies free from the wars and persecutions of the Old World. Whatever their motivations, the paths these men and women trod would be hard. Many would sacrifice their lives in the quest for a new country whose final dimensions they could not even imagine.

Great Britain was a latecomer to the game of exploration and colonization. By the early seventeenth century much of the choicest coastal land was gone or subject to disputing claims from various European powers. The failure and tragic disappearance of Sir Walter Raleigh's colony on Roanoke Island, North Carolina, in ca. 1588 boded ill for future attempts at settlement. The mid-Atlantic seaboard was swampy, bug-infested, and populated by testy natives. No immediate rewards in wealth or trade were apparent. Raleigh and other English adventurers nevertheless kept trying to explore and settle the area. The lure of the possible—and the dream of the impossible—kept driving them on. Their persistence in seemingly hopeless circumstances would lay the seed for the United States.

Three ships under a charter held by the Virginia Company of London—the *Discovery*, the *Godspeed*, and the *Susan Constant*—departed London in December 1606, carrying 144 passengers and crew. They were led by Christopher Newport, who had lost an arm fighting the Spanish in 1590. The British cohort also included John Smith, who was accused of mutiny halfway through the voyage and spent the rest of it in chains (he managed to stay alive, secure his release from custody, and take over leadership of Jamestown). The colonists came from many backgrounds, and included gentlemen and craftsmen, sailors and unskilled laborers. They all shared a desire for adventure and dreams of striking it rich in a new land, despite the disasters that had preceded them. Tossed by storms and wracked by dissension, they sailed by way of the Canaries and the West Indies, and finally sighted Virginia, entering the Chesapeake Bay on April 26.

The settlers' first foray ashore revealed sights of beautiful meadows, huge trees, and bubbling, crystal-clear streams. Colonist George Percy, who went on to become governor of the Virginia Colony, recalled feeling "almost ravished at the first sight thereof." As they returned to the ships that night, however, Percy noted, "there came the Savages creeping upon all fours, from the Hills, like Bears, with their Bows in their mouths." The natives attacked the settlers before they could scramble on board, injuring two of them. Only their muskets saved them. After the natives "had spent their Arrows, and felt the sharpness of our shot, they retired into the Woods with a great noise, and so left us." This bitter experience inspired caution, but no one thought of turning back.

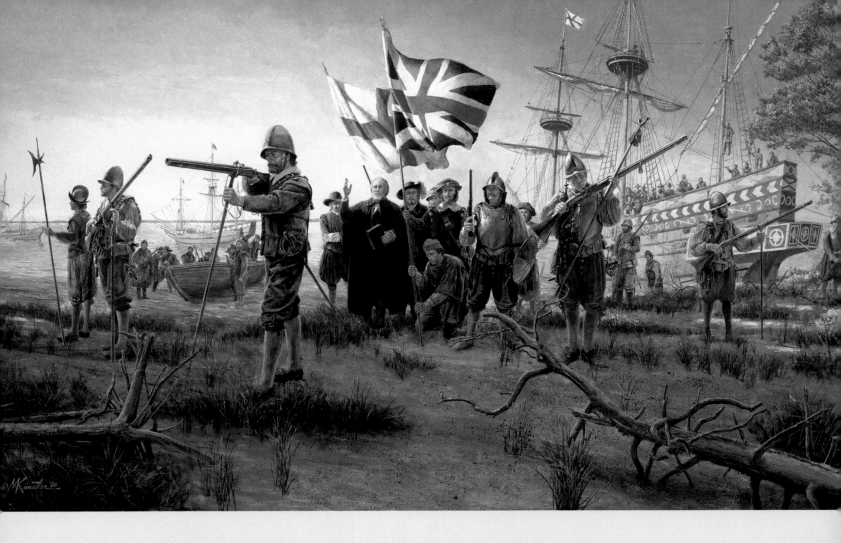

"*Our men were destroyed* with cruel diseases, as Swellings, Fluxes, Burning Fevers, *and by wars,* and some departed suddenly, but for the most part *they died of mere famine.* There were never Englishmen left in a foreign Country *in such misery* as we were in this new discovered *Virginia.*"

~George Percy, September 1607

Sketch for *The New World*

The New World
Jamestown, Virginia, May 14, 1607

AFTER PLANTING A CROSS AT WHAT THEY dubbed Cape Henry on April 29 to claim Virginia for England, the colonists moved upriver to explore the James River. Here they encountered a swampy peninsula they called Jamestown Island. Identifying a deep channel near the shore, they lashed the *Susan Constant* to a tree and debarked while the *Discovery* and *Godspeed* approached nearby. The date was May 14, 1607.

The first men ashore probably planted two flags—the ancient English Cross of St. George; and the Union Jack, which combined the Cross of St. George and the Scottish Cross of St. Andrew to symbolize the union of Great Britain. Musketeers bearing muzzle-loading matchlock muskets protected the landing zone—they were not going to be caught unawares again. Just over a hundred men debarked, and they worked strenuously to build a fort at Jamestown. But their labors had only just begun.

Disease, food shortages, internal disputes, frequently hostile natives and bad weather conspired to wreak havoc on the tiny Jamestown settlement. Year by year, it hovered on the verge of extinction. Eight months after the initial landing, only thirty-eight of the original settlers remained alive. Barely enough fresh settlers and supplies arrived from Britain to keep the settlement alive. At times, the settlers temporarily abandoned Jamestown, especially when famine began to take its toll. Recent discoveries of human remains from the horrific "starving winter" of 1609–10 have proven that some settlers resorted to cannibalism to survive. However they made shift, a hardened core of settlers would see it through and build the foundations of a new society.

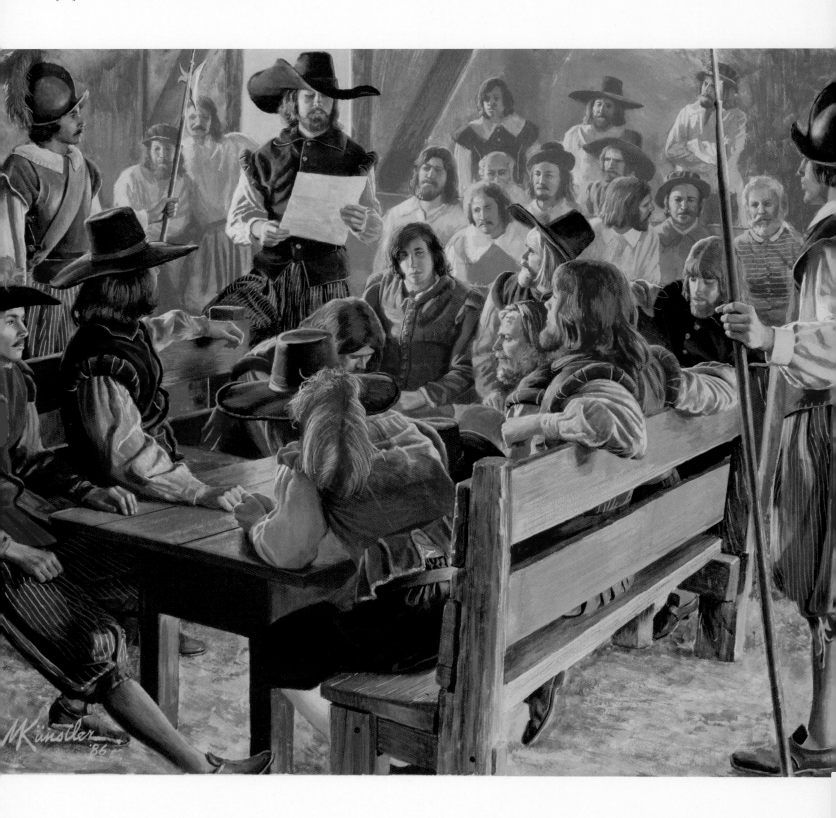

"[A] prayer was said by Mr. Bucke, the Minister, that it would please God to guide and sanctifie all our proceedings to his own glory, and the good of this Plantation."

~John Pory, secretary to George Yeardley,
governor of the Colony of Virginia

First Legislative Assembly
Jamestown, Virginia, July 30, 1619

JAMESTOWN SURVIVED. THE SETTLERS WERE often forced to live like barbarians in order to keep body and soul together, and at times it seemed that would be the best they could manage. After twelve years of suffering and trial, they were finally ready to think of the future. On July 30, 1619, under the direction of Governor George Yeardley, the colony's leading men—a group of elected officials called burgesses, and a governor's council—met for six days to establish a government for Virginia and create laws that would form the basis for a productive society. These men constituted the first legislative assembly in North America—a continent that later gave birth to concepts of liberty and freedom that would spread across the world.

"The most convenient place we could finde to sitt in," remembered John Pory, secretary to the governor and later first speaker of the assembly, "was the Quire [choir] of the Churche." Sensing the momentousness of the occasion, Pory reported that "forasmuche as men's affaires doe little prosper where God's service is neglected . . . a prayer was said by Mr. Bucke, the Minister, that it would please God to guide and sanctifie all our proceedings to his owne glory, and the good of this Plantation." The burgesses then took an oath of allegiance to King James I, and with great formality got down to work. In five days, they established laws on promoting agriculture and religion and combating vice, and converting Indians to Christianity. They also divided the colony administratively into four boroughs, looking ahead to the day when it would be able to expand far inland. The assembly then disbanded, but it would reconvene as the Virginia General Assembly.

The Mayflower Compact
Plymouth Colony, November 11, 1620

ONE YEAR AND THREE MONTHS AFTER THE Jamestown assembly, another assembly convened at Plymouth Colony in what is now Massachusetts. A cohort of 102 settlers—and two dogs—had sailed to America that year aboard the *Mayflower*, Christopher Jones master. These were very different people from those who had established the colony at Jamestown. Religious faith was their guiding motivation. Most were Puritans who had fled from England to Holland in order to avoid persecution by the established Anglican Church, and then sailed for the New World in order to achieve total independence from the Old. They left Holland in July 1620 and endured a brutal voyage in which they were pounded by rain and cold, tortured by delays, and subjected to seasickness and scurvy.

The *Mayflower* colonists had originally intended to settle somewhere between the mouth of the Hudson River and Chesapeake Bay, but the ship encountered rough seas and strayed off course. Fearing disaster, Jones decided to put ashore as quickly as possible, anywhere he could. Fate—or Providence—destined them for Cape Cod, where Jones finally sighted land on November 9.

By this point, months of hardships had left the colonists wracked by dissension. Realizing that they would never be able to realize their unique project without some sort of unifying compact, the colonists met while still at sea on November 11 a few miles off present-day Chatham, Massachusetts. Their deliberations resulted in the Mayflower Compact, which in time would form one of the foundations of civil government in the United States.

"Having undertaken, for the glory of God and advancement of the Christian faith and honor of our King and country, a voyage to plant the first colony in the northern parts of Virginia," the compact proclaimed, "do these present solemnly and mutually in the presence of God and one of another, covenant and combine ourselves together into a civil body politic, for our better ordering and preservation . . . and by virtue hereof to enact, constitute and frame such just and equal laws, ordinances, acts, constitutions and offices, from time to time, as shall be thought most meet and convenient for the general good of the Colony." According to legend, the colonists led by William Bradford then set ashore at a site that would be called Plymouth Rock.

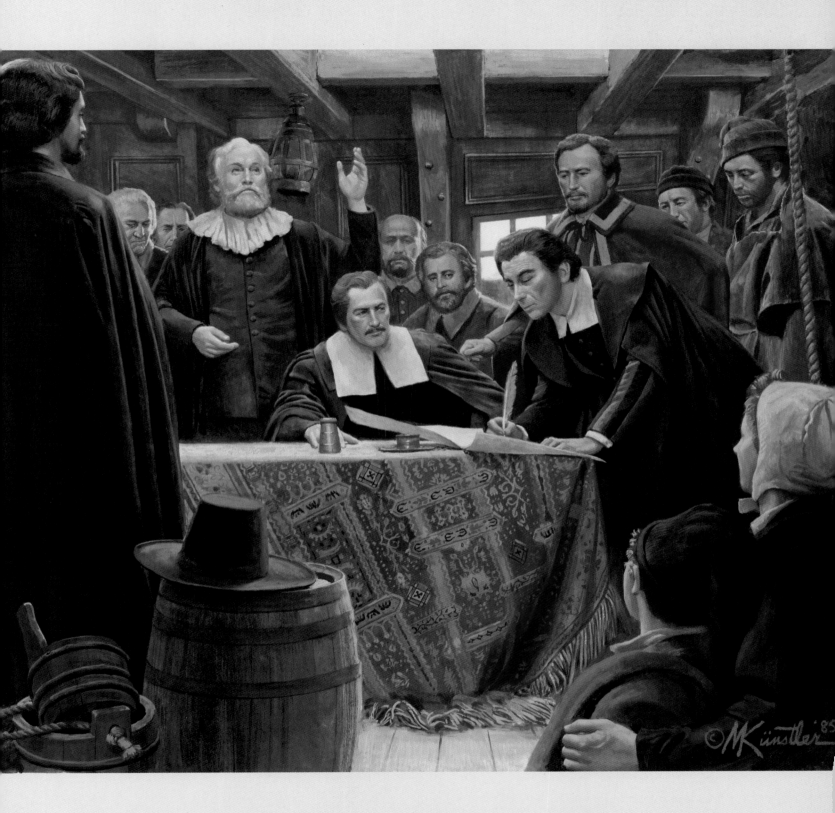

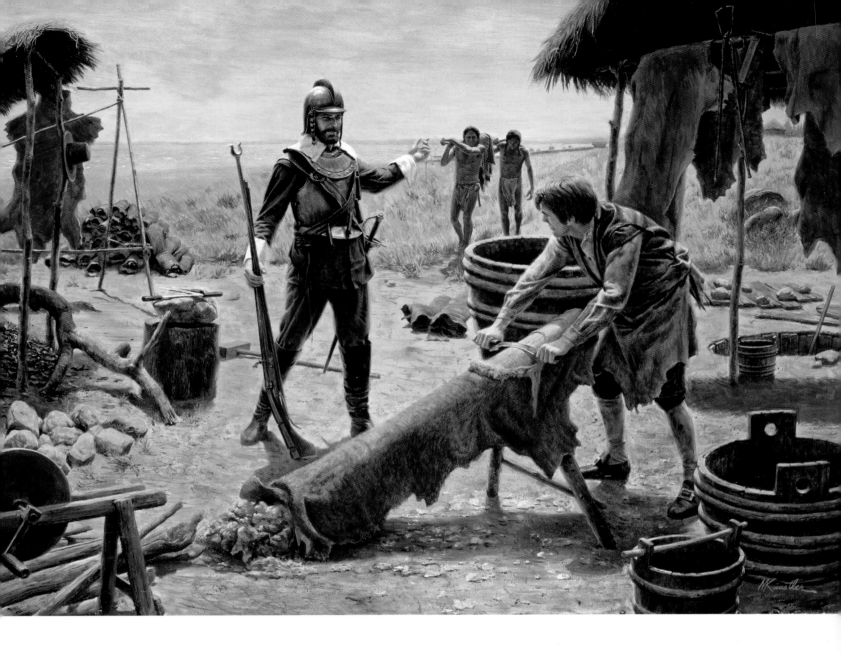

"[H]ere *every man may be master* and owner of his owne labour and land; or the greatest part **in a small time.** *If he have nothing* but his hands, he may set up this trade; and by industrie *quickly grow rich.*"

~Captain John Smith, *A Description of New England* (1616)

The First Tanner in America

Plymouth Colony, 1623 (*opposite*)

BY THE 1620S THE ENGLISH NEW WORLD colonies had begun to expand. At Plymouth, settlers such as Experience Michell (later Mitchell) brought new skills and added vitality to the community. Approximately twenty years old when he arrived in 1623, Michell became the first Pilgrim tanner in America; leatherwork was a vital profession at the time. The signs of his trade in the colonies' first tannery would have included piles of rolled hides set under the sun or hung up to dry and pits full of hides and oak bark settled to wait out the year of curing.

Tanners, farmers, tradespeople, and others depended for their economic security on men such as Captain Myles Standish, a *Mayflower* Pilgrim who served as the colony's military adviser and as both an intermediary with and first line of defense against the local Wampanoag Indians. Relations between natives and colonists were ambivalent and often violent. In 1623, Standish launched what he regarded as a preemptive attack on a group of natives, killing several and mounting the head of one on a pole outside Plymouth fort as a warning to the others.

Such episodes of violence did not deter the arrival of more Pilgrim settlers, who launched the Great Migration of the 1630s that established the bustling Massachusetts Colony. As described by Captain John Smith, their vision of a new society depended not just on the land's natural plenty, but on hard work: "[H]ere every man may be master and owner of his owne labour and land; or the greatest part in a small time. If he have nothing but his hands, he may set up this trade; and by industrie quickly grow rich."

Building of Castillo de San Marcos

St. Augustine, Florida, 1672–95 (*following pages*)

SPAIN LAID CLAIM TO FLORIDA IN 1565 WITH THE establishment of a settlement at St. Augustine. Over the following two hundred years the settlement and surrounding region would become a primary bone of contention among the great colonial empires, especially Spain, Great Britain, and France. The Spaniards in Florida struggled to endure incredible physical hardships, and endless attacks by English pirates and privateers, such as Sir Francis Drake, left their homes and the settlement's wooden fort in flame year after year.

A description by a Dr. Cáceres who visited in 1574 leaves the impression that the fort was a flimsy affair, and the work of repairing it somewhat akin to the futile labors of Sisyphus: "The fort is of planks with thick timbers for supports. It lasts four or five years, by which time the timbers are rotted by the damp earth and its saltiness. The soldiers repair it; they work all year on this fort."

In 1672, fed up after repeated raids and burnings of the settlement by Native Americans, the Spanish brought in slaves, Native Americans, and other laborers from Spain's colonies to begin construction of a masonry star fort to protect their interests. Don Pablo de Hita Salazar, governor of Florida, wrote to the Crown that he had "seen many Castillos of consequence," but "this one is not surpassed." It was completed in 1695, although many additional refinements would be added in following years. Although the new fort, the Castillo de San Marcos, provided somewhat more security, the struggles would continue for Florida's first European settlers.

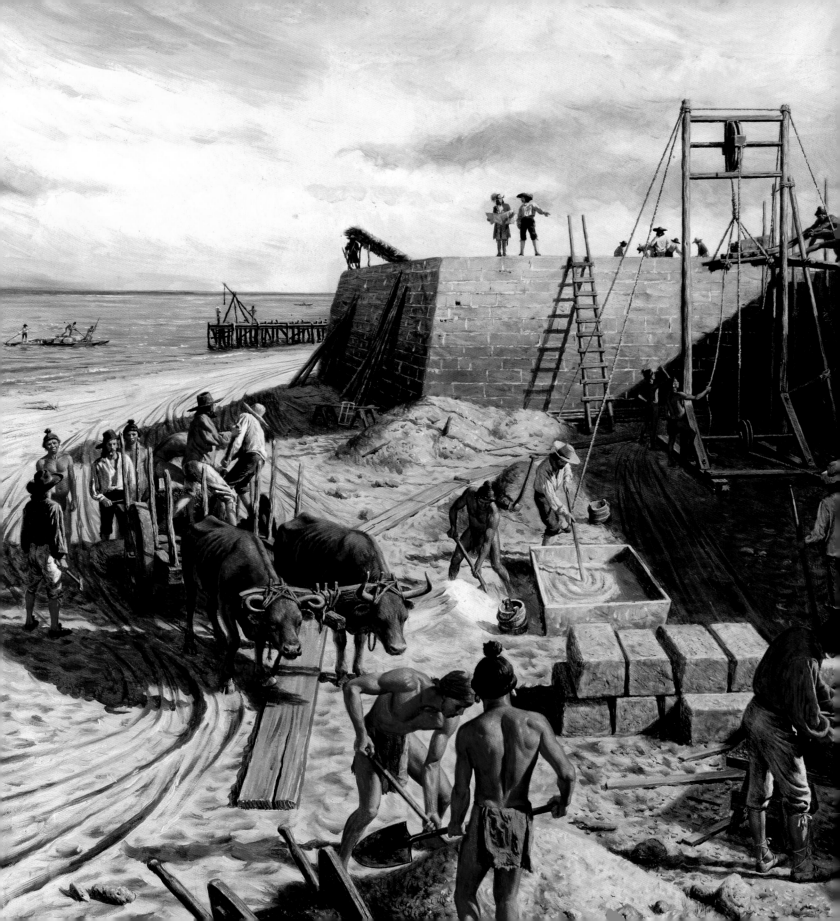

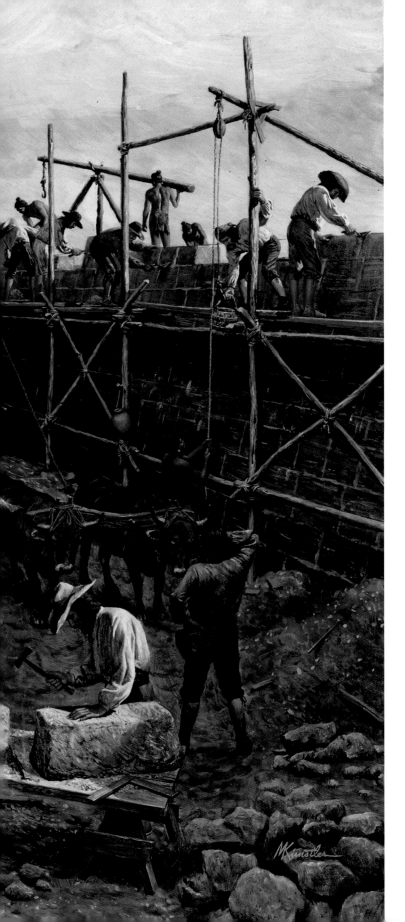

"*Although I* **have seen many** *Castillos of consequence and reputation* . . . **this one is not surpassed** *by any of those of greater character*. . . . *[I]f it had to be built in another place it* **would cost a double Amount**. . . . *Nor will there be Found the Stone, Lime, and Other materials* **so close at hand** *[as]* **in the Presidio.**"

~Capt. Gen. Don Pablo de Hita Salazar,
Governor of Florida, 1672

Battle for St. Augustine

Agony of a Town Aflame—Castillo de San Marcos,
November–December 1702

THE ONGOING STRUGGLE FOR SUPREMACY IN NORTH
America intensified at the beginning of the eighteenth century.
In Europe, the War of the Spanish Succession brought Great
Britain into conflict with France and Spain, and the fighting
soon spread through imperial dominions all over the globe. In
North America, the British royal governor of Carolina, James
Moore, decided to lead an expedition to capture St. Augustine;
the colonial legislature complied, proclaiming "the Encourage-
ment to free Plunder and a share of all slaves." Moore's expe-
dition, consisting of several hundred American militiamen and
allied Indians, arrived at St. Augustine in November and cap-
tured the town, but the Spanish soldiers withdrew into the new
and formidable Castillo de San Marcos. Moore sent for artillery,
and the two sides prepared for a siege.

For the Spaniards shut within the Castillo, the situation
was terrifying. Soldiers and civilians, priests, prisoners, women,
and children crowded within the fortification and shared the
same food, water, and "sanitary" facilities, such as they were.
The Spanish governor of Florida, Joseph de Zúñiga y Zérda,
described their plight in a letter to King Philip: "I had only
from sixty to seventy men fit to serve in the field, as many were
too aged, crippled, sick, or otherwise incapable of undertaking
an enterprise. I decided to gather together and to protect all of
the priests and friars and all of the women and children of the
Spanish and Indian families, which kept increasing until there
were in excess of 1,500 persons who entered without adequate
supplies."

In late November the English heavy artillery arrived and
opened fire on the fort in earnest. The fort's thick walls—
constructed of rock composed of crushed and calcified
seashells—resisted the British guns; meanwhile, Spanish sol-
diers and artillerymen failed to inflict any significant damage on
the British with their counterfire. In December, just as the fort
seemed near capitulation, Spanish relief ships arrived. Trapped
in the harbor, Moore burned his own ships and ignominiously
retreated by land. St. Augustine was safe—until the next war.

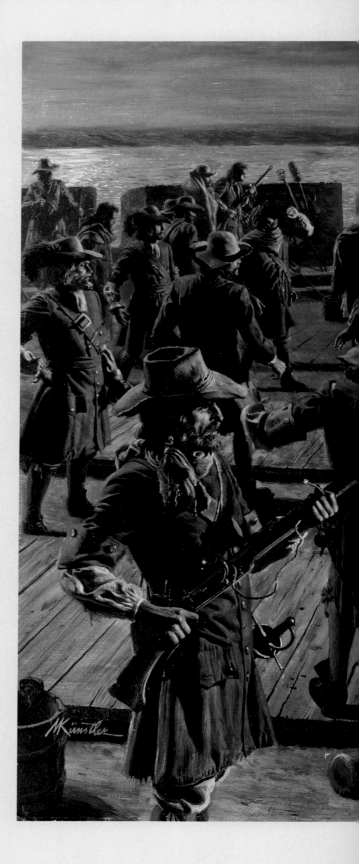

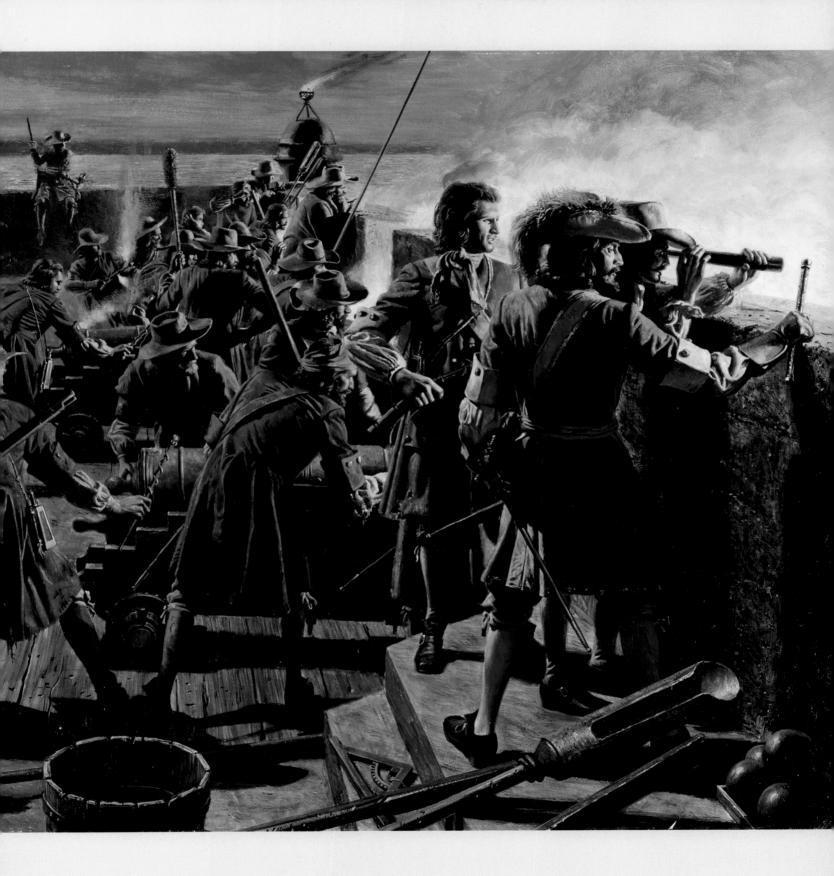

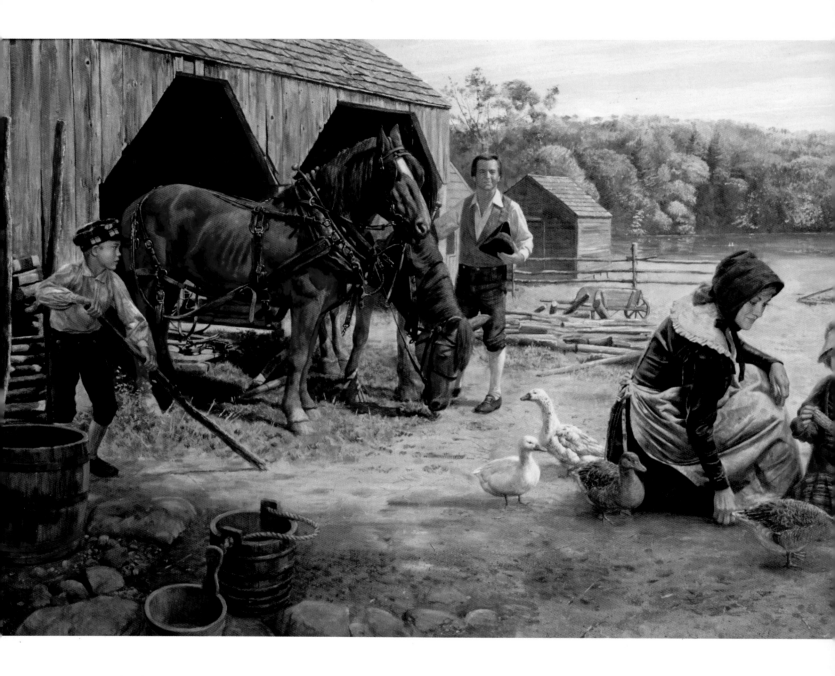

"*This day is forty years* since I left my Father's house and come here, and here have *I seen little else but hard labour and sorrow,* crosses of every kind."

~Mary Cooper, *The Diary of Mary Cooper:*
Life on a Long Island Farm 1768–1773

Fox Hollow Farm

Long Island, 1750

EVEN AS CONFLICT RAGED WITH SPANIARDS AND Native Americans along the peripheries of British North America, the colonies grew in prosperity and strength. By the mid-eighteenth century, thousands of settlers from England, Scotland, Germany, and other parts of Europe had established colonies all along the Atlantic seaboard and transformed the face of the land. Here, unlike in the Spanish and Portuguese dominions to the south and the French territories to the west, agriculture became a vital part of society and the economy. At places like Fox Hollow Farm on Long Island, New York, families cared for livestock, tilled land, raised children, participated in local government, celebrated and mourned, worked and played. Through it all, they began to think and act not just as transplanted Europeans, but as Americans.

Yet life on a colonial farm was not easy, especially for women, whose heavy responsibilities often left them feeling worn out and misunderstood. Mary Cooper, a beleaguered Long Island mother and housewife living near Oyster Bay, Long Island, described some of her travails in her diary. On July 13, 1769, she wrote: "This day is forty years since I left my Father's house and come here, and here have I seen little else but hard labour and sorrow, crosses of every kind. I think in every respect the state of my affairs is more than forty times worse than when I came here first, except that I am nearer the desired haven."

CHAPTER TWO

The French
and Indian War

"I fortunately escaped without a wound, tho' the right Wing where I stood was exposed to & received all the Enemy's fire and was the part where the man was killed & the rest wounded. I can with truth assure you, I heard Bulletts whistle and, believe me there was something charming in the sound."

— GEORGE WASHINGTON, DESCRIBING THE CROSSFIRE AT JUMONVILLE GLEN, IN A LETTER TO HIS BROTHER JOHN ON MAY 31, 1754

NORTH AMERICA'S FIRST COLONISTS HAD dreamed of a land unspoiled by war. That hope didn't last long. From the beginning, wars between Europeans and Native Americans, and rivalries among the European empires, ruined the prospect of peaceful settlement. By the mid-eighteenth century, the specter of war on a large scale seemed set to become a reality. It centered on the global rivalry between the world's two greatest empires, Great Britain and France. In Europe, the two empires had fought conflict after conflict and were poised for another round. In North America, the British colonies were increasingly at loggerheads with the French in Canada and west of the Appalachian Mountains. The Ohio Valley—contested by the British, the French, and the mighty Iroquois Confederacy—was possibly the world's most vulnerable tinderbox. In 1754, a young American named George Washington entered the Ohio Valley and ignited the spark that set off a global war.

Washington, a moderately wealthy Virginian with an ambition to accomplish great things, first strode onto the world stage in 1753. In the autumn of that year, Virginia's royal governor, Robert Dinwiddie, chose Washington to lead a small party of men to the wilds of western Pennsylvania and the Ohio Valley. His task: trek through the vast virgin forest in the dead of winter, seek and negotiate with potential native allies, scout French military installations, and deliver a message to the French commandant in the region ordering him to evacuate his forces in the name of the king of Great Britain. It was among the most dangerous missions imaginable, but Washington did not hesitate. He was eager to go.

Despite his bravery, Washington had never embarked on an expedition of this sort before, and it showed. He mismanaged negotiations with the Indians, irritated his men, and nearly collapsed from exhaustion. Fear of capture by hostile Indians led him on a hasty return journey through snow-choked woods that nearly ended when he tumbled off his raft while attempting to cross the icy Allegheny River. Nevertheless, he succeeded in delivering Dinwiddie's message and returning with the French commander's reply to Williamsburg; they would not comply. During the journey Washington had kept a meticulous journal of the expedition, which Dinwiddie published as propaganda to promote war. He then appointed Washington lieutenant colonel and eventually commander of the Virginia Regiment—a band of ragged, surly militiamen—and sent him on another mission to the wilderness the following year.

In late May 1754, Washington and his men were encamped in a clearing known as the Great Meadows (near present-day Uniontown, Pennsylvania) with a friendly band of Indians when they learned that a band of French soldiers was hiding in a ravine not far from the clearing. War hadn't been declared yet, but Washington nevertheless decided the French were hostile and ambushed them. The site of the attack became known as Jumonville Glen, after the French commander who was mortally wounded there.

Enraged at this assault on what they claimed was a diplomatic party, the French counterattacked and drove Washington to ground at a tiny log stockade he had built in the Great Meadows, named Fort Necessity. The French easily captured the fort and forced Washington to sign a paper confessing that he had "assassinated" Jumonville. Meanwhile, the Virginians broke into the fort's liquor supply and got drunk. Washington's humiliation seemed complete, and his career all but ruined.

Elsewhere, the gears of global conflict ground forward. Across Trans-Appalachia, French and Canadian soldiers and militia and their Native American allies attacked British settlements and were attacked in turn. The contest for the Ohio Valley resulted in another British disaster when General Edward Braddock's army was defeated along the Monongahela River in July 1755. Washington participated as an aide-de-camp and somewhat redeemed his reputation by rallying soldiers during the battle and then leading the beaten army off the field. In 1758, another British expedition under General John Forbes entered the Ohio Valley again and routed the French, who evacuated and burned Fort Duquesne. Farther north, the British captured Quebec and eventually the rest of French Canada, thanks to the heroism and self-sacrifice of men like Major General James Wolfe, who was slain in September 1759 on the Plains of Abraham. Despite these British victories, the outcome on the frontier, still plagued by Native American and French raiders, remained very much in doubt.

Sketch for *"Welcome to LeHewtown, Col. Washington"*

"Welcome to LeHewtown, Col. Washington"—Winter 1755

LeHewtown, Virginia, Winter, French and Indian War (*following pages*)

AS THE WAR RAGED ON, GEORGE WASHINGTON spent a great deal of time along the western frontiers of Virginia, Maryland, and Pennsylvania. He hoped that the war might provide an opportunity to expand trade and agriculture westward, and looked to ensure profit to Virginia and himself. Washington also chose the Virginia frontier as the best ground for concentrating and training a new force called the Virginia Regiment. At places like Fort Cumberland, Maryland, and LeHewtown (later Front Royal), Virginia, Washington posted his troops to defend the frontier against Indian raids and worked to meld them into a fighting outfit worthy of comparison with the best the British Empire had to offer. His goal was not just to earn honor for himself (and possibly a royal commission), but to prove that Americans could do anything the British could do—and possibly better.

In time, the British admitted that Washington's Virginians were a "fine body of men," and consented to their full and honorable participation in the conflict. Washington's careful attention to the needs of his troops earned him their complete devotion. When he resigned to marry Martha Custis in 1759, his officers wrote him a heartfelt address, praising his conduct as their leader and wishing him the best in domestic life. "Your approbation of my conduct, during my command of the Virginia Troops," Washington replied, "I must esteem an honor that will constitute the greatest happiness of my life, and afford in my latest hours the most pleasing reflections. I had nothing to boast, but a steady honesty—this I made the invariable rule of my actions; and I find my reward in it." He could not then imagine the greater responsibilities, plaudits, and awards that would follow before he reached his "latest hours."

"*Your approbation of my conduct,
during my command of the Virginia Troops,
I must esteem an honor that will constitute
the greatest happiness of my life.*"

~Response from George Washington
to the Officers of the Virginia Regiment,
January 10, 1759

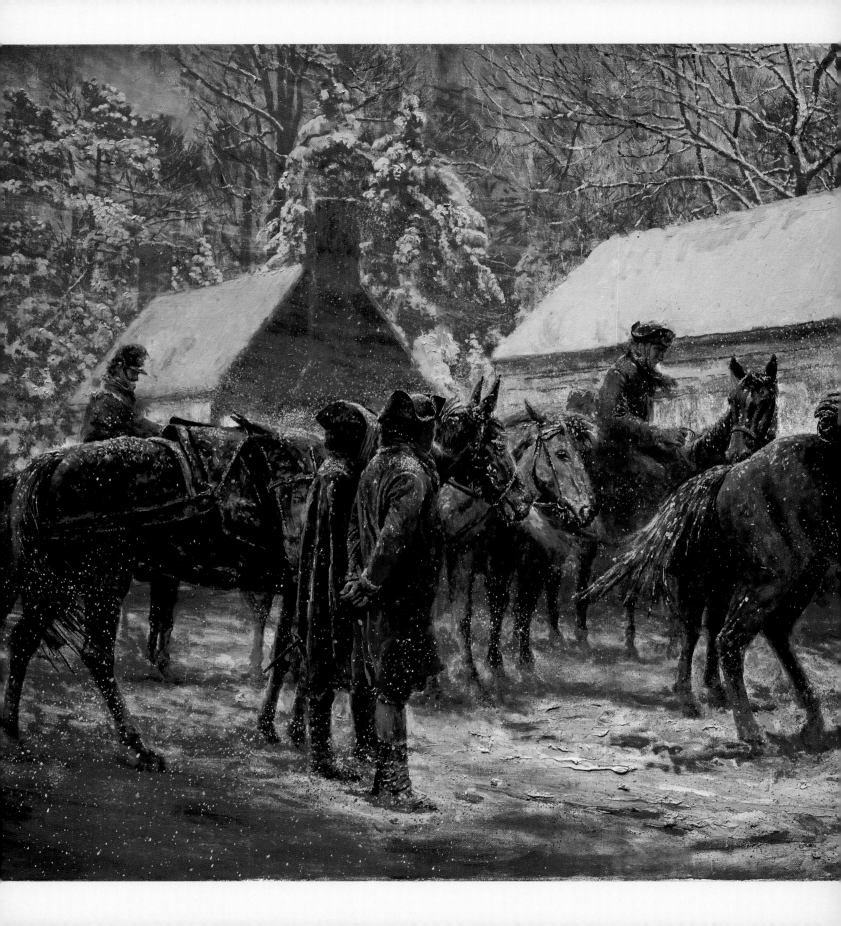

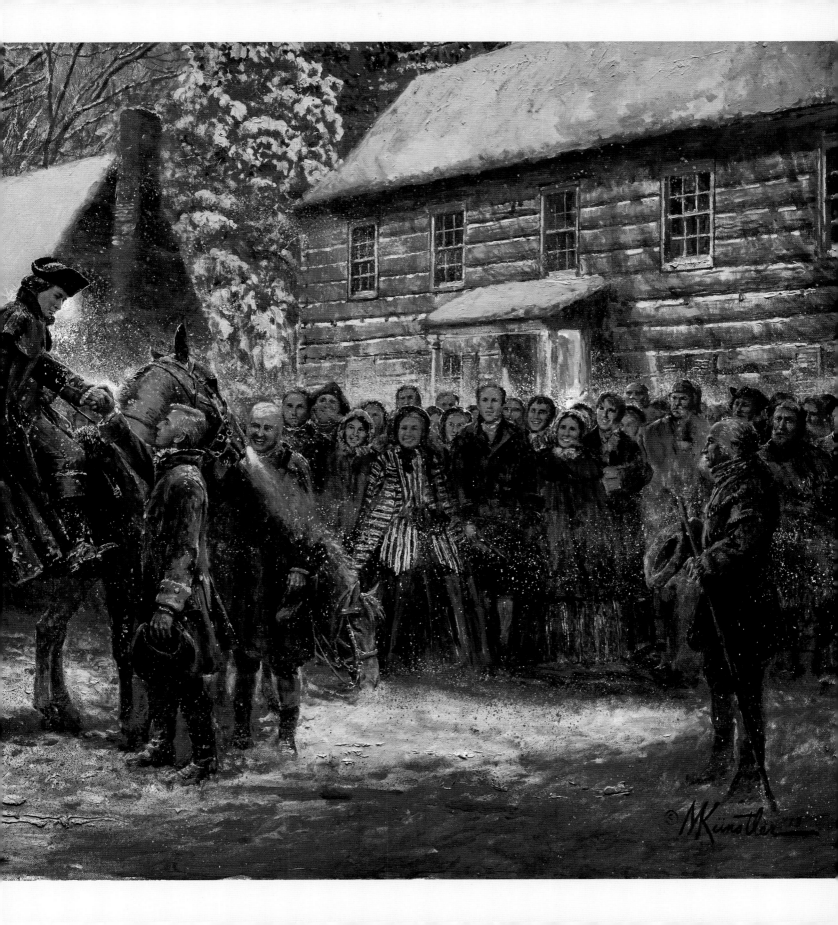

Rogers' Rangers—French and Indian War
Lake Champlain, September 1759

IN 1759, BRITISH-LED CAMPAIGNS IN NEW ENGland resulted in the capture of Fort Ticonderoga and Fort Niagara. British generals Jeffrey Amherst and James Wolfe had begun to penetrate Canada and placed Quebec under siege. To reach Wolfe's forces near Quebec, it would be necessary to open a route from Lake Champlain via the Abenaki Indian village of St. Francis, a nexus for Indian raiding parties into New England. After the Indians imprisoned British officers who attempted to parley and turned them over to the French, Amherst ordered American captain Robert Rogers to retaliate.

Rogers and his Rangers departed Crown Point fort in seventeen whaleboats on September 13, armed with instructions from Amherst that admonished him to "[t]ake your revenge, but don't forget that tho' those villains have dastardly and promiscuously murdered the women and children of all ages, it is my orders that no women and children are killed or hurt." Rogers' Rangers epic journey north would become the stuff of legend. Dodging French and hostile Indians, the Rangers had to work their way slowly through tortuous creeks and marshlands. But the French were alert, and when Rogers put ashore at Missisquoi Bay seventy miles shy of St. Francis, the French captured the Rangers' boats and cached provisions, and sent hundreds of men in pursuit. "We marched nine days through wet sunken ground," Rogers wrote in his journal. "When we encamped at night, we had no way to secure ourselves from the water, but by cutting the bows of trees, and with them erecting a kind of hammocks. . . . The tenth day after leaving Missisquoi Bay, we came to a river about fifteen miles above the town of St. Francis. . . . We got over with the loss of several of our guns, some of which we recovered by diving to the bottom for them." After destroying the village and killing dozens of Indians—including, despite Amherst's restrictions, women and children—the Rangers outdistanced their pursuers and managed to escape back to British-held territory.

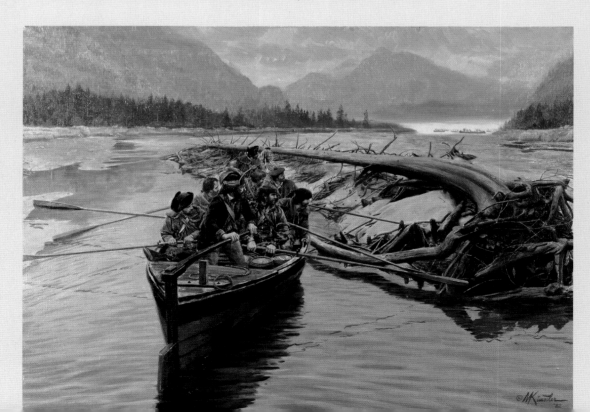

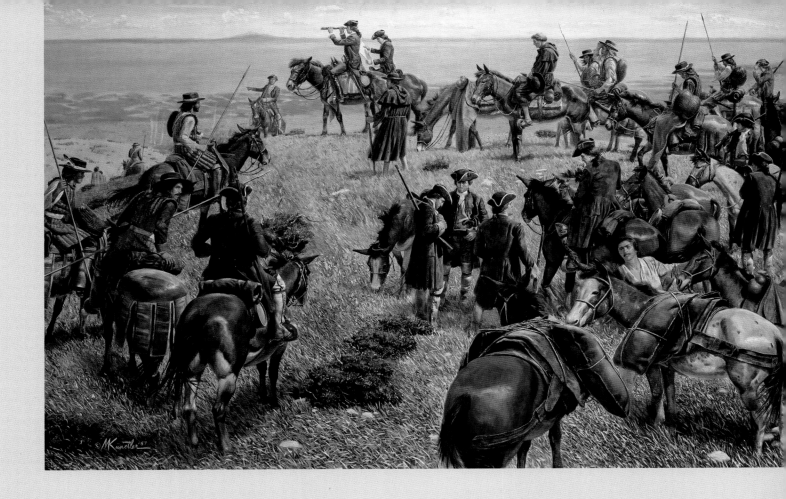

Portolá Discovers San Francisco Bay

California, November 4, 1769

AS THE FRENCH AND INDIAN WAR DREW TO A close, the balance of power shifted in North America. France lost its North American empire, while Britain gained Canada. Spain, by this time in decline as a world power, picked up the pieces. Enough remained of the Spaniards' conquistador spirit, however, for them to spread the domain of European influence and settlement all the way to the Pacific.

The Spanish governor of California, Gaspar de Portolá, left San Diego in 1769 on an expedition to establish a mission at Monterey. When he overshot his target and instead discovered San Francisco Bay, the Spaniards immediately recognized its importance as a potential harbor. Here too, however, other men had come first. In 1775, José Cañizares, a leader of one of the many expeditions the Spaniards sent to explore the area around the bay, described interactions with local native inhabitants in a report to the governor: "I traded with these people, not to buy anything from them, but to present them with the beads which your Excellency has given me for this purpose, together with some of my used clothing. Contact with them was very useful to me and the crew on account of the many gifts they made us of very choice fish (among them salmon), seeds, and ground meal. . . . [I] observed in them an urbane courtesy. . . . They tend to beg for nothing except for that which one gives them freely." Although the Spanish were the first Europeans to discover San Francisco and other parts of California, events on the far-distant east coast would determine how the region was to be developed.

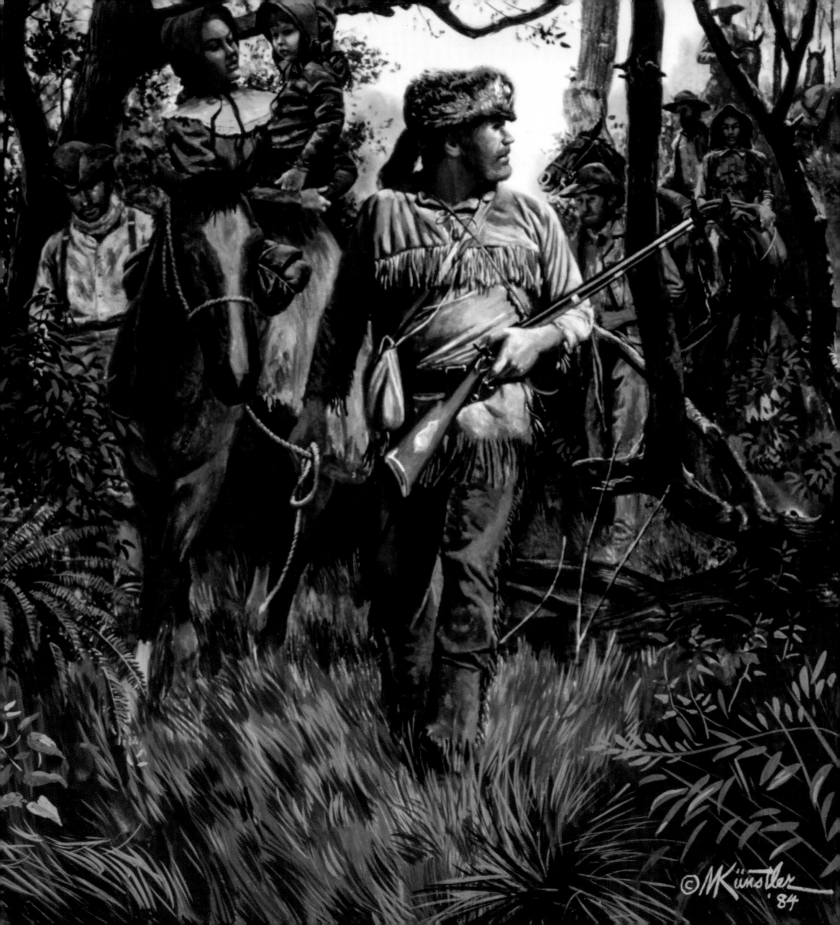

*"A sight so **delightful to our view** and **grateful** to our feelings almost inclined us, in imitation of Columbus, in transport to kiss the soil."*

~Felix Walker, *Narrative*, 1775

Daniel Boone
The Wilderness Road, 1775

EVEN AS THE SPANISH DISCOVERED SAN FRAN-cisco on the other side of the continent, French and Indian War veteran Daniel Boone was blazing a trail westward through the Cumberland Gap. Born in 1734 near Reading, Pennsylvania, Boone accompanied his family to the wilderness of western North Carolina as a teenager and learned the woodland skills that would come to identify the American frontiersman. He served as a wagoner during the French and Indian War—possibly meeting a young George Washington in the Braddock Expedition of 1755—and married Rebecca Bryan in 1756. He ventured farther into the wilderness in the years to come, exploring Kentucky in 1767 and marking the route west through the Cumberland Gap in 1769. In 1775 Boone, his wife and children, and several other men ventured northwest along the Wilderness Road into central Kentucky, where they founded Boonesborough.

One of those accompanying Boone was Felix Walker, who described their joyous discovery of the "rapturous appearance of the plains of Kentucky. A new sky and strange earth seemed to be presented to our view. So rich a soil we had never seen before; covered with clover in full bloom, the woods were abounding with wild game—turkeys so numerous that it might be said they appeared but one flock, universally scattered in the woods. It appeared that nature, in the profusion of her beauty, had spread a feast for all that lives. . . . A sight so delightful to our view and grateful to our feelings almost inclined us, in imitation of Columbus, in transport to kiss the soil. . . . The appearance of the country coming up to the full measure of our expectations, and seemed to exceed the fruitful source of our imaginary prospects." The prospect of great things to come would be realized in time. But first there was another war to fight.

CHAPTER THREE

The Road to Revolution

"At a time when our lordly Masters in Great Britain will be satisfied with nothing less than the deprivation of American freedom, it seems highly necessary that something shou'd be done to avert the stroke and maintain the liberty which we have derived from our Ancestors; but the manner of doing it to answer the purpose effectually is the point in question."

— LETTER FROM GEORGE WASHINGTON
TO GEORGE MASON, APRIL 5, 1769

THE FRENCH AND INDIAN WAR——CALLED the Seven Years' War in Europe—ended with the Treaty of Paris in 1763. France lost its North American empire in Canada and the vast territory of Louisiana. A primary source of conflict had disappeared, apparently opening the entire continent to peaceful expansion. Native Americans nevertheless remained determined to defend their territory. Moreover, new sources of tension opened up between the colonists and the government in Great Britain. These tensions increased exponentially in a very short time until by 1770 a new nation was about to awake.

Much of the difficulty between the American colonies and Great Britain focused on the problem of taxation. The British government had emerged from the French and Indian War deeply in debt, and it faced continued responsibilities to pay for troops to protect the western frontier against Indian incursions. To this point, the people of Great Britain had borne most of the burden of taxation, and it seemed only fair and natural to extend this burden to North America. Parliament therefore passed a series of measures designed to raise revenue to help pay the national debt in North America, including the Stamp Act in 1765 and the Townshend Acts in 1767.

The colonists rejected the arguments for increased taxation. They believed that they had won the French and Indian War largely on their own, and that they did not need British help to guard the frontier. Americans especially rejected Parliament's right to impose taxation without their consent. Taxation without representation, they cried, deprived them of their liberty and reduced them to slavery. In the 1760s, demonstrations against taxation spread throughout the colonies, and nonimportation associations formed to boycott British goods, including, of course, tea, as urged by the author of a letter excerpted below, which was published on April 15, 1768, in the patriot newspaper the *Boston-Gazette*:

We may declaim against luxury and effeminacy, as the bane, and ruin our country; and in all this we shall do well:—But here is one resolution more which would do us more essential service than all the rest; I mean a resolution to discard from our houses that most pernicious article of Luxury, TEA. . . . The whole continent is so bigotted and devoted to Tea, that there is really some reason to fear they would part with all their liberties, and religion too, rather than renounce it.—Good God! Is this possible! Is man a rational creature, or is he more stupid than the cattle! . . . Let us abjure the poisonous baneful plant and its odious infusion—Poisonous and odious, I mean, not on account of its physical qualities, but on account of the political diseases & death that are connected with every particle of it.

George Washington wrote to his neighbor, Virginia burgess George Mason, in 1769 that peaceful protest was necessary to protect "the liberty which we have derived from our Ancestors." But what if the British refused to give in? "That no man should scruple or hesitate a moment to use arms in defence of so valuable a blessing" as liberty, Washington wrote, "on which all the good and evil of life depends, is clearly my opinion; Yet arms I would beg leave to add, should be the last resource." Within a year, blood would be shed and Washington's fears would come true. The conflict would soon become a contest of arms.

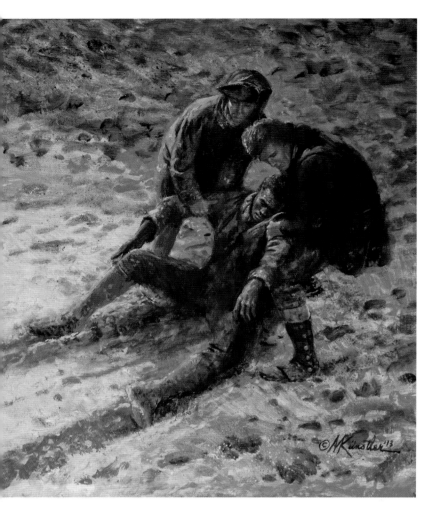

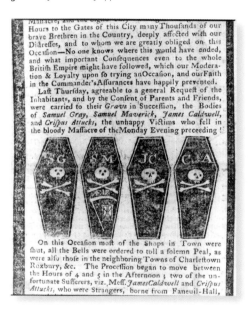

Boston Massacre, 1770
Boston, March 5, 1770

ON MARCH 5, 1770, BRITISH REDCOATS NEARLY set the revolutionary powder keg in Boston alight. American anger with Parliament had been growing for years, and in 1768, British soldiers took up posts in the city to enforce royal rule. The redcoats were not popular. Thomas Preston quoted an American justice as issuing dire words of warning by proclaiming openly "that the soldiers must now take care of themselves, nor trust too much to their arms, for they were but a handful; that the inhabitants carried weapons concealed under their clothes, and would destroy them in a moment, if they pleased." By 1770, fights between soldiers and civilians were breaking out all over Boston. On the evening of March 5, a dispute outside the Custom House on King Street between some townspeople and a British sentry spiraled out of control as soldiers arrived to back up the sentry and someone broke into nearby churches and rang the bells. A crowd assembled and zeroed in on the commotion. Civilians taunted, spit on, and finally started throwing debris at the soldiers, who then opened fire. In the ensuing melee three Americans were killed—including a runaway slave of African and Native American descent named Crispus Attucks—and two others mortally wounded. Patriot propagandists depicted the affair as a deliberate "horrid massacre" perpetrated by bloodthirsty redcoats. American rage became unquenchable.

Boston Tea Party, 1773

Boston, December 16, 1773

INSTEAD OF WORKING TO CALM THE colonists and reduce tensions, Parliament made a bad situation worse in 1773 by passing the Tea Act. This act allowed the British East India Company to ship tea directly to the colonies, simultaneously bypassing American middlemen and forcing the colonists to pay taxes on British tea. Once again, tempers flared. Colonists cried, "No taxation without representation!" In Boston, angry mobs tarred and feathered British customs agents—a painful and sometimes fatal process for those who endured it. The arrival in Boston of British ships loaded with tea finally drove the protesters past the tipping point.

On December 16, patriot Samuel Adams assembled a meeting of colonists at the Old South Meeting House. Whether spontaneously or at a prearranged signal, dozens of angry Americans, some of them dressed as Mohawk Indians, poured out of the meeting house and clambered aboard the British ships. In a trice, they dumped overboard all the crates of tea, which brewed in the chilly harbor water. Sixteen-year-old Joshua Wyeth described the scene: "As [the tea crates] were hauled on deck others knocked them open with axes, and others raised them to the railings and discharged their contents overboard. . . . We were merry, in an undertone, at the idea of making so large a cup of tea for the fishes but we used not more words than absolutely necessary. I never worked harder in my life." The festive spirits of the patriots could not conceal the grim meaning of the pace of events: war was not far away.

> "*We were merry,* in an undertone, at the idea of making so large a cup of *tea for the fishes.*"

~Boston Tea Party participant Joshua Wyeth

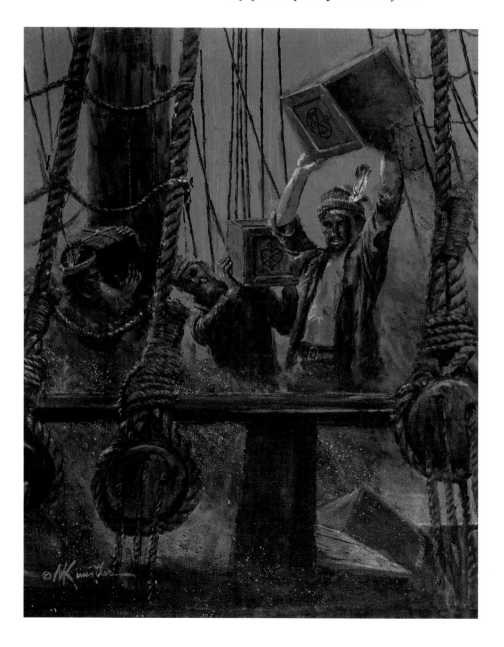

Patrick Henry's Speech

St. John's Church, Richmond, Virginia, March 23, 1775

BY 1775, THE IMPENDING AMERICAN REVOLUTION had grown beyond simple anger and resentment at British taxation and military occupation, and become a movement of ideas. Men like Thomas Jefferson, Benjamin Franklin, and John Adams based their resistance to Parliament on concepts of liberty that would, in time, transform the world. Good ideas were of little use, however, without gifted individuals capable of articulating them to the people. One such man was Patrick Henry. His origins were undistinguished. Born into the middling Virginia gentry in 1736, he failed at farming and business before deciding to become a lawyer. His understanding of the law was good if not exceptional. As an orator, however, he shone brighter than any man of his day. And by the 1760s, he had a cause in which to put this talent to use: opposition to the British crown.

In March 1775, the Second Virginia Convention moved inland from Williamsburg to Richmond in order to avoid the baleful gaze of the royal governor, Lord Dunmore, and his enforcers, the Royal Marines. Some delegates to the convention urged Virginians to take up arms in defense of their rights. Others urged conciliation. Into the midst of this debate strode Patrick Henry, who stood up on March 23 to deliver an oration that would shake the world. No one took notes, but none could ever forget his final words: "Gentlemen may cry, Peace, Peace—but there is no peace. The war is actually begun! The next gale that sweeps from the north will bring to our ears the clash of resounding arms! Our brethren are already in the field! Why stand we here idle? What is it that gentlemen wish? What would they have? Is life so dear, or peace so sweet, as to be purchased at the price of chains and slavery? Forbid it, Almighty God! I know not what course others may take; but as for me, give me liberty or give me death!" It was a clarion call to revolution and war.

"The Regulars Are Coming Out!"
Lexington, Massachusetts, April 19, 1775
(*following pages*)

Sketch for *"The Regulars Are Coming Out!"*

BY APRIL 1775, THE BRITISH WERE ENTIRELY FED up with the colonists. Realizing that the rebellion was one step from veering totally out of control, they reasoned that the time had come to secure large caches of arms and kick some of the American ringleaders out of the way. But the Americans were no fools. Anticipating that British troops in Boston under General Thomas Gage might move at any moment to capture the arsenal at Concord and seize their leaders, the Massachusetts Provincial Congress took steps to prepare. Their goal was to forestall any potential British moves against the militia and protect leading patriots, such as John Hancock and Samuel Adams. They depended for information on men like Paul Revere and his so-called "mechanics"—local Boston patriots who set up the first organized intelligence network in American history. Revere was one of the principal couriers for the Boston Committee of Correspondence and the Massachusetts Committee of Safety, but little did he know that one of his rides in the spring of 1775 would later be immortalized in a poem by Henry Wadsworth Longfellow ("Paul Revere's Ride," 1860) and transform him forever into a national symbol of freedom.

On the night of April 18–19, Revere and another "mechanic," shoemaker Henry Dawes, received word of an imminent British movement and set out to alert patriots that the redcoats were coming. (His actual cry was believed to be "The regulars are coming out!") Revere embarked on his legendary ride. On his way, he had a close call that he later described: "I set off upon a very good Horse; it was then about 11 o'Clock, and very pleasant. After I had passed Charlestown Neck . . . I saw two men on Horseback, under a Tree. When I got near them, I discovered they were British officers. One tryed to git ahead of Me, and the other to take me. I turned my Horse very quick, and Galloped towards Charlestown Neck, and then pushed for the Medford Road. The one who chased me, endeavoring to Cut me off, got into a Clay pond, near where the new Tavern is now built. I got clear of him, and went thro Medford, over the Bridge, and up to Menotomy."

In Lexington, Revere found Hancock and Adams and warned them to flee—just in time. As the patriot leaders departed, Revere, now joined by Dawes, raced on to alert the militia at Concord. Redcoats caught Revere at a roadblock and held a pistol to his chest, demanding information. Reasoning that the truth would serve him best, Revere told them of the thousands of militiamen then gathering in the area, and soon the redcoats fled. One job remained to be done—Hancock had left behind some important papers in a trunk at Munroe Tavern. Revere rode back furiously to Lexington. As he was dragging the trunk from a room upstairs in the tavern, he looked out a window and saw British troops on the march. Riding off with the trunk a few minutes later, dodging redcoats, Revere heard the first shots of the Revolutionary War.

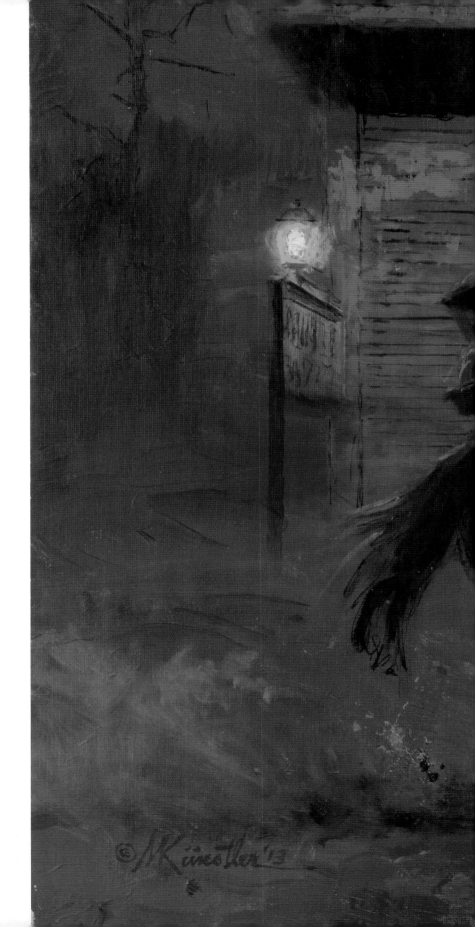

"I set off upon a very good Horse; it was then about II o'Clock. . . . I saw two men on Horseback, under a Tree. When I got near them, I discovered **they were British officers.** One tryed to git ahead of Me, and the other to take me. I turned my Horse very quick, and **Galloped towards** Charlestown Neck, and then pushed for the Medford Road."

~Paul Revere, recalling his famous ride of April 18–19, 1775

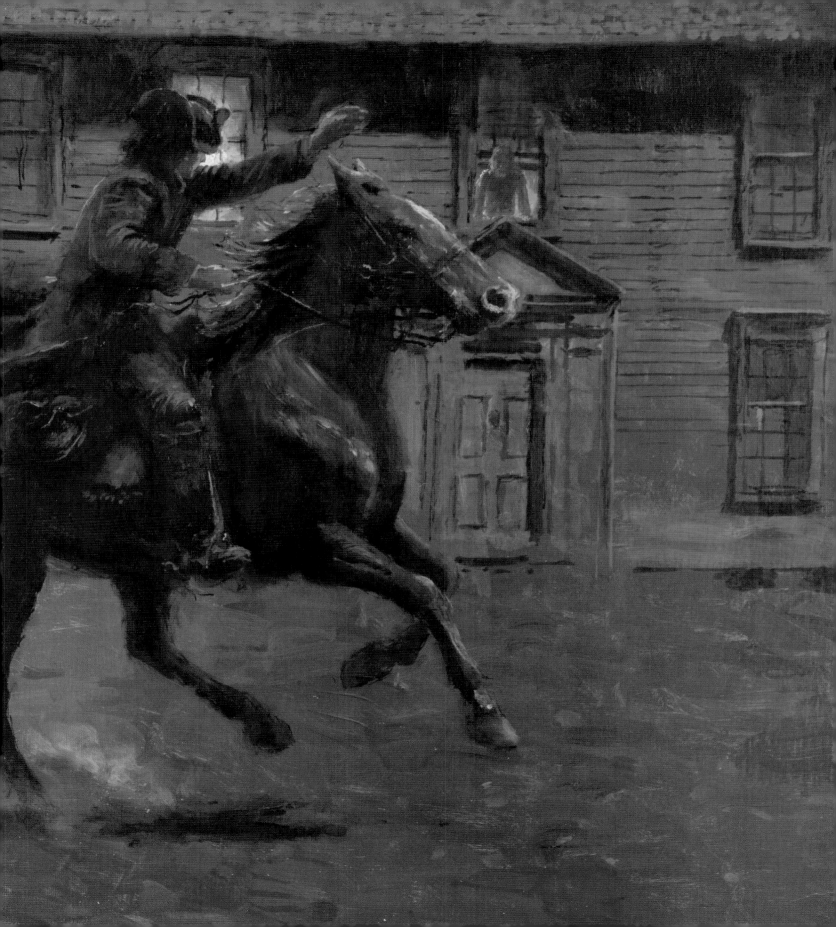

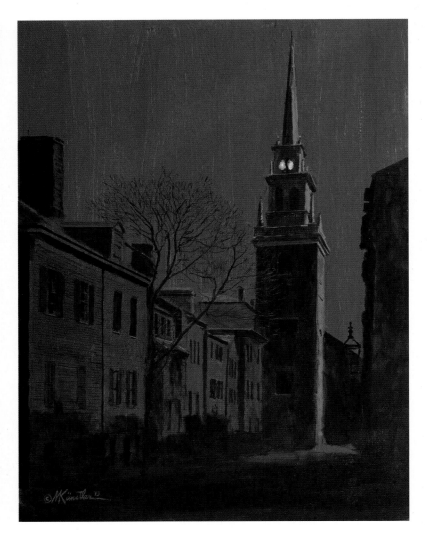

Two If by Sea

Boston, April 18–19, 1775

WHILE PAUL REVERE RODE, ANOTHER SIGNALING system that he and his compatriots had put in place began to function. During planning meetings a few days earlier, Revere had agreed "that if the British went out by Water, we would show two Lanthorns in the North Church Steeple; and if by Land, one, as a Signal; for we were apprehensive it would be difficult to Cross the Charles River, or git over Boston neck." The Old North Church was one of the most venerable and visible structures in Boston, with a 191-foot steeple. The sexton, Robert Newman, was also an avid patriot; and as British troops left Boston and rowed to Cambridge he duly carried two lanterns up the church steeple. In truth, the signal—meant to warn patriots in Charlestown that the British were on their way—was unnecessary. It had only been intended as a backup plan in case a mounted messenger could not make it there with the information—which the messenger did. Necessary or not, however, the signal (thanks in part to the Longfellow poem) became one of the most iconic moments of the beginning of the Revolutionary War.

North Bridge

Concord, Massachusetts, April 19, 1775 (*opposite*)

GENERAL THOMAS GAGE'S ATTEMPT AT A QUICK strike on patriots around Boston lost the element of surprise thanks to Revere's heroics. But the real work had not yet begun. Nine hundred British light infantry and grenadiers passed through Lexington that night, and while they failed to catch any patriot leaders, they easily scattered the first ragged bands of American Minutemen—whose members would be ready "at a minute's notice"—who showed up. A small band of American militia retreated slowly before the redcoats as they approached Concord, then withdrew across the rickety North Bridge to a small hill north of town, from where they watched the British destroy the arsenal. While the British searched for weapons and any stray patriots, more militia assembled. Soon more than four hundred Americans lay opposite the North Bridge, where the British posted a light infantry company of fewer than a hundred soldiers to stand guard. The American militia, under Colonel James Barrett, debated whether to take advantage of their superior numbers and storm the bridge.

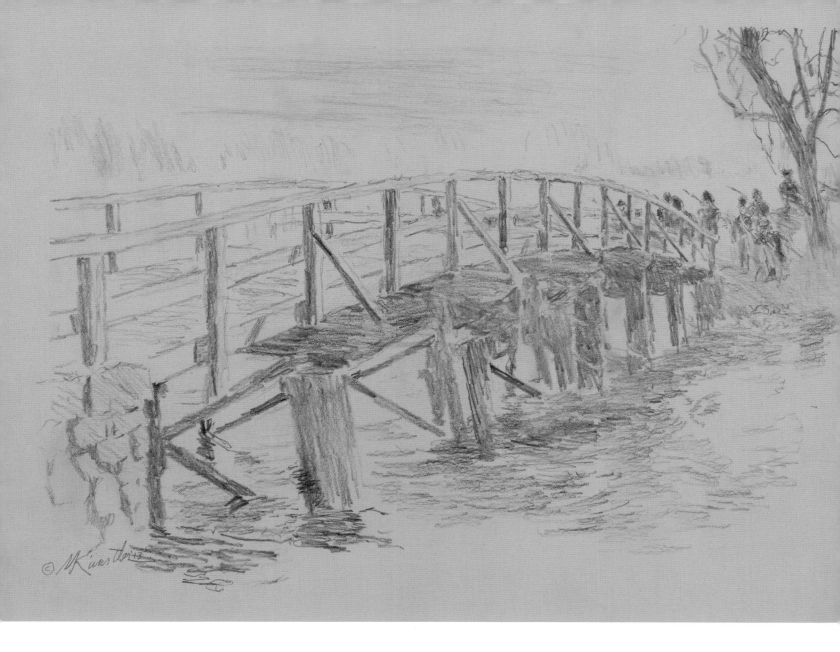

Captain Isaac Davis, commanding a company from nearby Acton, made up Barrett's mind by proclaiming "I'm not afraid to go, and I haven't a man that's afraid to go." While the British hesitated, the militia moved forward. Somewhere along the line, a nervous redcoat fired a round, and others followed suit. A few Americans toppled. It was like the Boston Massacre all over again—except this time the Americans fired back. Scattered musketry erupted along the river, and soon men fell on both sides. For the British, the contest clearly could end in only one way—their total defeat. The redcoats withdrew, leaving the stunned Americans in possession of the useless old bridge. In the brief skirmish, they had fired what Ralph Waldo Emerson later called, in his poem "Concord Hymn," the "shot heard round the world":

By the rude bridge that arched the flood,
Their flag to April's breeze unfurled,
Here once the embattled farmers stood,
And fired the shot heard round the world.

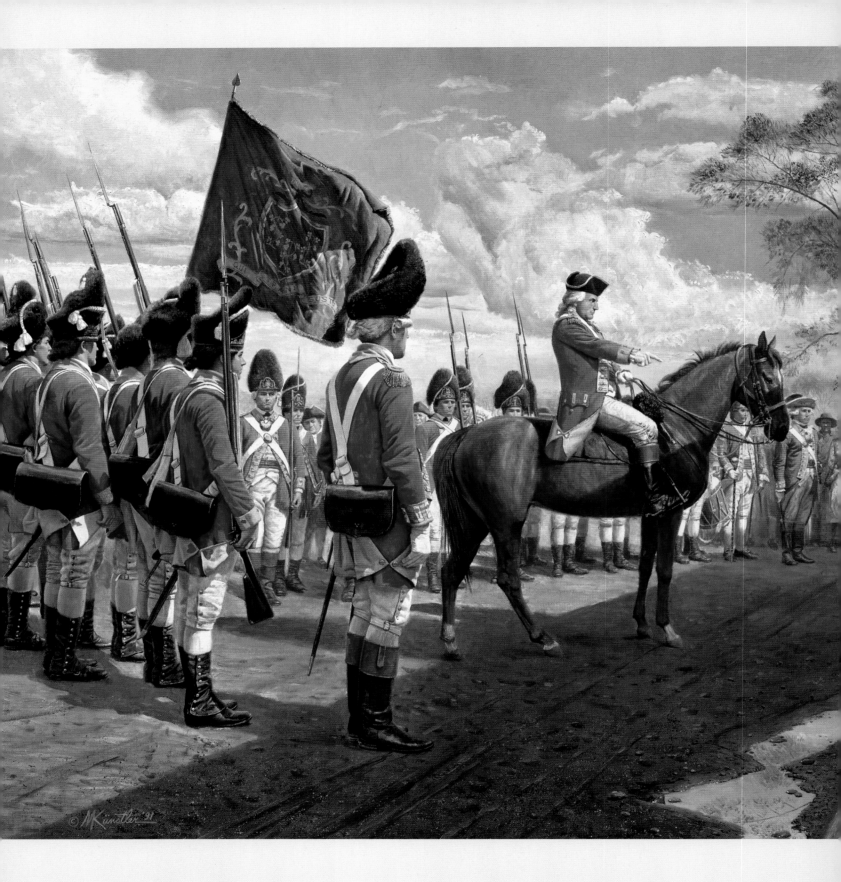

Benedict Arnold Demands the Powder House Key

New Haven, April 22, 1775

AS THE BRITISH MARCHED FROM CONCORD TO Lexington, and from there to Boston, the militia pounced. The redcoats pushed toward Boston in square formation, but Americans surrounded them on all sides in loose bands of skirmishers who opened fire incessantly from woods and behind fences, inflicting and taking casualties. By the time Gage's troops reached Boston around sundown, they had suffered more than 270 casualties, including seventy-three dead; the Americans had lost just under a hundred.

News of the battles spread like chain lightning across the continent. Delegates on their way to join the Second Continental Congress about to convene in Philadelphia found the country in arms, including noted Lutheran pastor Henry Melchior Muhlenberg, who observed that "boys, who are still quite small, marching in companies with little drums and wooden flints to defend their inherited liberty." In New Haven, Benedict Arnold, commanding the 2nd Company of the Governor's Foot Guard, decided to lead his men to aid their fellow patriots at Boston. His men were willing enough—all they lacked were weapons and powder. The town selectmen hesitated, however, hoping for something more official (or for someone else to take the responsibility). The impetuous Arnold fumed with frustration. Imperiously, he told the selectmen that they could either give him the key to the powder house, or he would have his men break it open. "You may tell the selectmen," he reportedly said, "that if the keys are not coming within five minutes, my men will break into the supply-house and help themselves. None but Almighty God shall prevent my marching." The selectmen reluctantly handed over the key. Armed and ready for battle, Arnold's men began the three-day march to Cambridge.

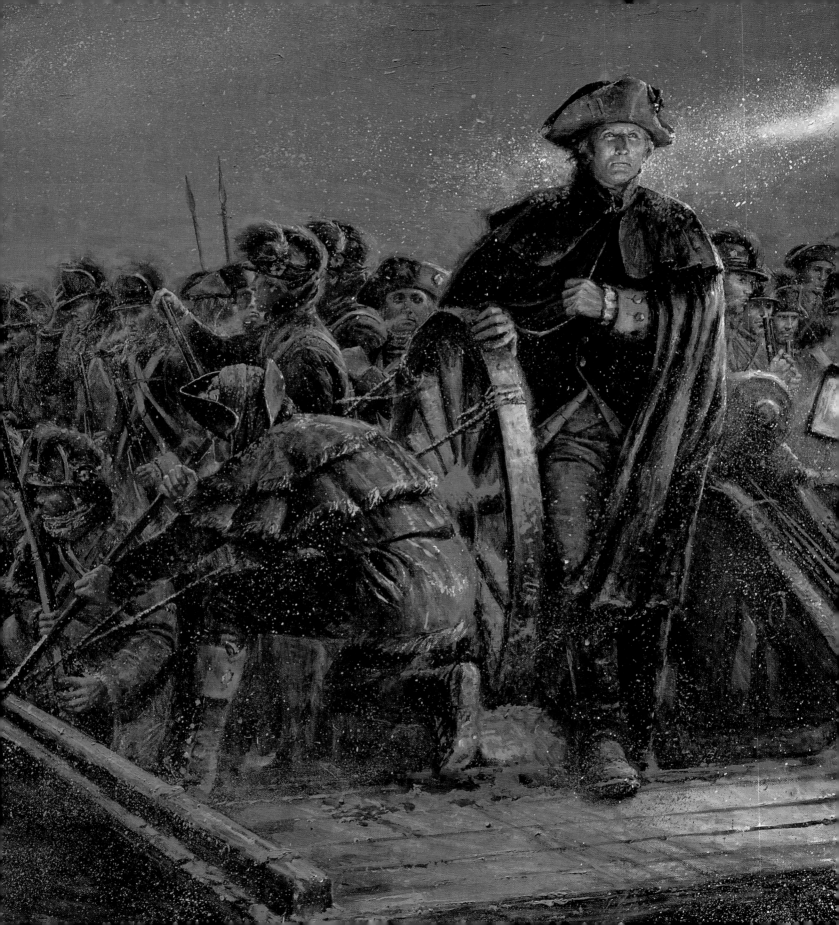

PART TWO

War

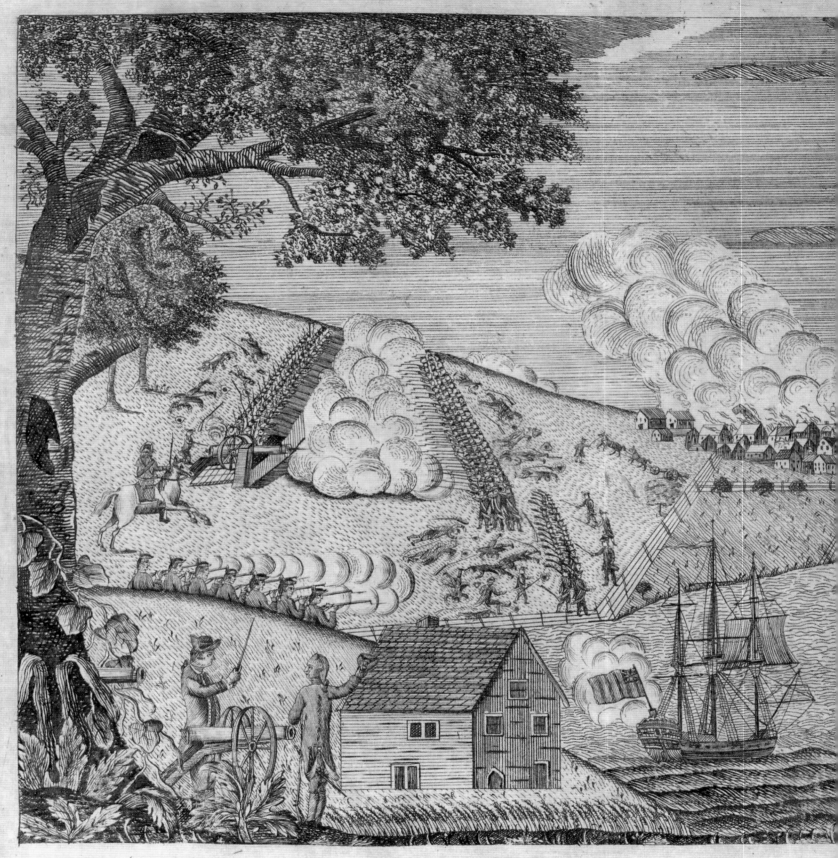

A CORRECT VIEW of THE LATE BATTLE AT CHARLES

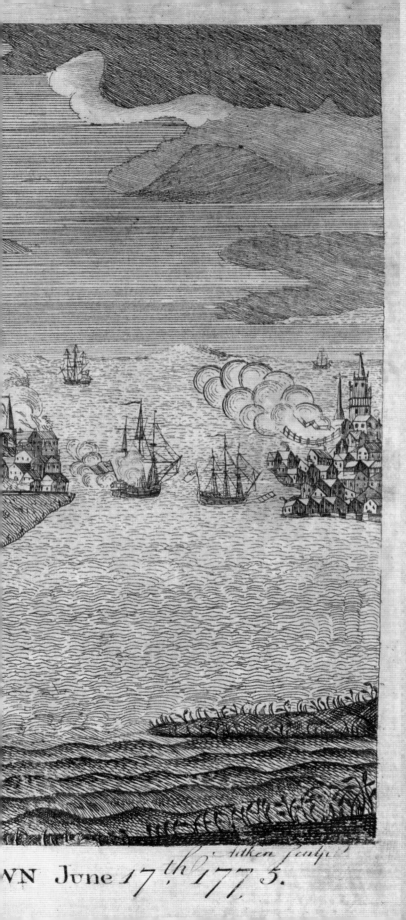

A MERICAN SOLDIERS HAVE ALWAYS HOPED AND
dreamed of being home in time for Christmas. As he
took his leave of Mount Vernon and his beloved wife,
Martha, in June 1775, George Washington wrote fondly, "I
shall return safe to you in the fall—I shall feel no pain from
the Toil, or the danger of the Campaign—My unhappiness
will flow, from the uneasiness I know you will feel at being left
alone." These words from the commander in chief echoed those
written or spoken by thousands of other Americans set to join
the Continental army in the battle for independence from Great
Britain. All missed their loved ones and hoped to return home
in time to share the joy of a holiday meal.

The war lasted eight long years. It left cities and regions
devastated, and tore communities apart. Long before the Civil
War, brothers fought against brothers, and sons against fathers.
For the first and only time in the history of the United States,
the entire country was a battleground. From Georgia to what
is now Maine, invading armies and bands of guerrillas rav-
aged the land. Great armies fought important battles in upstate
New York, Pennsylvania, New Jersey, Virginia, the Carolinas,
Florida—and Canada. Settlers and Native Americans engaged
in ruthless combat on the frontier.

Great Britain possessed many important advantages over
her rebellious colonies. British generals were better trained
and experienced than their American counterparts, and their
troops were better equipped. The British navy ruled the seas.
Perhaps most important, Great Britain enjoyed an established
and stable political system, and a debt-ridden but nonetheless
strong economy. Americans had to create all of these things
from scratch. In 1775, they had no army, no navy, no govern-
ment, and no economy. That they were able to build such com-
plex systems and organizations on the run, while doing battle
with the greatest empire in the world, is a testament to their
genius and determination.

A Correct View of the Late Battle at Charlestown, June 17th, 1775
[ca. 1775]; this map, published by Philadelphia printer Robert Aitken,
depicts the Battle of Bunker Hill.

VN June 17th 1775.

CHAPTER FOUR

The War Begins

"The Continental Congress, having now taken all the Troops of the several Colonies, which have been raised, or which may be hereafter raised for the support and defence of the Liberties of America. . . . They are now the Troops of the UNITED PROVINCES of North America; and it is hoped that all Distinctions of Colonies will be laid aside; so that one and the same Spirit may animate the whole, and the only Contest be, who shall render on this great and trying occasion, the most essential service to the Great and common cause in which we are all engaged."

— GEORGE WASHINGTON, GENERAL ORDERS TO
THE CONTINENTAL ARMY, HEADQUARTERS,
CAMBRIDGE, MASSACHUSETTS, JULY 4, 1775

THE CONTINENTAL CONGRESS APPOINTED George Washington to command the Continental army in June 1775. As he journeyed to take command at Cambridge outside Boston, where a huge contingent of New England militiamen had entrapped a British force under General Thomas Gage, Washington learned about the Battle of Bunker Hill.

Overconfident and contemptuous of their American adversaries, the British had attempted to rout militia under General Israel Putnam from positions on Breed's Hill near the city. They succeeded, but at terrible cost. The sight of the heaped bodies of hundreds of redcoats fallen beneath their guns inspired Americans in the belief that they could both fight and inflict severe damage on their colonial overlords. Perhaps a few more such battles would convince the British to give up the fight, although few Americans dreamed just then that they might think of independence.

The British hold on Boston was tenuous. Once they saw that the Americans were determined to fight, policymakers in London made plans to evacuate the city. Washington managed to hurry them out earlier than they had intended, but the British came roaring back in the summer of 1776 with a massive invasion of New York City and the surrounding region. The defending Americans had the will to fight but lacked the skills necessary to win. Suffering defeat after defeat, Washington fell back across New Jersey. The slow British pursuit assured the Continental army's survival, and gave Washington time to reorganize and consider new plans. Then the unthinkable happened.

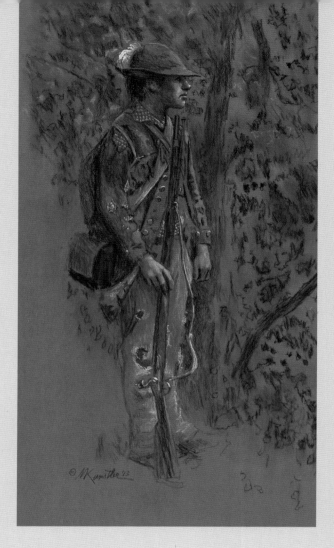

The Patriot
Cambridge, Massachusetts, Summer 1775

THE CONDITION OF THE CONTINENTAL "ARMY" at Cambridge horrified Washington. Everywhere he looked, he saw filth and lack of discipline. The soldiers wore rags; they slept in tattered tents made of tablecloths or in shacks constructed from discarded wood. The stench was intense. Washington issued a string of general orders in July and August that were little heeded, at first. He required "that exact discipline be observed, and due Subordination prevail." He ordered his officers to make "punctual attendance on divine Service," but as often as not he found them playing cards or guzzling rum with their men. He ordered new latrines dug, "the Streets of the encampment and Lines to be swept daily, and all

Offal and Carrion, near the camp, to be immediately buried." The soldiers, mostly militia or short-term Continentals from New England, had joined up to repel the British from Massachusetts. After that they expected to go home. Why, they wondered, should they submit to what seemed like foolish rules, or train like professional soldiers? It seemed almost un-American! Washington uttered more than a few groans that summer as he surveyed the extent of his challenge.

To make matters worse, there was no supply system to speak of. Lacking a commissariat, soldiers simply lived off the land—causing immense suffering to local civilians and deterring good discipline. By summer's end, the army was running out of basic supplies. On September 21, Washington wrote to the president of Congress, John Hancock, how "inexpressibly distressing" it was "to see the Winter fast approaching upon a naked Army . . . the Military Chest is totally exhausted. . . . [T]he greater part of the Army [is] in a State not far from mutiny." Without some remedy, he worried, the army "must absolutely break up."

Yet rather than despair, Washington acted boldly to handle the growing supply crisis. With a capacity for hard work that astonished his officers, the general built an army supply infrastructure and wrangled supplies any way he could short of requisitioning them from civilians. He had a passion for details. He counted every wagon of every supply convoy and prioritized deliveries, ensuring that each shipment contained what the men most needed to survive. Basics included weapons, gunpowder, clothing, food—and rum. The commander in chief also taught his men how to make do with less, issuing instructions on how to efficiently prepare food, cut cloth, manufacture soap, and construct proper shelter. It was a preview of his later actions at places like Valley Forge and Morristown, and the means by which he would blaze the trail to victory.

Fife and Drum

Cambridge, Massachusetts, Summer 1775

ONE ASPECT OF WASHINGTON'S BRILLIANCE AS a military leader became evident right away: he understood the importance of fundamentals. And nothing was more fundamental than the men who would fight under his command. Within a few weeks of Washington's arrival the army of New Englanders was joined by soldiers from places like Pennsylvania, Maryland, and North Carolina. Their origins were diverse, and they didn't always get along. Some were old men barely capable of handling a musket, others were hale and hearty, and many were only boys. Some were wealthy men-about-town, and others were indigent. Convincing soldiers such as these to think like a unit was Washington's primary objective. Many Americans believed that the will to victory would suffice. But Washington knew that to win, he would need a well-drilled force of men who were attentive to the commands of vigorous officers and capable of maneuvering together in the field.

Washington began his training regimen with seemingly simple, irrelevant rules, but details mattered. For example, when officers passed sentries and guards, Washington dictated that "[t]he Commander in Chief is to be received with rested Arms; the Officer to salute, and the Drums to beat a march: The Majors General with rested Arms, the Officer to salute and the Drums to beat two Ruffles; The Brigadiers General with rested Arms, the Officer to salute and the Drums to beat one Ruffle." The men grumbled but—increasingly—they obeyed. They weren't sure what the new commander in chief was aiming at—but he seemed determined.

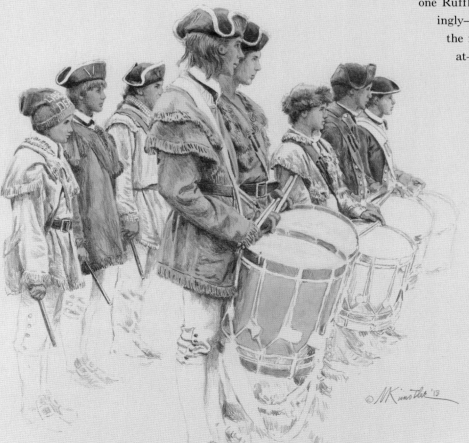

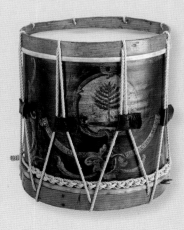

This attractively painted Massachusetts regimental drum is embellished with a pine tree, which was used in the period prior to the war as a symbol for New England, and throughout the war as a symbol of resistance.

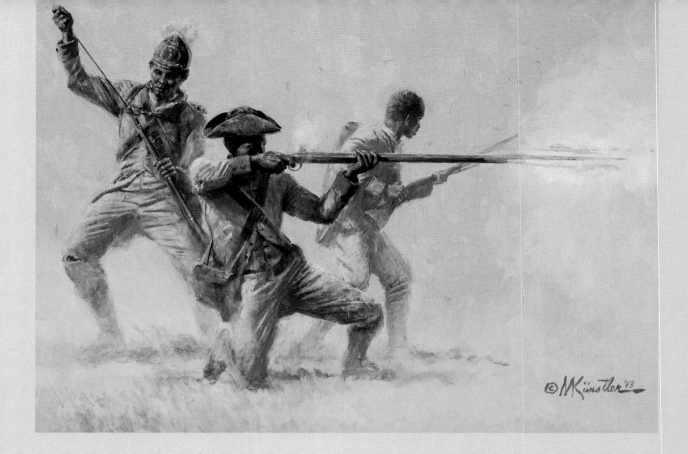

First Rhode Island

Cambridge, Massachusetts, Summer 1775;
Rhode Island 1778

AMERICANS JOINED THE ARMY ENTHUSIASTI-
CALLY enough, but typically for no more than a year.
The Continental Congress, fearful that a standing army
based on long-term enlistments would become alienated
from civilian society and possibly impose military gov-
ernment, restricted terms of service to twelve months.
As a result, men departed the army just as they finished
their courses of training and were beginning to know
their jobs well. This forced Washington into the position
of taking men almost wherever he could get them, but he
believed that he had to draw the line somewhere. Dis-
mayed at the number of "Boys, Deserters, and Negroes"
in the ranks at Cambridge, in July 1775 he insisted that
recruiters should not enlist "any deserter from the Min-
isterial [British] army, nor any stroller, negro, or vaga-
bond." Supported by his officers, Washington—a slave-
holder who feared that arming blacks might provoke

a slave rebellion—grouped together free and enslaved
black men with "boys unable to bear arms" and "old
men unfit to endure the fatigues of the campaign" as
unacceptable soldiers.

Despite Washington's opposition, African Americans
continued to serve in the Continental army throughout
the war. In 1778, Rhode Island created a regiment
manned mostly by blacks, and it served with distinction.
Washington's views eventually changed too. Friends
and comrades such as Gilbert du Motier, Marquis de
Lafayette, and John Laurens urged him to arm blacks
on a large scale. While he balked at doing that much, he
did learn to tolerate fully integrated black troops who
may have constituted as much as 10 percent of the army
by 1781. His experience of their patriotism and bravery
may have contributed to his later decision to write an
order freeing his slaves into his final will and testament.

Morgan's Rifles

Cambridge, Massachusetts,
Summer–Fall 1775

IN JUNE 1775, THE CONTINENTAL
Congress ordered the formation of ten
rifle companies from Pennsylvania,
Maryland, and Virginia. Virginian
Daniel Morgan, who had served as a
wagoner for the British army during
the French and Indian War, raised a
company of sharpshooting frontiersmen
from Virginia in approximately ten days
and headed to Washington's headquar-
ters at Cambridge. The rifle compa-
nies' Pennsylvania rifle—with its long,
light, spiral-grooved barrel—was more
maneuverable and accurate at longer
distances than the British musket,
which made it advantageous in guer-
rilla tactics.

Several weeks after arriving in
Massachusetts, the company, known as
Morgan's Riflemen, set off on a journey
north to join General Richard Mont-
gomery and Colonel Benedict Arnold
on their ill-fated mission to cap-
ture Quebec in December 1775.
At the Battle of Quebec on
the thirty-first, Montgomery
was killed, Arnold wounded
in action, and Morgan and
many of his riflemen were
captured. Morgan was held
prisoner by the British until
the end of 1776. Upon his
release he served with distinc-
tion (see pages 74, 108, and 110).

Daniel Morgan, by Charles
Willson Peale, ca. 1794

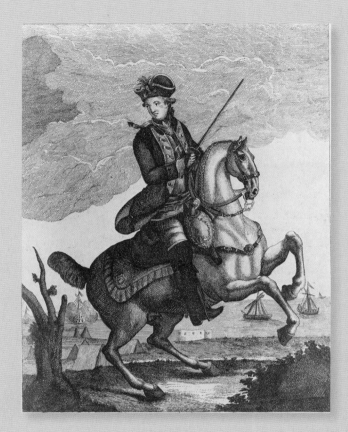

General Howe, Esqr. of the Conecticut [sic] *and Comander* [sic] *Army in America*, engraved by Johann Michael Probst, ca. 1776—90. William Howe, 5th Viscount Howe took command of the British army from Thomas Gage in October 1775.

The Loyalist
Boston, Massachusetts, 1775–76 (*opposite*)

DESPITE THEIR PROBLEMS OF DISCIPLINE, organization, firepower, and supply, patriots believed that the righteousness of their cause and, above all, their will to win, set them apart from their adversaries. In his orders of August 23, 1776, Washington exhorted his officers to remember "what a few brave men contending in their own land, and in the best of causes can do, against base hirelings and mercenaries." Since the French and Indian War, Americans had come to believe that the redcoats were hyper-disciplined automatons who were unable to fight like free men. But they underestimated the British at their peril. Great Britain had not acquired an empire by accident. British officers were effectively trained and battle-seasoned; their men were well supplied and equipped, and they knew how to fight. Moreover, the British also thought their cause was just, and expected to win. Their ranks were boosted by approximately thirty thousand Loyalist soldiers and militiamen, in addition to thirty thousand Hessians. "Believe me," a British officer wrote home from Boston, "any two [British] regiments here [can] beat, in the field, the whole force of the Massachusetts Province; for tho' they are numerous, they are but a mob, without order or discipline, and very awkward at handling their arms." A British surgeon dubbed the Continental army as "truly nothing but a drunken, canting, lying, praying,

"[*A*]ny two [British] regiments here [can] beat, in the field, the *whole force* of the Massachusetts Province; for tho' they are numerous, they are but a mob, *without order or discipline,* and very awkward at handling their arms."

~British officer commenting on the Continental army

hypocritical rabble, without order, subjection, discipline, or cleanliness; [that] must fall to pieces of itself in the course of three months."

It was true, the American soldiers were under-equipped, undisciplined—and none too clean. Washington himself called them "an exceeding dirty and nasty people." Their officers were enthusiastic amateurs. And yet the Americans possessed certain qualities that set them apart from those of any other nation: a special blend of endurance and adaptability. In 1775 and 1776, many aspects of warfare would seem beyond their reach. American officers (including Washington) struggled to deploy their men properly. All too often, the soldiers bungled their responsibilities on the battlefield. Time and again in the war's first years, they would be broken and defeated. The Americans always recovered and reentered the fray, however—and each time a little better than before. Without formal training, without regular supplies, and all too often without strong leadership, the Americans learned their lessons and applied them efficiently, adapting to circumstances in ways the British could not anticipate. British officers were creative, and their men steadfast and determined—but they still fought by the book. Americans, by contrast, wrote the book as they went along.

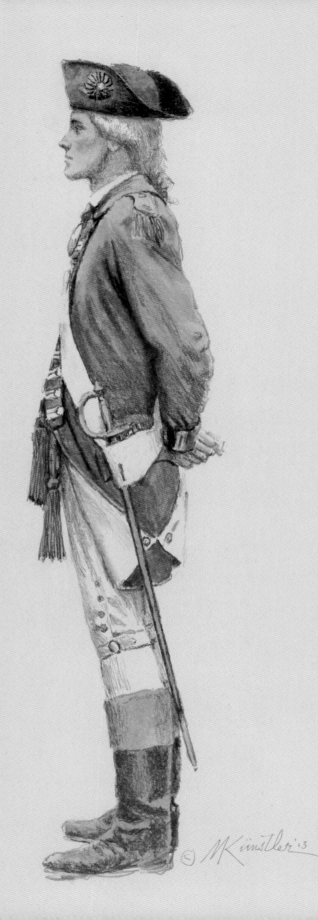

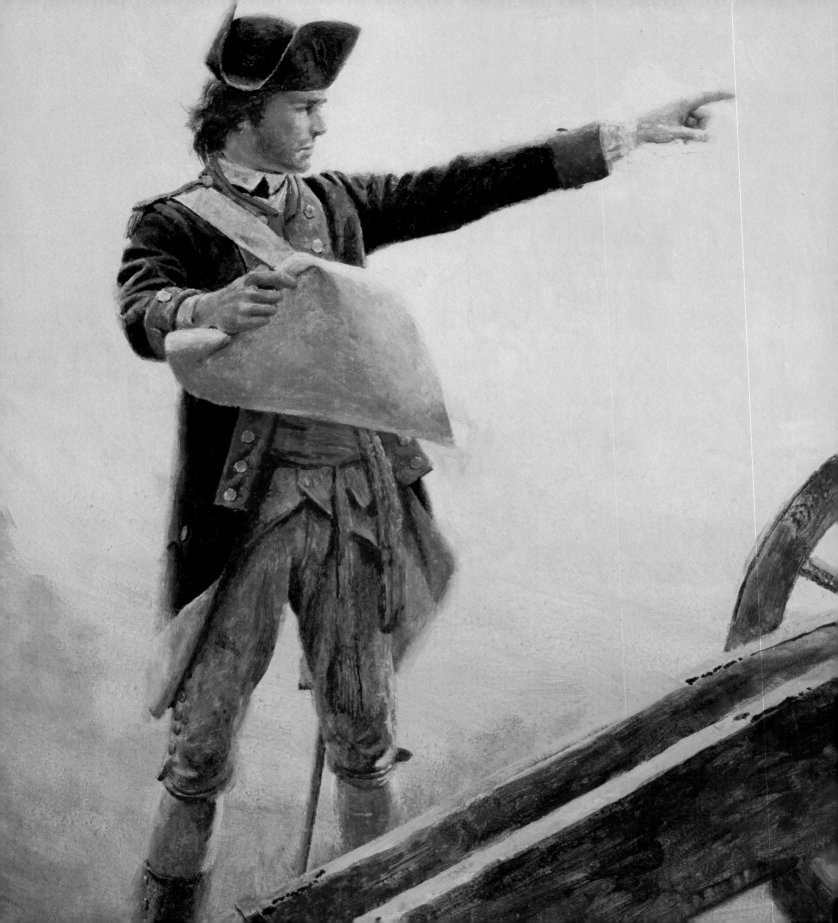

"*The rebels have done more in one night than my whole army would have done in a month.*"

~British General William Howe

"Move the Guns Up"
Dorchester Heights, Boston, March 5, 1776

AFTER BUNKER HILL, THE TWO SIDES SETTLED into stalemate. The Americans heavily outnumbered the redcoats, but the British defenses around Boston seemed impenetrable. Washington and his officers batted ideas back and forth about how to overcome the enemy. Some suggested using incendiary weapons to burn the British out. Washington considered attacking the enemy entrenchments frontally. He even pondered waiting until the harbor was frozen and attacking across the ice—presumably with men on skates! None of the ideas seemed practical, however; partly because the Continental army lacked both artillery and ammunition.

The bravery of a Boston bookseller, the creativity of an obscure officer, and Washington's willingness to take risks ultimately made the difference. Henry Knox, a portly and amiable Bostonian who had made his living purveying books, scoured New England for guns. He finally hit upon the idea of transporting heavy artillery that had been captured at Fort Ticonderoga in May 1775 all the way to Washington's camp at Cambridge. To do so, he improvised heavy sledges that teams of oxen hauled over frozen waterways and ice-choked roads. Washington and his officers decided to deploy the cannon on Dorchester Heights, overlooking Boston and the harbor, in plain sight of the enemy. The idea seemed impossible at first. But then a burly, semiliterate lieutenant colonel named Rufus Putnam came forward with the idea of constructing wooden fortifications for the protection of the guns beforehand. Soldiers could lug the prefab fortifications and guns up to the heights overnight, and open fire on the British at dawn. Washington decided to take the risk. Amazingly, the plan came off. On the morning of March 5, British General William Howe—who had taken over from Gage in Boston—awoke to find his army helpless under the frowning muzzles of well-protected American guns. "The rebels have done more in one night," Howe is said to have exclaimed, "than my whole army would have done in a month." Within two weeks, the British had abandoned Boston.

The Americans could hardly believe their eyes. For one brief shining moment, victory seemed assured. Except for Canada, the British had been entirely ejected from North America. Boston selectman Timothy Newell watched the last British sail disappear over the horizon and breathed a sigh of relief. "Thus," he wrote in his diary, "was this unhappy distressed town . . . relieved from a set of men whose unparalleled wickedness, profanity, debauchery and cruelty is inexpressible."

Yet Washington never doubted for a moment that the British would be back, and that they would target New York. Even before the evacuation of Boston, he made plans to defend Manhattan. The problem was that the city could not be held for long against an enemy with control of the sea. "What to do with the City, I own puzzles me," General Charles Lee told Washington. "It is so encircled with deep navigable water, that whoever commands the Sea must command the town." Washington—prodded by Congress—nevertheless determined to try and hold the place, whatever the peril. New York, he said, was "of the last [utmost] importance to us in the present Controversy." As Boston rejoiced, the Continental army moved south to New York.

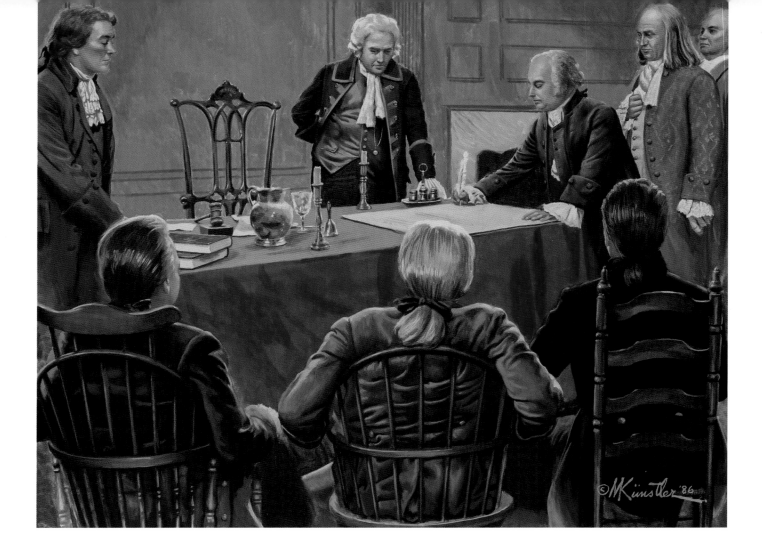

The Signing
Philadelphia, July 4, 1776

AS EXPECTED, SOON ENOUGH A BRITISH ARMADA began to arrive off New York Harbor. From the end of June through August 12 the flotilla amassed; it was the largest amphibious force ever in the entire glorious history of the British Empire—almost 400 ships bearing 32,000 troops. The ships pressed through the Narrows, the strait between Staten Island and Brooklyn, while rebels took potshots at them from the shore. On July 2, redcoats swarmed ashore on Staten Island, occupying it without a fight. That same day, in Philadelphia, Congress approved the Declaration of Independence.

The Declaration was an act of astonishing defiance, unique in the world to that time. True, the British had been ousted from Boston in an essentially bloodless coup, but King George III remained determined to restore colonial rule in North America. The delegates knew that a massive British armada was at their door, yet proceeded as if the world was at their fingertips—as indeed in a sense it was. Two days later, members of Congress began signing their names to the revolutionary document. Each stroke of their pens rendered the British ships bobbing in New York Harbor increasingly impotent and irrelevant. From now on, the world would never be the same.

Reading the Declaration of Independence to the Troops

New York, July 9, 1776 (*following pages*)

NOT EVERY PATRIOT AGREED WITH the Declaration of Independence. For some, it went too far. Many Americans who opposed the measures of Parliament were anti-British but not yet ready for full independence. For others, the Declaration was simply ill-timed. Washington—as passionate a believer in the cause as any—was a cautious man. Given the choice, he probably would have postponed any talk of independence. Now that it was here, however, he bowed to the wishes of Congress. "It is certain that it is not with us to determine in many instances what consequences will flow from our counsels," he told John Hancock, "but yet it behooves us to adopt such, as under the smiles of a Gracious & All kind Providence will be most likely to promote our happiness; I trust the late decisive part they have taken is calculated for that end, and will secure us that freedom and those privileges which have been and are refused us."

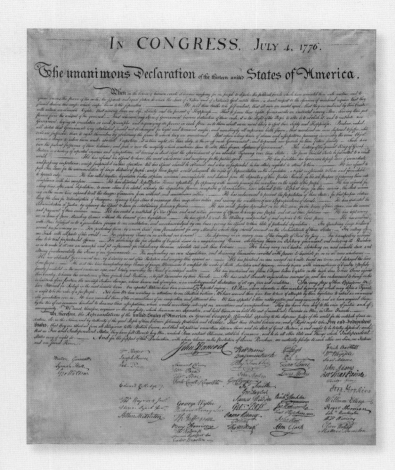

The U.S. Declaration of Independence, signed by Congress July 4, 1776.

On the morning of July 9, General Orders had proclaimed that "[t]he General hopes this important Event will serve as a fresh incentive to every officer, and soldier, to act with Fidelity and Courage, as knowing that now the peace and Safety of his Country depends (under God) solely on the success of our arms." That evening at 6:00 p.m., thousands of Continental army troops stationed around New York City assembled at the parade grounds in Lower Manhattan (near present-day City Hall) to hear the Declaration read by their commanding officers, such as the men of Brigadier General Nathaniel Heard's New Jersey Brigade (*following pages*). The words of the Declaration rang out across the parade grounds to the assembled brigades. After the conclusion—"And for the support of this Declaration, with a firm reliance on the protection of divine Providence, we mutually pledge to each other our Lives, our Fortunes and our sacred Honour"—the crowd broke into deafening cheers and marched down Broadway to Bowling Green park, where they tore down a statue of King George III. The Declaration "seemed to have their hearty assent," Washington laconically remarked.

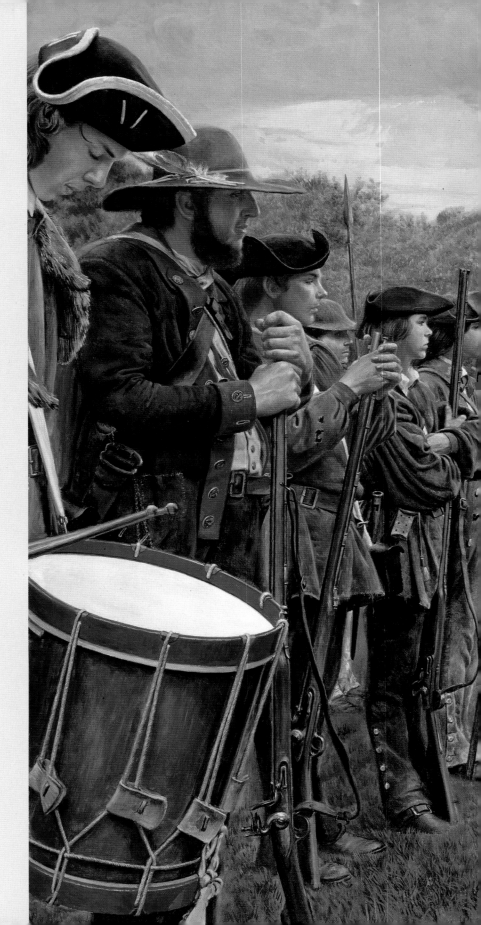

"The General hopes this **important Event** will serve as *a fresh incentive* to every officer, and soldier, to **act with Fidelity** and Courage, as knowing that now the **peace** and **Safety** of his Country depends [under God] solely on the **success** of our arms."

~General orders to the Continental army, New York, July 9, 1776

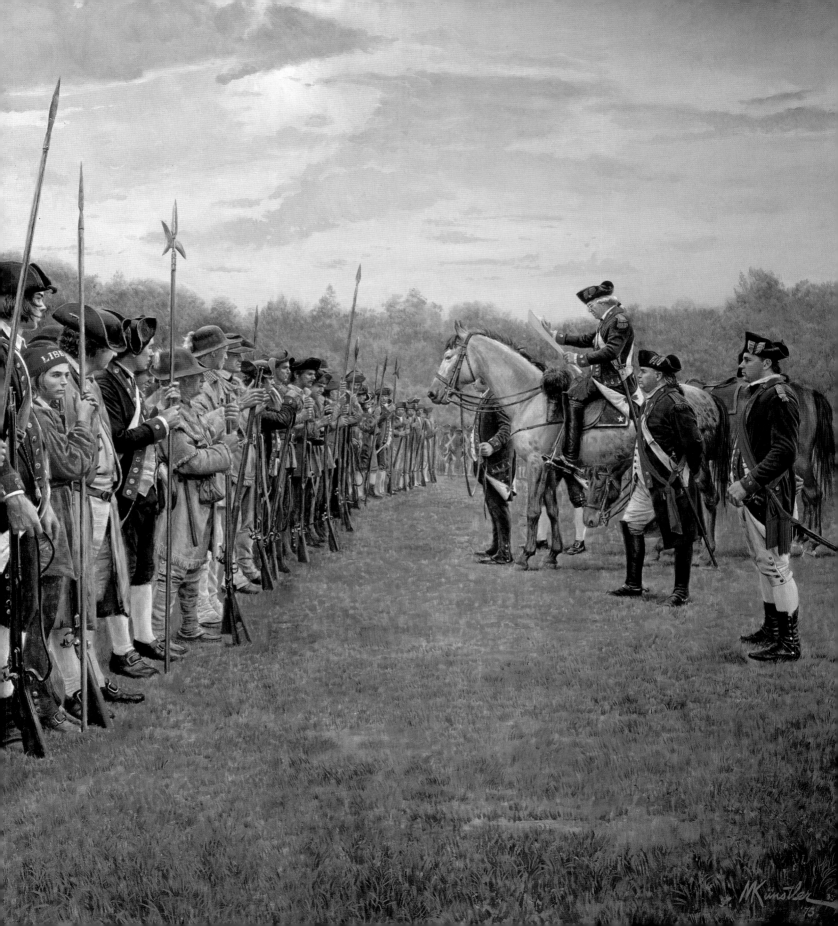

The Redcoats
The Battle of Long Island, August 27, 1776

THE EUPHORIA DIDN'T LAST LONG. SLOWLY, methodically, the British stranglehold on New York City tightened. Washington and his officers planned to defend Manhattan block by block; but first they hoped to hold on to at least part of Long Island by constructing a stronghold around Brooklyn Heights and farther east on Gowanus Heights. Troops under Generals Israel Putnam and John Sullivan established defensive positions they hoped could at least bloody the British. The British moved quickly and efficiently, however, while the American dispositions were clumsy. Howe's redcoats and German troops deftly outflanked and routed the Continentals. Washington, stunned at the defeat, reportedly shouted "Good God! What brave fellows I must this day lose" as he watched his men fall dead or wounded.

The British and Germans might very well have pushed on to storm Brooklyn Heights, capturing the bulk of the Continental army and probably Washington himself; but Howe, fearing another Bunker Hill–style bloodbath, held his troops back. Still, the British felt they had reason to rejoice. "It was a glorious achievement," crowed a British officer in General Simon Fraser's Scottish regiment, "and will immortalize us and crush the Rebel colonies." He went on to boast how they had butchered Americans attempting to surrender. "We took care to tell the Hessians that the Rebels had resolved to give them no quarters in particular," he explained, "which made them fight desperately and put all to death that fell into their hands. You know all stratagems are lawful in war, especially against such vile enemies to their King and country."

A map of part of New-York Island showing a plan of Fort Washington, now call'd Ft. Kniphausen, with the rebels lines on the south part . . . ; created by Claude Joseph Sauthier, surveyor to British general Hugh Percy, November 16, 1776. The fort was renamed after Hessian general Wilhelm von Knyphausen.

The Hessian
New York and New Jersey, Summer and Autumn 1776

WASHINGTON EVACUATED LONG ISLAND ON THE night of August 29, and soon the Americans began withdrawing from Manhattan. Howe's army followed, cautiously attempting to cut off his adversaries and force their surrender. Unlike the boastful officer in Fraser's regiment, Howe hoped to end the war with as little bloodshed as possible so that Great Britain and the Americans could reach peaceful conciliation.

The Continentals fell back from New York and across New Jersey. At General Nathanael Greene's advice, Washington left a few thousand Continentals behind at Fort Washington on the Hudson. Hessian soldiers—recruited from King George III's dynastic holdings in Hesse and other German states—stormed the fort, however. They then took revenge on the fort's defenders—who had inflicted serious casualties on the attackers—by beating and torturing them. Washington watched helplessly from across the river. As October passed into November and December, the retreat continued. Washington's army slowly disintegrated as soldiers deserted or went home at the expiration of their enlistment. Soon only a few thousand ragged and exhausted soldiers remained—the hard core of Americans willing to sacrifice everything, including their lives. Washington nearly despaired of victory and even considered resignation.

Washington's Crossing

McKonkey's Ferry, Delaware River, December 25–26, 1776 (*following pages*)

AT THIS LOW EBB, THE MOMENT DEMANDED someone who could articulate the patriots' anguish and yet keep them focused on the cause and victory. That man was Thomas Paine. Number 1 of his sixteen-part work *The American Crisis* (1776–83) began: "These are the times that try men's souls: The summer soldier and the sunshine patriot will, in this crisis, shrink from the service of his country; but he that stands it NOW, deserves the love and thanks of man and woman. Tyranny, like hell, is not easily conquered; yet we have this consolation with us, that the harder the conflict, the more glorious the triumph." Buoyed by words like these, a hardy few determined to follow Washington across the Delaware River to Pennsylvania. And these same men followed him back again, striking a blow at Trenton that would lead to one of the most brilliant military campaigns in American history.

Paine's *Crisis* Number 1 provided vital inspiration, but it was not enough to turn the tide. No one knew this better than Washington, who always kept his finger on the pulse of American popular feeling. As early as December 14, he was considering whether a "lucky blow" against the enemy could "raise the spirits of the People." Washington's friend and adjutant general, Joseph Reed, agreed. "Even a failure," he wrote, "cannot be more fatal than to remain in our present situation. In short some enterprise must be undertaken in our present circumstances or we must give up the cause." Washington quickly made up his mind. It was a case, he decided, of victory or death.

A secret meeting at Washington's headquarters on December 22 established the plan of attack. With all of its detachments brought together, the Continental army amounted to 6,000 men, most of whom were scheduled to depart by the end of the year as their enlistments expired. To make use of them quickly, Washington determined to launch a surprise attack on the enemy garrison at Trenton, which consisted of about 1,500 German soldiers in a brigade of three regiments. For many days, the Americans had been harassing the Germans in a series of pinprick raids, driving them to exhaustion by keeping them constantly on their guard. By now, they were ripe for the plucking. Washington told his assembled officers at headquarters to prepare for a multipronged attack across the Delaware River on Christmas night—approximately 4,600 men in total, with 2,400 under Washington.

On Christmas Eve, Dr. Benjamin Rush visited a nervous Washington at headquarters. While they spoke, the general wrote notes on small pieces of paper on his desk. Finally, Washington rose and swept out of the room, and as he closed the door a piece of paper fluttered to the floor at Rush's feet. It read "Victory or Death"—the words that Washington had chosen as the sentinels' passwords for the following night.

As the Continentals quietly celebrated Christmas morning and then prepared for the attack, the skies became leaden and overcast. A winter storm was brewing. As the soldiers marched just before sunset, a fierce nor'easter brought in gusts of icy rain, followed by sleet and snow. "It will be a terrible night for the soldiers who have no shoes," an officer (believed to be Lieutenant Colonel John Fitzgerald) quickly scrawled in his diary. "Some of them have tied old rags around their feet; others are barefoot, but I have not heard a man complain."

Washington's column reached the river at sunset. Troops began crossing at once, rowed in sixty-foot Durham freight boats, and perhaps flatboat ferries and scows (see caption for Leutze painting *opposite*), crewed by men of General John Glover's 14th Continental Regiment from Marblehead, Massachusetts. The river, clogged by ice and buffeted by wind, looked dangerous—but to prevent hesitation, Washington set a leader's example by stepping onto a flatboat ferry,

guided by cable, and crowded with troops, cannons and horses, and sternly ordering the crew to take him across. On the other side he stepped ashore and stood resolutely on the bank to watch the other boats follow. The troops lit bonfires as they landed and fought to keep warm. At 4:00 a.m., Washington led the troops forward to change the course of history.

As the march toward Trenton began, Washington did not realize that his column was the only one to make it across the river. The other two had struggled with the ice and turned back. But even if he had known, it wouldn't have made any difference to the commander in chief. His example inspired the men as they had never been inspired before. The attack on Trenton the morning of December 26 was swift and effective, and the entire German garrison was captured. More miracles followed in the coming days as Washington convinced most of his remaining soldiers to extend their enlistments past the New Year instead of returning home. He then led them on a brilliant campaign that resulted in another victory at the Battle of Princeton (January 3, 1777) and forced the British to abandon most of their gains in New Jersey.

In 2011, Mort Künstler ignited a media firestorm when he created the painting *Washington's Crossing* shown on the following pages, which many believe is a more factual representation of the momentous scene than Emanuel Leutze's iconic work *Washington Crossing the Delaware* [1851], in the collection of the Metropolitan Museum of Art in New York [shown *below*]. In *Washington's Crossing* Künstler depicts Washington on a sixty-foot-long flatboat ferry in a blinding snowstorm.

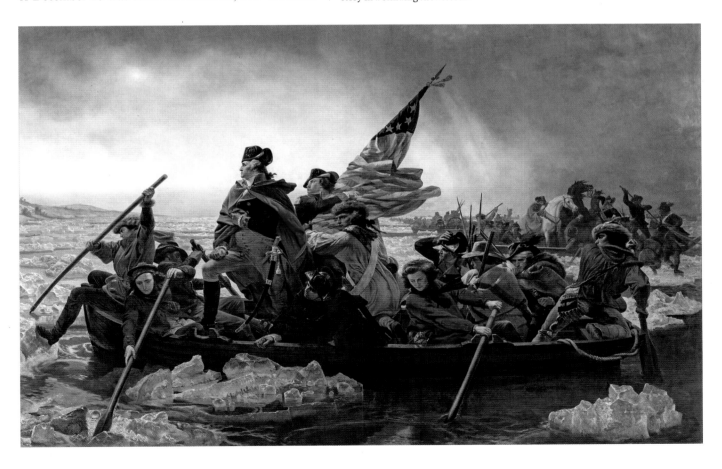

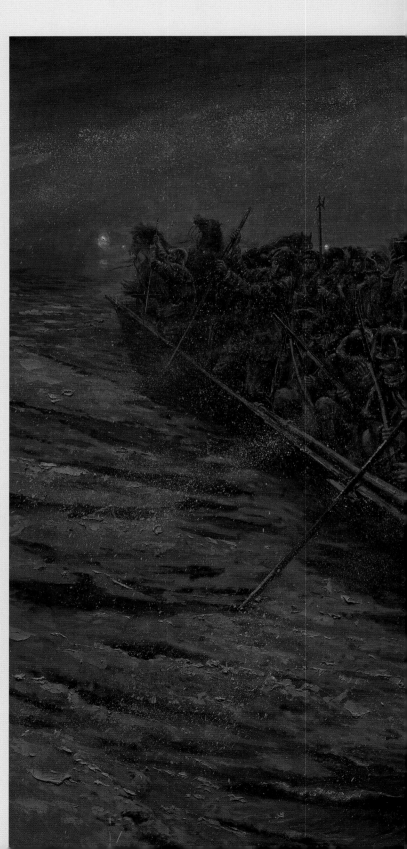

"*These are the **times that try men's souls:*** *The summer soldier and the sunshine patriot will, in this crisis,* **shrink from the service** *of his country; but he that stands it NOW, deserves the* **love** *and* **thanks of man and woman.** *Tyranny, like hell, is not easily conquered; yet we have this consolation with us, that* **the harder the conflict, the more glorious the triumph.**"

~Thomas Paine, *The American Crisis,* Number 1, 1776

Sketch for *Washington's Crossing*

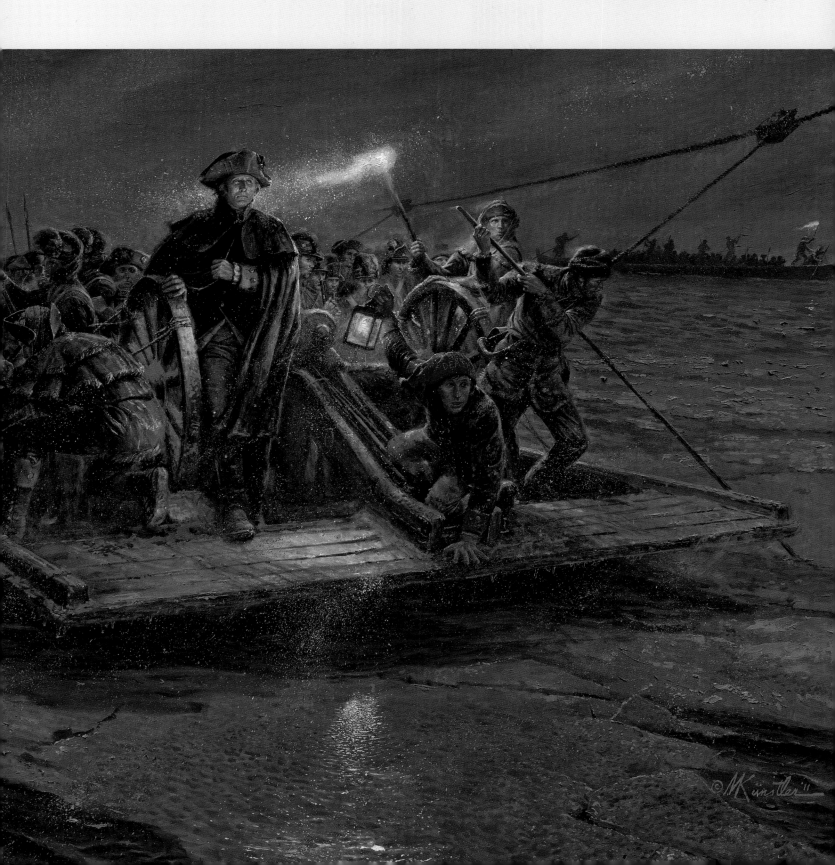

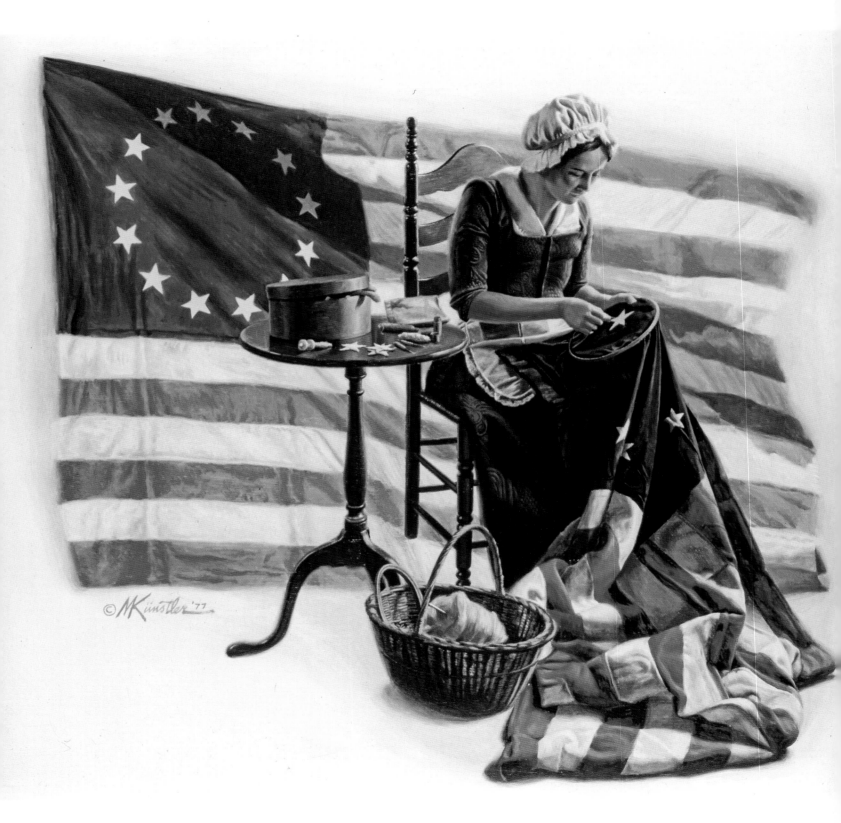

The Stars and Stripes Are Born
Philadelphia, June 14, 1777

BY THE SPRING OF 1777, WASHINGTON HAD MANAGED, ALMOST SINGLE-handedly, to reverse the fate of the continent. With the cause secure—at least for now—Congress turned to pressing questions of military recruitment, supply, and reform, and strongly pursued attempts to get France to enter the war as an ally. Equally important were the delegates' debates over a symbol to represent the fledgling country. Hitherto, the cause had been represented by dozens of flags, uniforms, and varying colors. The time had come for one to stand above all the others. According to legend, Washington and three delegates of Congress secretly visited Philadelphia seamstress Betsy Ross in 1776 and asked her to design a flag for the United States. Washington provided all the ideas except for one—Ross insisted on five-pointed instead of six-pointed stars. She sewed the flag in private and then—so the story goes—walked down to the city wharf and ran her creation up a flagpole. The assembled delegates approved the flag and appointed her national seamstress.

The legend of Betsy Ross was just that—a legend; it likely began when her grandson William J. Canby gave a talk about Ross at a meeting of the Historical Society of Pennsylvania in 1870. The actual national flag, adopted by Congress on June 14, 1777, was probably designed by the multitalented Francis Hopkinson, who had signed the Declaration of Independence. Yet whether the story about her is valid or not, Betsy Ross would in time become every bit as much of a national symbol as the flag she is supposed to have designed. Today the image of her sewing the Stars and Stripes is one of the iconic images of the United States of America.

Philadelphia artist Charles Weisberger also helped create the legend of Betsy Ross after his painting, *Birth of Our Nation's Flag*, became a national sensation when it was first exhibited in 1893. He went on to help to found the Betsy Ross Memorial Association in order to raise funds to purchase and preserve Betsy Ross's house in Philadelphia, dubbed the "American Flag House." Certificates such as the one shown here issued in 1889 featured a reproduction of the painting and were sold by the association for ten cents.

CHAPTER FIVE

The Crisis

"The General assures his countrymen and fellow soldiers, that he believes the critical, the important moment is at hand, which demands their most spirited exertions in the field. There glory waits to crown the brave, and peace, freedom and happiness will be the rewards of victory. Animated by motives like these, soldiers fighting in the cause of innocence, humanity and justice, will never give way, but, with undaunted resolution, press on to conquest. And this, the General assures himself, is the part the American Forces now in arms will act; and thus acting, he will insure them success."

— GEORGE WASHINGTON TO HIS TROOPS, SEPTEMBER 5, 1777

THE PHILADELPHIA CAMPAIGN OF THE summer and autumn of 1777 was one of the defining moments of George Washington's military career. Several months after his famous victories at Trenton and Princeton, he faced a new threat as British forces under General William Howe took a roundabout route by sea through the Chesapeake Bay and then moved across Delaware and southeastern Pennsylvania toward the acting American capital at Philadelphia. Washington has often been portrayed as a cautious commander who sought to preserve his army from defeat while wearing down the British in a long insurgency conflict. In this instance, however, Washington's aggressive, gambling nature came to the fore. Hoping to inflict a sharp, possibly decisive defeat on the British, he placed his army squarely athwart the British line of advance and dared Howe to do battle. Unfortunately, a lack of precautionary measures—not least a failure of adequate reconnaissance—left the American army in a dangerously vulnerable position that very nearly resulted in disaster.

In the north, meanwhile, another British army under the command of General John Burgoyne crossed the border from Canada and pushed down the Hudson River Valley toward Albany, New York. Here too the Americans faced disaster as Burgoyne's confident soldiers rudely thrust Continental militiamen out of their way and pushed relentlessly southward. For every militiaman hurled backward, however, another ten came to take his place. Soon the British found themselves surrounded by a horde of Americans as numerous as the north woods' mosquitos—and far more deadly. Cut off from his route of supply, Burgoyne drove his soldiers toward a series of battles that would change the entire character of the Revolutionary War.

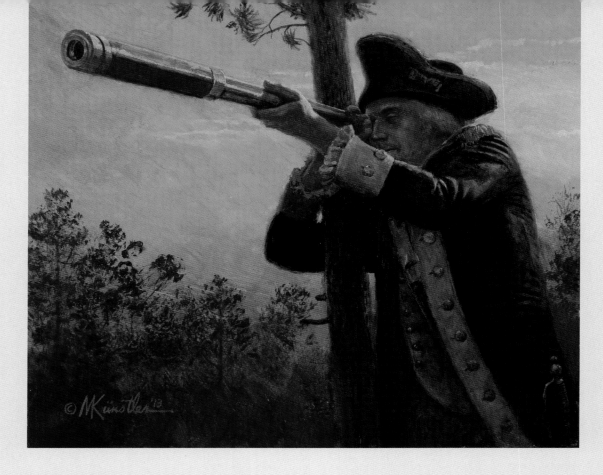

Washington's Spyglass

Head of Elk, Maryland, August 26, 1777

A FLEET OF MORE THAN 200 SHIPS DEBARKED 17,000 British and German troops at Head of Elk, Maryland (present-day Elkton), on August 25. After weeks at sea in brutal heat, the horses on board had suffered severely from dehydration. The redcoats did not feel much better. Nevertheless, they managed a cheer as General William Howe and his brother Lord Richard Howe came ashore. They then turned to the business of establishing a landing perimeter and foraging in the surrounding woods, which were "filled with snakes and toads," and where the racket raised by cicadas and katydids was so loud that "two men could not speak to each other."

Washington meanwhile had held a tense Council of War in Warwick Township, in Bucks County, Pennsylvania, on August 21. Some advised an immediate attack on the British, while others urged caution. To gather more information, Washington set out with the Marquis de Lafayette (just arrived from France), Nathanael Greene, and a cavalry guard on August 26 to scout the enemy lines. From a hill above Head of Elk, Washington cocked a spyglass against a tree and observed the enemy. The British were tired, but prepared—and the general decided an assault on them would be premature.

Evening fell before he and his party could depart. They wandered in the gathering twilight looking for shelter, and then slogged blindly through an evening rainstorm. Finally, in the murk they sighted a house, apparently empty. Here they spent the night, only fifteen minutes' ride away from the enemy lines. After a sleepless night, the Americans raced off early the next morning. Only later did they discover that the house they had stayed in was owned by a prominent local Tory, and that they had been lucky to avoid detection.

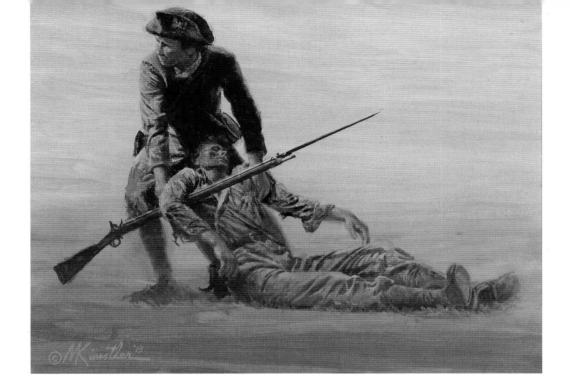

The Casualty

Chadds Ford, Pennsylvania, September 11, 1777

THE BRITISH ADVANCE FROM HEAD OF ELK began on September 3. After a brief skirmish at Cooch's Bridge, Delaware, Howe pushed directly on toward Philadelphia. Washington decided to defend the city, and after an evening lit up by a bizarre aurora borealis, he deployed his troops along Brandywine Creek at Chadds Ford, Pennsylvania. The position appeared strong, but unfortunately Washington had not reconnoitered his ground well. Unknown to the Americans, an undefended ford offered access around Washington's right flank. A British spy or a Tory informer told Howe about the ford, and he decided to take advantage of it. The British attack began on September 11.

The combat was brutal. "The Enemy Soon began to bend their principal force against the Hill," wrote General John Sullivan, "& the fire was Close & heavy for a Long time. . . . [F]ive times did the Enemy drive our Troops from the Hill & as often was it Regained & the Summit often Disputed almost muzzle to muzzle." Finally, after almost two hours the British took possession of the hill—but not, wrote Sullivan, "till we had almost Covered the Ground . . . with The Dead Bodies of the Enemy." For Washington, the battle had ended in defeat; but thanks in part to a gallant rearguard action by troops under General Nathanael Greene, the army withdrew in good order. On the sixteenth, Washington prepared for a last-ditch battle to defend Philadelphia. His troops were not deployed effectively, and likely would have faced another, possibly catastrophic defeat. Fortuitously, a sudden thunderstorm struck just as the battle was about to begin. The soldiers' powder was soaking wet, so not a man could fire his musket, and the Continentals withdrew rather than face the British bayonets unarmed. This encounter, dubbed the Battle of the Clouds, ended the contest for Philadelphia. Howe feinted toward the major American supply depot at Reading, Pennsylvania, which Washington moved to defend. The British then sidestepped and moved to Philadelphia, which they occupied on September 26. Congress had already fled.

British at Germantown
Germantown, Pennsylvania, October 4, 1777

REMEMBERING HIS SUCCESS AT TRENTON THE previous winter, the commander in chief ordered a surprise attack on British positions at Germantown, Pennsylvania, on October 4. The battle that followed was bitterly fought, and nearly ended in a significant American victory. Unfortunately, fog and clouds of powder smoke led to confusion on the battlefield, and British soldiers courageously defended a stone house in the center of the American line of advance. Washington ordered his men to assault the house and witnessed the hand-to-hand combat that ensured. "They attacked with great intrepidity," wrote a British officer, "but were received with no less firmness; the fire from the upper windows was well directed and continued; the rebels nevertheless advanced, and several of them were killed with bayonets . . . attempting to force their way in at the door." The British defenders were stunned at the heroism and self-sacrifice of the American attackers, but fought on regardless. And they held. At the end of the battle for the stone house, a Hessian officer, Captain Johann Ewald, "counted seventy-five dead Americans, some of whom lay stretched in the doorways, under the tables and chairs. . . . [It] looked like a slaughterhouse because of the blood splattered around." Stymied here and elsewhere, the Americans had to withdraw.

In the coming weeks—in an attempt to starve the British out of Philadelphia—Washington's soldiers fought savagely to hold on to Forts Mifflin and Mercer, which blocked the Delaware River below the city. But it was not to be. By mid-November, the British had captured the forts and secured their hold on Philadelphia. Washington and his army had been totally defeated.

"They attacked with great intrepidity, but were received with no less firmness."

~British officer at the Battle of Germantown

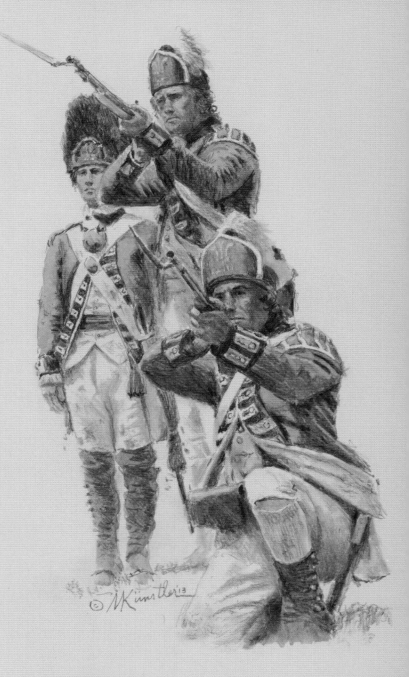

Militia and Minuteman

The Saratoga Campaign, New York State, Summer 1777

WHILE WASHINGTON FOUGHT TO DEFEND Philadelphia, a very different operation was developing in the north. During the Saratoga Campaign (June–October 1777), British and German soldiers led by General John Burgoyne had pushed south from Canada toward Albany, hoping to capture the entire Hudson River Valley. Unlike in Maryland and Pennsylvania, where Howe enjoyed a fairly straight and easy route to Philadelphia, Burgoyne faced terrain perfectly suited for defense. Thick forests, seemingly endless, enveloped his columns as they advanced. And unlike in the mid-Atlantic, where Washington struggled to convince the militia to come out and fight the British, the men of upstate New York and New England were more than eager to defend their homes. As Burgoyne pushed south, capturing Fort Ticonderoga in July and dispersing American formations, thousands more militia soldiers rose up and flocked to the American flag. By late summer General Horatio Gates commanded an army that well outnumbered the British.

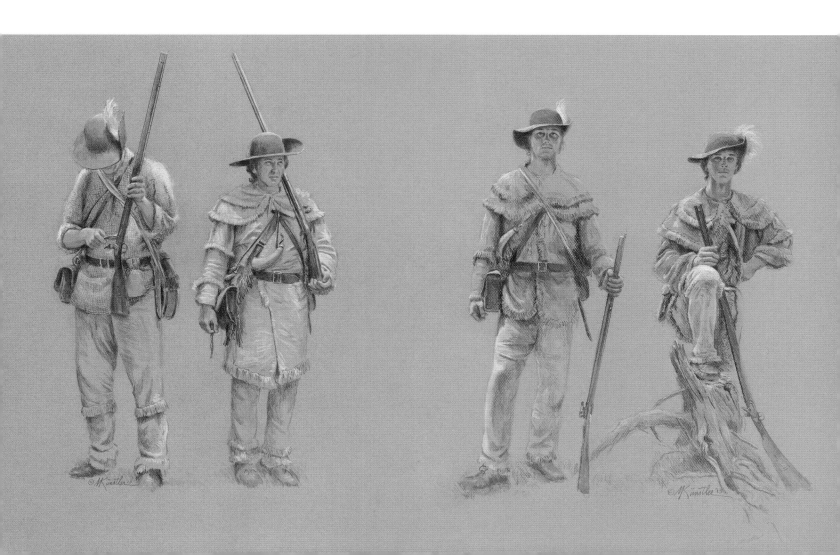

"Fire!"

The Saratoga Campaign, New York State, September–October 1777

ON AUGUST 16, AMERICAN MILITIA AND ALLIED Indian warriors completely defeated a column of General John Burgoyne's German troops at Bennington, Vermont. Burgoyne's main army soldiered on regardless, nearing Albany. Redcoats exhausted themselves hacking through the woods, enduring hit-and-run raids from militia and Indians and moving more and more slowly. By mid-September their lines of communication with British-occupied Ticonderoga and Canada had mostly disappeared. Finally, on September 19 and October 7, Burgoyne fought two major engagements with General Horatio Gates at Freeman's Farm (land belonging to Loyalist John Freeman) near Saratoga. Thanks in part to the heroism and wise leadership of men like Daniel Morgan, Benedict Arnold, and Gates, the battles ended in disaster for the British. Far from any aid, and with his men desperate and exhausted, Burgoyne surrendered his entire army on October 17. The Continental army's victory at Saratoga would lead directly to French support of the American cause in early 1778 and ultimately change the course of the war.

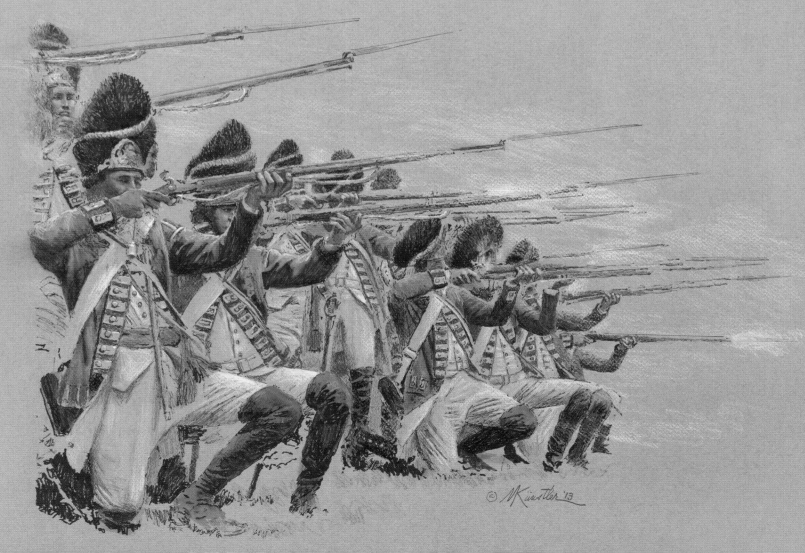

Surrender of General Burgoyne at Saratoga N.Y. Oct. 17th. 1777, published by N. Currier, ca. 1852, after an 1821 painting created by colonial artist and soldier John Trumbull. The painting hangs in the U.S. Capitol rotunda. Before resigning his military commission in 1777, Trumbull served as an aide to General Washington and later, to General Gates.

General Horatio Gates, detail of an illustration from *An Impartial History of the War in America . . .*, London, 1780.

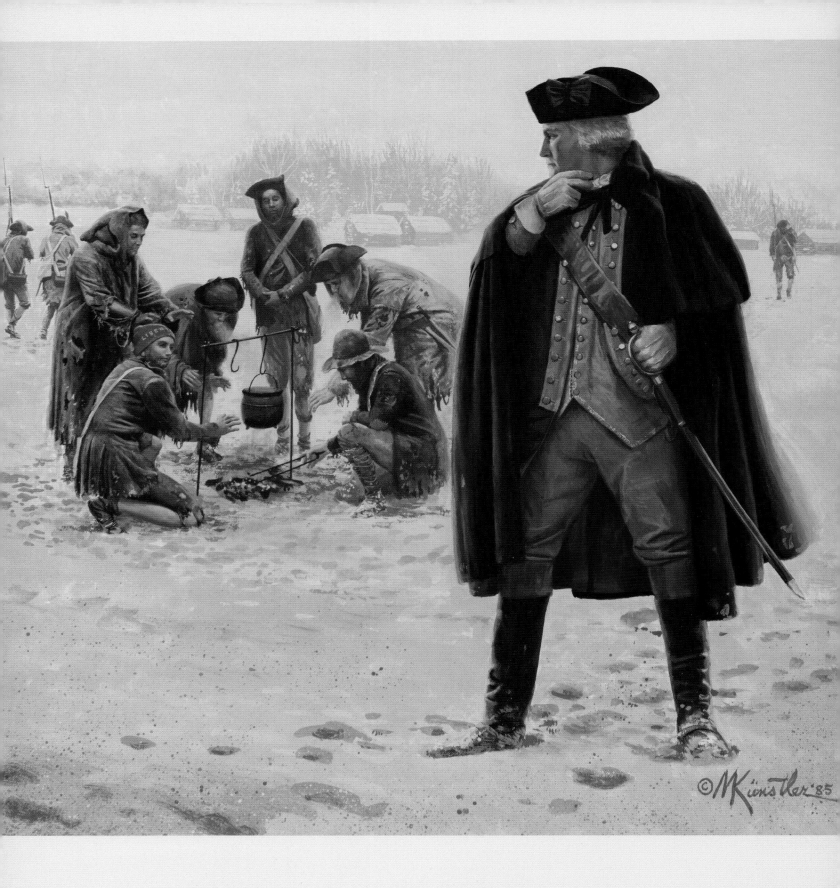

"This army must inevitably be reduced to one or other of these three things: Starve—dissolve—or disperse."

~George Washington, letter to the
Continental Congress, December 23, 1777

Washington at Valley Forge
Valley Forge, Pennsylvania, December 19, 1777

WASHINGTON REJOICED AT THE "GLORIOUS termination" of the northern campaign at Saratoga. Others, however, compared General Horatio Gates's victory with Washington's defeat in Pennsylvania. General Thomas Conway, one of Washington's senior officers and Congress's choice for inspector general of the army, derided the commander in chief behind his back as a "weak general." Other enemies in the army and in Congress schemed to replace Washington with Gates. Though men like Lafayette, Henry Knox, Alexander Hamilton, and Nathanael Greene stood firmly by Washington's side, his continued leadership of the army seemed in doubt.

It was in these circumstances that Washington decided to move his army into winter quarters at Valley Forge on December 19. His men could not understand it. Traditionally, armies spent the winter in towns, where they could find food, shelter, and civilian companionship. But Valley Forge? There was nothing there except trees, open fields, and a few farmhouses. For Washington, the site was well placed to allow him to continue to contest the British for control of the countryside around Philadelphia. But his soldiers were not interested in military reasoning. They wanted rest and comfort, and saw no prospect for either.

Making a bad situation worse, food supplies began running out on the very day the army marched to its new encampment. Disgusted with the rotten victuals that their commissaries had tried to issue them, the Continentals launched a furious protest demonstration in front of their horrified officers. "No meat! No meat!" they cried, and began hooting and cawing in imitation of owls and crows. Those who knew what the men endured could not help but sympathize. Dr. Albigence Waldo, a surgeon at Valley Forge, attempted to illustrate their plight in his diary by describing "a soldier, his bare feet are seen through his worn out shoes, his legs nearly naked from the tattered remains of an only pair of stockings, his breeches not sufficient to cover his nakedness, his shirt hanging in strings, his hair disheveled, his face meager. . . . [He] cries with an air of wretchedness and despair, I am sick, my feet lame, my legs are sore, my body covered with this tormenting itch—my clothes are worn out, my constitution is broken, my former activity is exhausted by fatigue, hunger and cold, I fail fast, I shall soon be no more! And all the reward I shall get will be—'Poor Will is dead!'" On Washington's promise to tend to their needs, the soldiers returned grumbling to their tents. But Washington feared their trust and obedience would not last long. Without some change, he warned Congress, "this army must inevitably be reduced to one or other of these three things: Starve—dissolve—or disperse."

Crisis at Valley Forge
Valley Forge, January–February 1778

THROUGH THE NEXT TWO MONTHS THE CRISIS gradually grew worse. Snow fell, then freezing rain. Roads turned to slush. Rivers overflowed, washing out the bridges, fords, and ferries that supply convoys had to cross in order to reach camp. Basic necessities disappeared. Washington ordered his troops to build huts, and in time they established a reasonable degree of shelter. He taught them to make soap from tallow, and enforced rules on sanitation in order to prevent the spread of disease. These well-intentioned and valuable measures were pointless, however, if the troops had no food or drink.

The supply chain depended on officers, commissaries, and quartermasters who were often not up to the job. Some simply quit and went home. Others were corrupt and attempted to line their pockets at the expense of the men. Many were simply incompetent. Whatever the cause, the result was the same: hardship. Washington attempted to take on as many responsibilities as he could, but he was only one man. "I must attempt (for it can be no more than an attempt) to do all these duties myself," he wrote in a letter to Brigadier General George Weedon on February 10, "and perform the part of a Brigadier—a Colonel—&c. (because in the absence of these everything relative to their business comes directly to me) or, I must incur displeasure by the denial."

By mid-February, food—always scarce—ran out completely, and famine threatened. "An American Army in the Bosom of America," cried Gouverneur Morris, a New York delegate to Congress, "is about to disband for the want of something to eat!" Horses died and were butchered.

The hour demanded a man of dedication and genius. Fortunately, one was at hand in the person of George Washington. He was not the best tactician or even the best politician. What set Washington apart were certain qualities of mind and heart that helped him to understand what his soldiers needed, and to identify the men and measures required to put his plans into effect.

Winds of Change

Washington at Valley Forge, March 4, 1778 (*following pages*)

GEORGE WASHINGTON WAS A COMBAT VETERAN. In the French and Indian War, he had lived the life of a soldier, and he knew what it meant to live years away from home. Nothing mattered more to soldiers, he knew, than fundamental necessities: food, drink, clothing, shelter, sanitation, sleep—and hope in the future. To secure these necessities for his men, Washington worked like an ox. No item was too small for his careful attention. He arranged foraging expeditions; identified the supplies needed, and in what quantity; and arranged supply convoys. He communicated with farmers, local and state government officials, and Congress to keep army supply structures and finances working smoothly, and to secure much-needed reforms. Washington even overhauled the military hospitals. The results of his efforts were tangible. Supplies flowed in. The most important was food—first in a trickle, and then in steady quantities. The soldiers' lives became bearable and eventually even grew comfortable, allowing them to focus on drilling and weapon cleaning instead of just scrabbling to survive.

Washington's men did not ask for speeches or symbolic gestures. They did not even ask for battlefield victories—at least not yet. What they sought was a man who cared for their welfare, and in Washington they found such a man. The Continentals saw him working, day and night, on their behalf. It was a vision they would never forget. Valley Forge transformed the relationship between the general and his soldiers. After that terrible winter was over, they would follow Washington anywhere. In time, the powerful bond that grew between Washington and his officers and soldiers at Valley Forge would save democracy in the United States.

Washington did not have to go it alone. The roll of heroes at Valley Forge includes men like Henry Knox; Henry "Light Horse Harry" Lee; Lafayette; and especially Nathanael Greene, who took over as quartermaster general in March 1778. Another important—if unlikely—hero, was Friedrich Steuben, often called the Baron von Steuben. Whether he was really a baron or even an aristocratic "von" was uncertain. He claimed that he had been one of the most important officers of King Frederick the Great of Prussia, but could never offer any proof of his high rank. To Washington, Steuben's background didn't really matter. It was what he could do that counted. Although he barely spoke a word of English, Steuben's talents were substantial. Named inspector general of the army in place of Thomas Conway—who had resigned in disgrace—Steuben arrived at Valley Forge on February 23 and proceeded to draw up and enforce a new manual of drill and training for the entire Continental army. His system worked, not least because he seemed "to understand what our soldiers are capable of," remarked John Laurens, one of Washington's aides; "he will not give us the perfect instructions . . . but the best which we are in condition to receive." The soldiers chuckled at Steuben's vanity and bombast, but they listened to him. By the time they left Valley Forge in June, they were smarter and better disciplined than ever before.

The troops—now cheerful and well fed—were drilling efficiently under Steuben's directions on May 5

Detail of sketch for *Winds of Change*

when Washington announced tremendous news. On February 6, 1778, in Paris, French and American ministers had signed the Treaty of Alliance to bring France into the war on the side of the United States, as well as the Treaty of Amity and Commerce. Congress ratified the treaties on May 4. The patriots were no longer alone. Washington decreed a day of thanksgiving to be followed by an immense celebration.

The commander in chief led them all in a series of "remarkable toasts" and then mingled freely with the men in "mirth and rejoicing." Whatever hangovers they all may have felt the next morning were more than tempered by an outpouring of hope. The road ahead might be hard, but the worst was over. For the first time, victory seemed a realistic prospect.

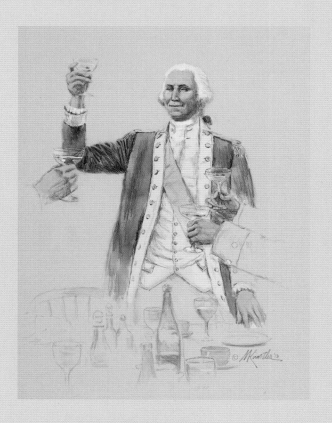

The Toast, Valley Forge, May 6, 1778

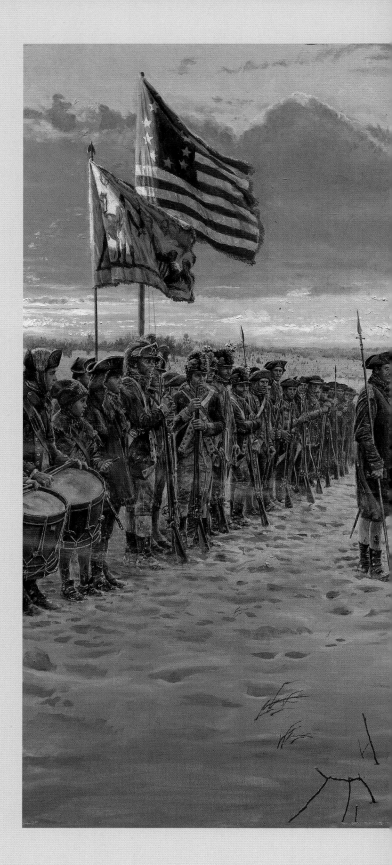

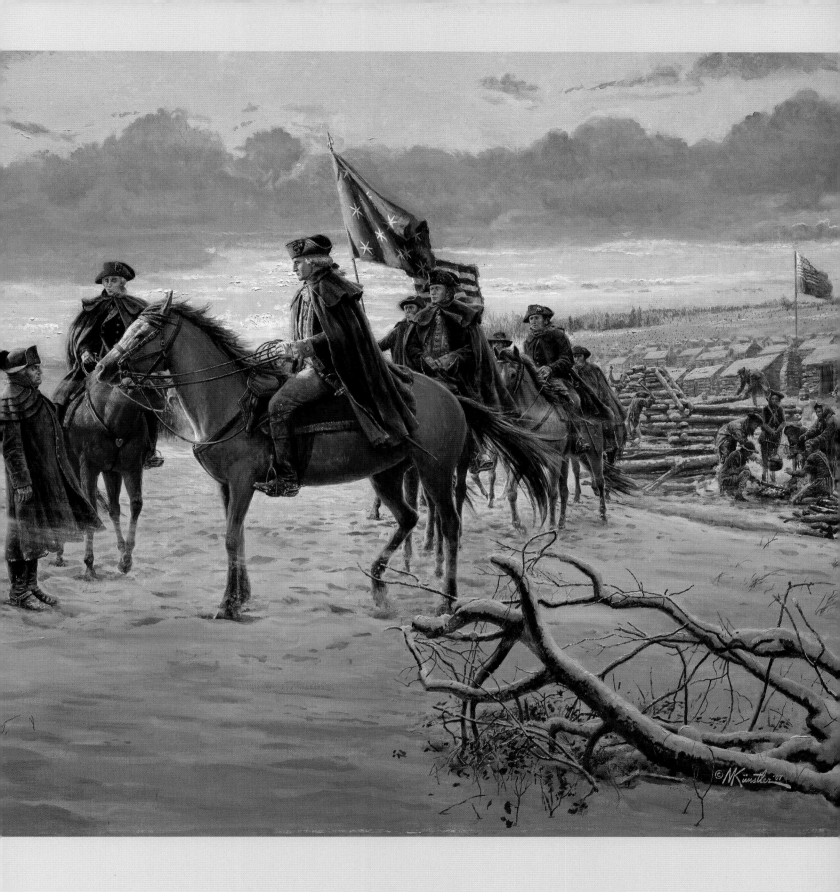

The Guns of Monmouth

Monmouth Court House, New Jersey, June 28, 1778

THE FRENCH ALLIANCE WITH AMERICA convinced the British and their new leader General Sir Henry Clinton—who had replaced Howe—to abandon Philadelphia and relocate to New York. On June 18, the British army departed the city they had worked so hard to capture and began a long, hot march across New Jersey to board ship transports at Sandy Hook for the journey to New York. Always eager for a fight, Washington ordered pursuit and caught up with the British rear guard, commanded by Lord Charles Cornwallis, at Monmouth Court House on June 28. In the ensuing, close-fought battle, Washington's presence steeled the Continentals to fight the redcoats to a standstill. "General Washington seemed to arrest fate with a single glance," said Lafayette. "His nobility, grace, and presence of mind were never displayed to better advantage." Alexander Hamilton declared that "America owes a great deal to General Washington for this day's work. . . . By his own presence, he brought order out of confusion, animated his troops and led them to success." Though the battle ended in a draw, and the British fled to New York, they had been given a real fight.

The Scout

Sullivan's Expedition,
Iroquois Confederacy, 1779

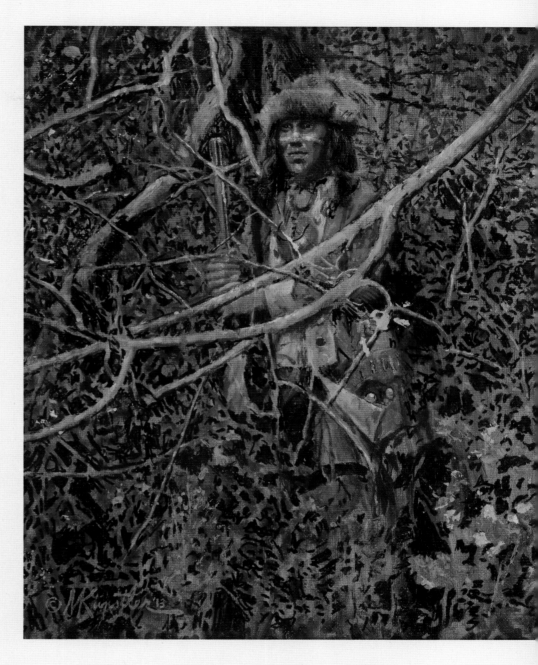

AFTER THE BATTLE OF Monmouth, the fighting in the mid-Atlantic and northeast retracted to an inconclusive series of skirmishes and short raids. Washington looked for opportunities to come to grips with the enemy, but Clinton remained holed up in and around New York. Meanwhile, the first stages of the southern campaign got underway as the British moved on Georgia and South Carolina. Only on the frontier did any decisive events take place.

For three years, Washington had been too preoccupied with events in the east to pay much attention to the frontier. That changed in the winter of 1778–79 as Iroquois Indians and Loyalists inflicted such devastating raids on western New York that the state government seemed on the verge of collapse. In February 1779, Congress called for Washington to order a military expedition for the "chastisement of the savages," and the commander in chief moved quickly to comply. That summer, he sent General John Sullivan with a division of Continentals to ravage Iroquois settlements and seek battle if possible. The object, said Washington, was "the total destruction and devastation of their settlements and the capture of as many prisoners of every age and sex as possible." He ordered Sullivan to reject all peace overtures, and specified that the Indians' land must "not be merely overrun, but destroyed." Sullivan did his work with ruthless efficiency. Although only a few Iroquois were killed or captured, huge swathes of their land and many settlements were annihilated in Sullivan's scorched-earth campaign. In later years the Iroquois would attack the frontier again, but the reality was that their power had been destroyed forever.

"I Have Not Yet Begun to Fight"

September 23, 1779, the North Sea, off Flamborough Head, England

NOWHERE WAS THE INTERVENTION OF FRANCE more transformative than in the war at sea. Washington understood this perhaps better than anyone. Early in the war, he had helped to outfit privateer ships to challenge the British blockade, and he urged Congress and the various state governments to build more warships. The exploits of these individual ships and their crews captivated the American public, and no one provided more inspiration than John Paul Jones. In February 1779, King Louis XVI of France provided the Scottish-born American captain—who had already gained fame as a privateer—with a ship that Jones dubbed the *Bonhomme Richard* after Benjamin Franklin's *Poor Richard's Almanack*. With this new weapon Jones prowled the coast of Scotland, panicking (and also exciting) British civilians and capturing numerous prize vessels.

Jones's gadfly career seemed doomed to a premature and inglorious end on September 23, 1779. While leading a squadron of four vessels on operations in the North Sea, the *Bonhomme Richard* came upon the forty-four-gun frigate HMS *Serapis* and a small sloop, the *Countess of Scarborough*, escorting a convoy of some forty merchant ships from the Baltics. The *Bonhomme Richard* daringly engaged in combat with the larger and better-armed *Serapis*. Although both ships were badly mauled early in the battle, the *Bonhomme Richard* seemed doomed; Captain Richard Pearson of the *Serapis* asked if Jones was ready to surrender. Instead—so the story goes—Jones bellowed, "I have not yet begun to fight!" and fought on. After Jones managed finally to lash the two ships together, the combat went on point-blank for three hours until the exhausted and bloodied British capitulated. Jones surveyed the scene, with his ship "mangled beyond my power of description . . . [and] the tremendous scene of carnage, wreck, and ruin, which everywhere appeared. Humanity cannot but recoil from the prospect of such finished horror, and lament that war should be capable of producing such fatal consequences." Jones thereupon transferred his command to the *Serapis* while the feisty *Bonhomme Richard* sank. News of the contest would inspire not only the Revolutionary generation, but many generations to come.

John Paul Jones, George Bagby Matthews after Charles Wilson Peale, ca. 1890

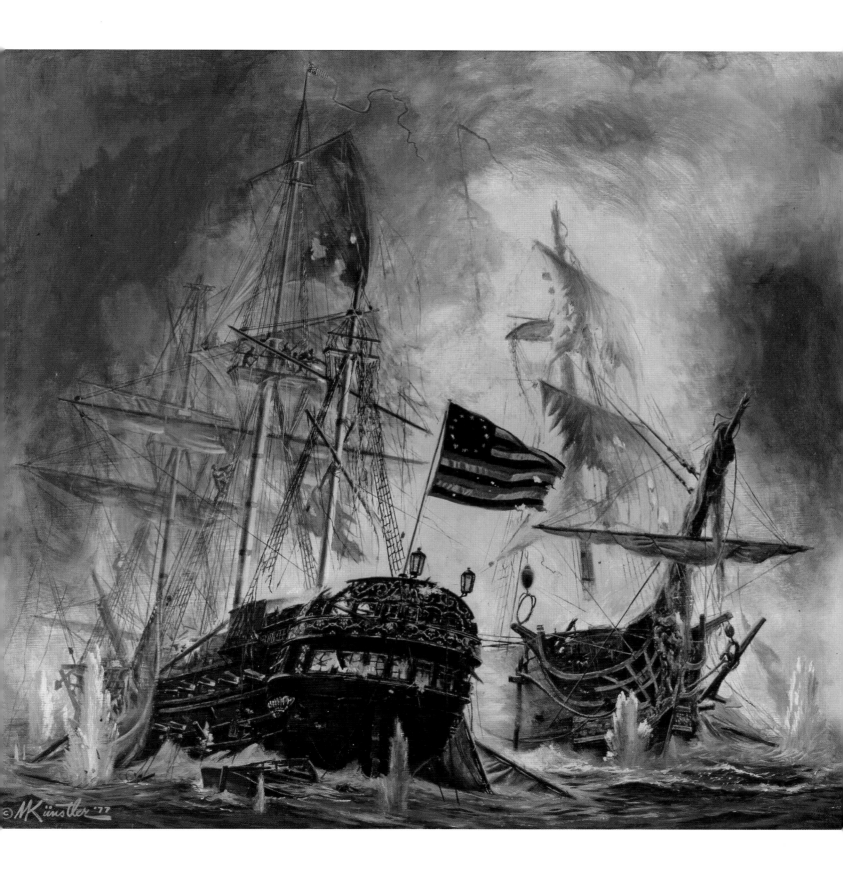

Detail of sketch for *Washington's "Watch Chain"*

"West Point is to be considered as the first and principal object of your attention.... You will neglect nothing conducive to its security, and will have the Works directed for its defence prosecuted with all the vigour and expedition in your power."

~George Washington, in a letter to Major General
Alexander McDougall, November 27, 1778

Washington's "Watch Chain"

West Point, New York, November 30, 1779 (*following pages*)

A MASTER STRATEGIST, WASHINGTON NEVER imagined that he would be able to defend the entire continent of North America. Instead, he focused on protecting certain key points. Nothing preoccupied him more than West Point. Since the very beginning of the war, the British had made numerous attempts to seize the Hudson River corridor and sever New England from the rest of the United States. So far they had failed, but Washington knew they would try again. Just as the British might stake everything on grabbing the Hudson Highlands and West Point, he had to stake everything on their defense.

The commander in chief spent much of 1779 at West Point, supervising every element of the construction of fortifications and river defenses. By autumn the works neared completion, but Washington was unsatisfied. Fearing a British movement, he nagged subordinates to get their work done as quickly and thoroughly as possible. "West Point is to be considered as the first and principal object of your attention," he wrote to Highland commander Major General Alexander McDougall on November 27, 1778. "You will neglect nothing conducive to its security, and will have the Works directed for its defence prosecuted with all the vigour and expedition in

your power." Central to the defenses was a great chain across the Hudson, meant to prevent enemy shipping from passing upriver. It was no ordinary chain, but a massive construction completed by special contract with the owners of the Sterling Iron Works in Warwick, New York. The Great Chain was five hundred yards in length, with each link two feet long and weighing about 114 pounds. Installed on April 30, 1778, it stretched across the Hudson from West Point to Constitution Island.

For the next five years the massive construction was installed in the spring, and then was pulled in just before the winter freeze. On November 28, 1779, orders were issued for the annual drawing-in of the chain: "Forty men who know boats to be ready tomorrow at sunrise. When the chain is cast off a cannon will be fired from the rampart of Fort Arnold. Officers and men of the garrison will repair to headquarters to aid in drawing it in." The actual drawing in took place on November 30, when a diarist wrote: "This day the chain . . . was removed by hoisting the same whole between boats and was taken on shore to be laid up for the winter," very close to Washington's headquarters. The general departed to face the difficult winter ahead at Morristown.

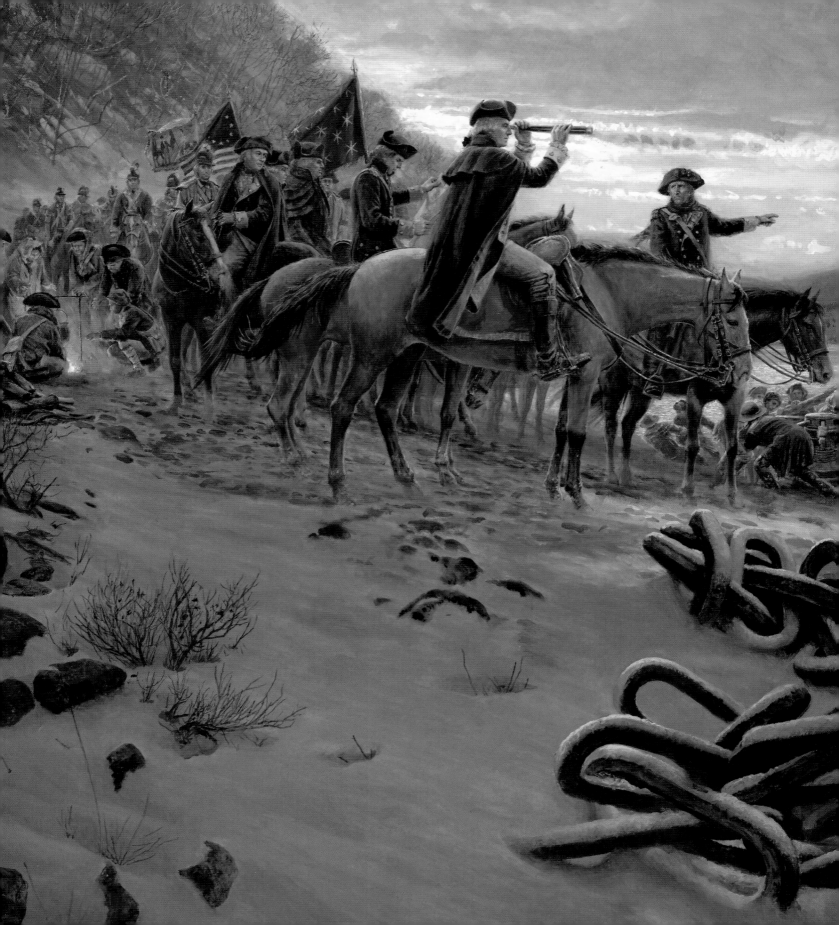

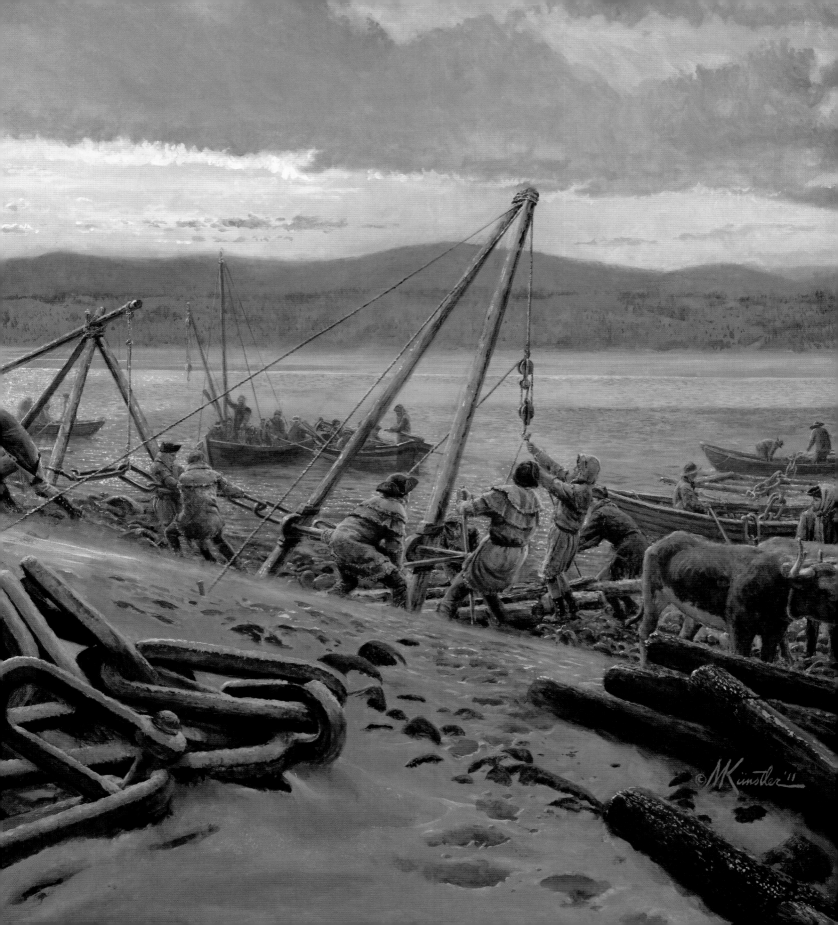

"Though you are a General, *you are but a Man.*"

~Remark by Deborah Olney
to George Washington at a Morristown party

"Caty" Greene
Morristown, New Jersey, Winter 1779–80

THE MOST BRUTAL MONTHS OF THE AMERICAN Revolution were at Morristown in the winter of 1779–80; it was far worse than Valley Forge. The entire East Coast was encased in snow from December to April. The Chesapeake Bay froze over, and waterways were clogged with solid ice. At Morristown, snowdrifts grew higher than three men standing feet to shoulders. Nathanael Greene remarked with horror that "almost all the wild beasts of the field, and the birds of the air, have perished with the cold." With supply convoys stuck fast in the ice, soldiers braved frostbite to secure food from local farmers' barns.

Once again, Washington worked heroically to provide his troops with basic necessities. For all his strength he was still just a man, however, as one lady was quick to remind him. That winter the general held a grand party at which several officers and their wives were present. The latter included Nathanael Greene's wife, Catherine "Caty" Greene, who had been known to dance with the commander in chief for two or three hours straight, so much did they enjoy each others' company. Martha did not seem to mind, but the disproportionate attention that George devoted to Caty offended some other women who equally sought the general's favor.

After the party, the men and women retired to separate rooms, according to standard practice. This time, however—perhaps fueled by the free-flowing wine—the women "held hostage" one of

the male guests, Rhode Islander George Olney. Washington swiftly organized a mock raiding party to enter the ladies' chamber and free their captive. A brief melee ensued, during which Washington himself playfully tussled with the captive's wife, Deborah Olney, but she was resentful at having earlier been spurned for Caty. Furiously, she screamed that if he did not let go of her hand she would scratch out his eyes and tear out the hair from his head. "Though you are a General," she shouted, "you are but a Man." Stunned, Washington dropped her like a hot potato and hurried off. Leaderless, the men retired in total and humiliating defeat.

Sketch for "Caty" Greene

Lafayette with Washington at Morristown
Morristown, New Jersey, Spring 1780

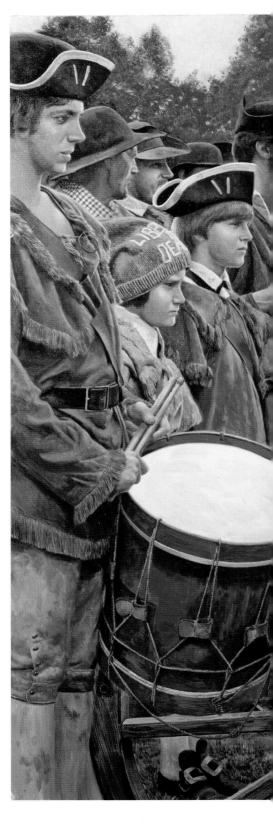

AS SPRING ARRIVED, THE SNOWS MELTED AT MORRISTOWN. Washington emerged from the Ford Mansion, where he had spent the winter, and was warmly welcomed by his men. Equally warmly, he welcomed back the Marquis de Lafayette, who had spent several months in France.

The previous autumn, while Lafayette was away, Washington had held a dinner for Anne-César, chevalier de la Luzerne, the French minister to the United States. During the meal, Washington raised a glass of wine and drank to the health of Lafayette. He turned to Luzerne's secretary, François, marquis de Barbé-Marbois, and asked if he had seen Lafayette in France. Yes, Barbé-Marbois replied, and added that Lafayette had spoken of Washington with the "tenderest veneration." Hearing that his friend was well and honored by his countrymen, Washington "blushed like a fond father whose child is being praised." Barbé-Marbois remembered that "[t]ears fell from his eyes, he clasped my hand, and could hardly utter the words: 'I do not know a nobler, finer soul, and I love him as my own son.'"

Lafayette's return from France and appearance side by side with Washington brought an air of festivity and expectancy to the soldiers gathered in Morristown. There was indeed good news. Lafayette had brought word that significant help—a French army, and possibly a fleet—was on the way. The war was about to enter its final phase.

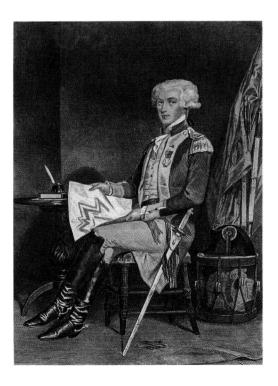

Lafayette, Alonzo Chappel, 1863

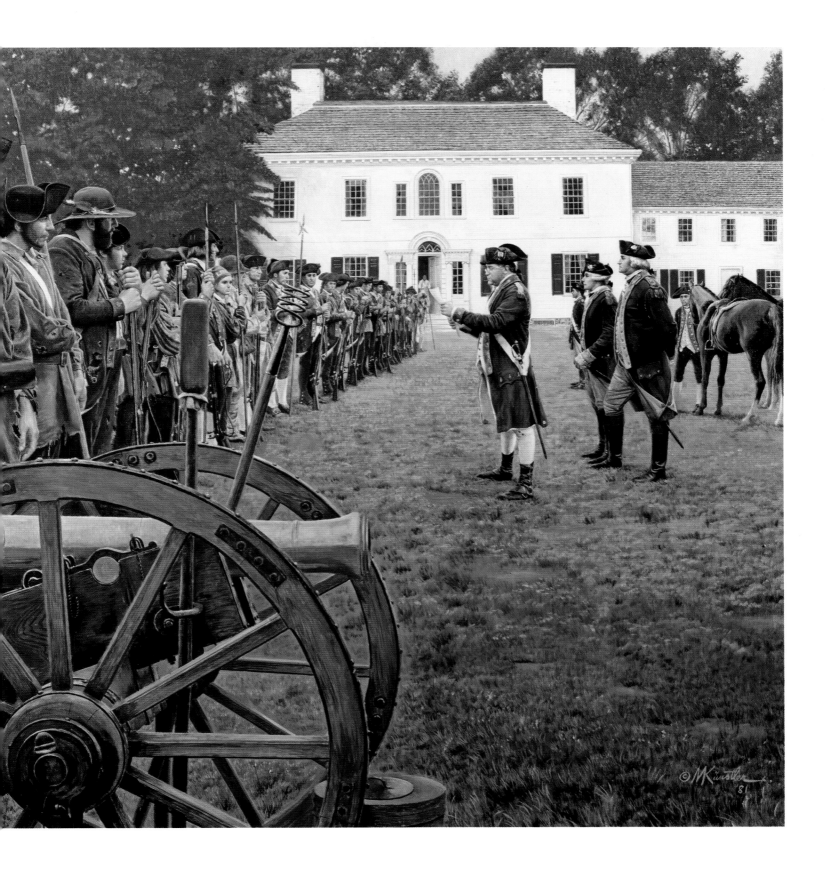

CHAPTER SIX

Spies

"The necessity of procuring good Intelligence is apparent & need not be further urged——All that remains for me to add, is, that you keep the whole matter as secret as possible. For upon Secrecy, Success depends in most Enterprises of the kind, and for want of it, they are generally defeated, however well planned."

— LETTER FROM GEORGE WASHINGTON TO
COLONEL ELIAS DAYTON, JULY 26, 1777

A S WASHINGTON'S THOUGHTS TURNED toward the war's endgame, the image of New York City hovered before his eyes. He was sure that the final showdown with King George III's armies would take place there. He had never come to terms with the loss of New York City in 1776. Sooner or later, he was determined to take it back. Now, with the news that a French army was on the way to America, the commander in chief hatched plans for an all-out assault on New York. With a French army by his side, and a French fleet holding off the British at sea, he was convinced he could seize the city and destroy British hopes of conquest in North America. To realize that dream, however, he needed one thing above all: intelligence. And to gather that intelligence, he needed spies.

Washington loved spy craft. Though far from being an expert spymaster, he nevertheless enjoyed the thrill of planning and executing escapades behind enemy lines. Washington's most famous espionage operation was the Culper spy ring, which operated between Manhattan and Long Island to provide intelligence about British troop and ship movements in and around the city. The ring centered around two spies, Abraham Woodhull and Robert Townsend, who shared the pseudonym Samuel Culper.

Washington did not take to the idea of the Culper ring right away. Major Benjamin Tallmadge, their primary "handler," told Washington that he would "pawn my honour" on Woodhull's "fidelity," but the commander in chief trusted no man he had not met face-to-face. He also liked to arrange espionage operations personally. "If you think you can really depend on Culper's fidelity," he told Tallmadge, speaking of Woodhull, "I should be glad to have an interview with him myself." They met, and Washington was impressed enough to dictate a mode of proceeding:

As all great movements, and the fountain of all intelligence must originate at, & proceed from the head Quarters of the enemy's Army, C––[Culper] had better reside at New York—mix with—and put on the airs of a Tory to cover his real character, & avoid suspicion.

In his initial meeting with Woodhull, Washington decided to "put the mode of corresponding upon such a footing, that even if his letters were to fall into the enemy's hands, he would have nothing to fear on that account." This "mode" depended on the use of invisible ink. Early in the war Sir James Jay—brother of Continental Congress president John Jay and an amateur chemist—developed a special recipe for invisible ink. A spy could write a letter using the invisible ink on white paper—sometimes between the lines of seemingly innocuous letters, or on newspapers—and then send it out of the city. The recipient could then apply a reagent—what Washington called a "sympathetic stain"—to bring out the writing. Washington raved about the recipe. "Fire

which will bring lime juice, milk & other things of this kind to light, has no effect on it," he wrote on May 3, 1779, in a letter to delegate Elias Boudinot:

> A letter upon trivial matters of business, written in common Ink, may [thus] be filled with important intelligence which cannot be discovered without the counterpart, or liquid here mention'd.

Spies on both sides used all means possible to avoid detection. The British deliberately fed false information to known spies, and Washington did the same. The American commander in chief was initially reluctant to use double agents—ostensible spies for the British who were actually working for Washington. "I always think it necessary to be very circumspect with double spies," he wrote to General Alexander McDougall on March 25, 1779.

> Their situation in a manner obliges them to trim a good deal in order to keep well with both sides; and the less they have it in their power to do us mischief, the better; especially if we consider that the enemy can purchase their fidelity at a higher price than we can. It is best to keep them in a way of knowing as little of our true circumstances as possible; and in order that they may really deceive the enemy in their reports, to endeavour in the first place to deceive them.

He eventually came around, however, and used double agents to feed false information to the enemy. On one occasion in 1779, Washington instructed one of these agents to tell the British that Continental officers plied their men with "a good deal of whiskey," which "I suppose helps with the lies their officers are always telling them to keep up their spirits."

Washington loved spy craft. Though far from being an expert spymaster, he nevertheless enjoyed the thrill of planning and executing escapades behind enemy lines. So extensive was the reach of the commander in chief's espionage that many of his plots remain secret to this day. Legends and rumors abound. On one occasion, a female spy in Philadelphia, a Quaker midwife named Lydia Barrington Darragh and her young son John were supposed to have gathered intelligence that saved Washington's army from destruction. It was even said that James Rivington, an arch-royalist from New York who ran the city's main pro-British newspaper, was in Washington's pay. What is known for certain, however, remains exciting enough.

Second page of George Washington letter to Elias Boudinot about invisible ink, May 3, 1779.

"I Want to Be a Spy!"
Long Island Sound, 1776–83

SPIES CAME IN ALL SHAPES AND sizes. They included soldiers and civilians, Native Americans and African Americans, men and women—and even children. They played an amateur's game, but for the highest possible stakes. Officers of all ranks and civilian officials recruited their own spies, paid them in coin, and ordered them to gather intelligence of enemy movements by all possible means. Their methods might be as complex as impersonating British soldiers and infiltrating enemy headquarters, or as simple as gathering gossip from drunken tavern patrons or listening at keyholes. Washington was always on the lookout for any "intelligent young man" who could move freely between the lines and supply information to him directly. The identity of many of these spies, some of them undoubtedly children, will never be known.

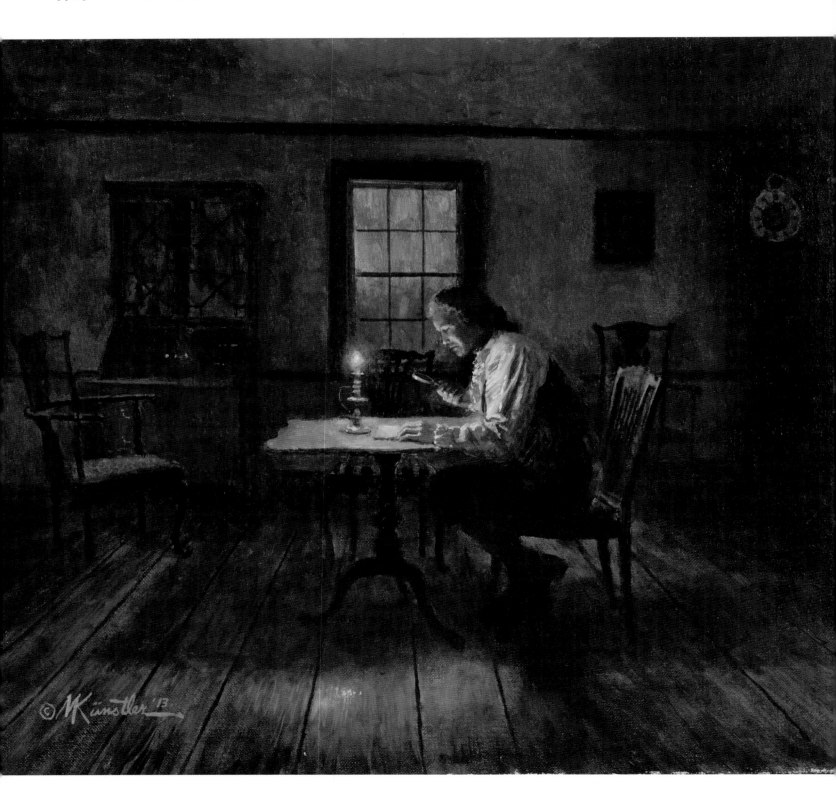

"The Consideration of having several Officers quartered in the next Chamber, added to his constant fear of detection & its certain Consequences made him rationally conclude that he was suspected."

~Benjamin Tallmadge letter to George Washington, April 21, 1779

The Culper Spy Ring

The Homestead, Oyster Bay, Long Island, New York, 1779

THE TWO LEAD SPIES IN THE CULPER SPY RING both hailed from the North Shore of Long Island: Abraham Woodhull, of Setauket, was the first spy recruited to the Culper spy ring. He signed his intelligence reports as "Samuel Culper" or "Samuel Culper, Sr." Robert Townsend, who usually signed his reports as "Samuel Culper, Jr.," was a merchant from Oyster Bay, who operated from his dry goods firm in Manhattan. He was recruited to Washington's service in the spring of 1779. Townsend's father, Samuel—who was unaware of his son's spy activities—was also a merchant, and a member of the New York Provincial Congress. Samuel's house in Oyster Bay, known as the Homestead (eventually renamed Raynham Hall), was taken over by British officers in 1778 (see page 100) The painting here shows Robert Townsend reading an encrypted letter during a visit to the Homestead.

Using invisible ink did not always give the Culpers a sense of safety. In April 1779, Tallmadge wrote Washington that Woodhull was

much pleased with the curious *Ink or Stain*, & after making some Experiments with the same, he was set down to answer my letter which accompanied it. He had finished the enclosed when very suddenly two Persons broke into the Room [his private apartment]—The Consideration of having several Officers quartered in the next Chamber, added to his constant fear of detection & its certain Consequences made him rationally conclude that he was suspected, & that those Steps were taken by said Officers for discovery. Startled by so sudden & violent an obtrusion, he sprang from his seat, snatched up his papers, overset his Table, & broke his Vial—This step so totally discomposed him that he knew not who they were, or even to which Sex they belonged—for in fact they were two Ladies who, living in the house with him, entered his Chamber in this way on purpose to surprise him—Such an excessive fright & so great a turbulence of passions so wrought on poor C– – that he has hardly been in tolerable health since.

The stress of working in Manhattan amid suspicious British officers—and adjacent to a pack of frolicsome ladies—soon convinced Woodhull to move to Long Island and pass on the duties of city work to his newly recruited colleague, Robert Townsend.

Sally's Valentine
The Homestead, Oyster Bay,
Long Island, 1778–79

LONG ISLAND BRIMMED OVER WITH information—and danger—for spies and patriot sympathizers. British and Loyalist troops prowled there regularly, suppressing patriots and fighting off whaleboat raiders from Connecticut. In the winter of 1778–79, a Loyalist unit called the Queen's Rangers under Lieutenant Colonel John Graves Simcoe camped in Oyster Bay. Simcoe took up quarters in Samuel Townsend's house, the Homestead. The accommodations provided an additional attraction in the form of Townsend's nineteen-year-old daughter Sarah, or "Sally." Many officers courted her, but of course the tall and handsome Simcoe stood foremost. He fell hard for the young damsel.

Some time that winter, it is said, Simcoe penned a valentine to Sally, adding to it a pair of hearts with their initials pierced by an arrow, along with a poem. "Fairest Maid where all are fair," it began, "Beauty's pride and Nature's care; To you my heart I must resign; O Choose me for your Valentine!" Whether disgusted by such doggerel or (as legend states) irritated at Simcoe's decision to cut down her father's apple orchard, Sally spurned her suitor and sent him packing. As an avowed patriot, she might well also have passed on intelligence of the Queen's Rangers to any of the American spies who were plentiful in the area. It is believed that she remembered the incident so fondly, however, that she kept Simcoe's valentine until the end of her life in 1842.

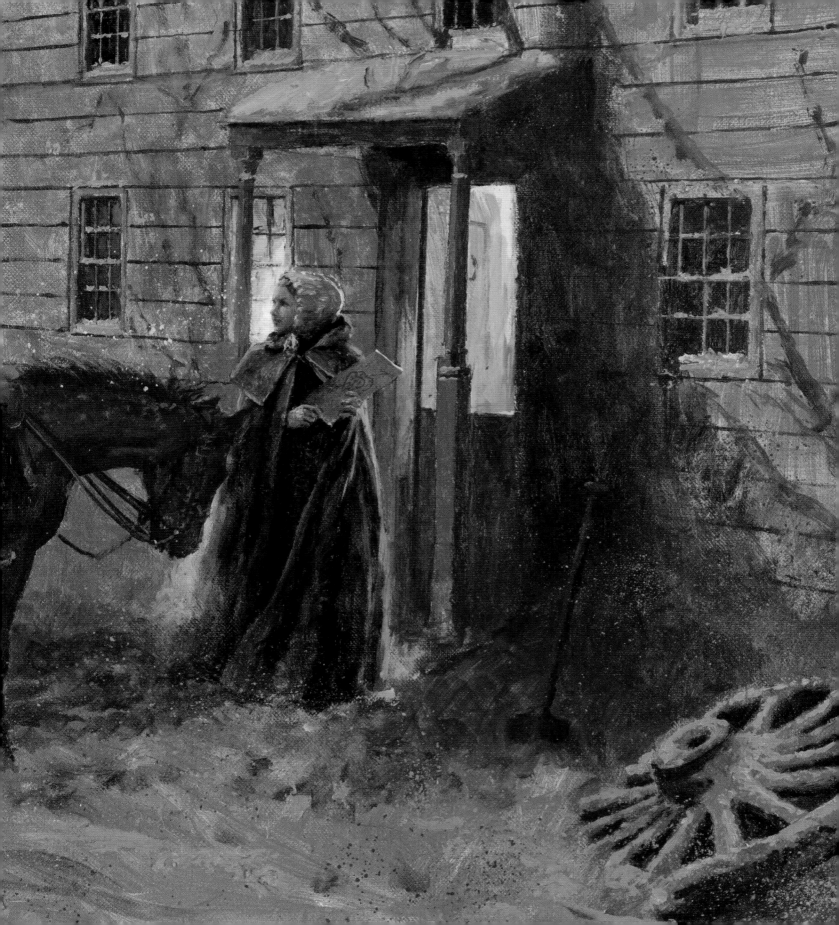

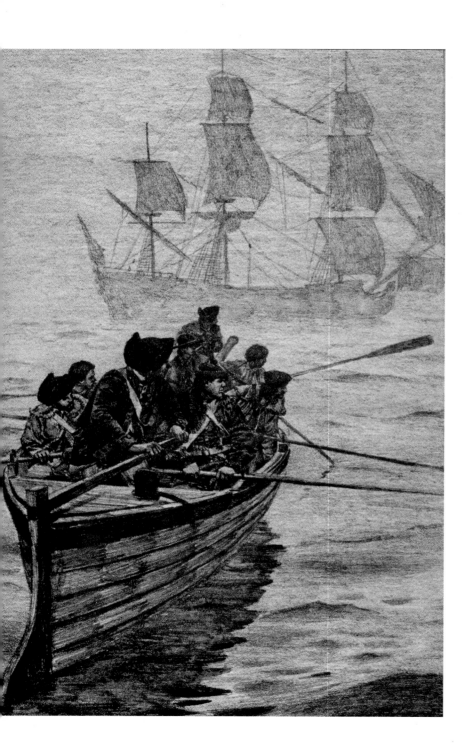

Spies on the Devil's Belt
Long Island Sound, 1778–83

GETTING INTELLIGENCE TO GENERAL Washington from out of the city, or across Long Island Sound (called the "Devil's Belt" in colonial times), posed major challenges. Typically, Robert Townsend sent his reports to Woodhull, who reported to Major Benjamin Tallmadge. Tallmadge, himself operating under the pseudonym "John Bolton," in turn communicated the intelligence to Washington. From Manhattan, one of the Culpers or a courier would carry intelligence reports more than fifty miles east to Setauket, Long Island. From there, boatmen would carry the reports across Long Island Sound to some point on the opposite shore near Fairfield, Connecticut. Usually a dragoon under Tallmadge's supervision would then pick up the report and carry it via New Haven and Danbury to Washington's headquarters farther west at Fredericksburg, New York (present-day Patterson and surrounding area)—a ride sometimes amounting to more than one hundred miles; when Washington moved his headquarters to New Jersey later in the war, the distance was even greater.

The commander in chief bristled at the long line of communications between the Culpers and headquarters. "I wish C– – could fall upon some more direct channel by which his Letters could be conveyed," he complained in a letter to Tallmadge on March 21, 1779, "as the efficacy of his communications is lost in the circuitous route." Because the more direct route from New York to New Jersey was heavily patrolled by British shipping, however, the Culpers had to continue to make do with the longer route. Amazingly, their line of communications was never discovered or broken.

"He's Just a Boy"

Spy Games, 1776–83

WASHINGTON'S INTEREST IN ESPIONAGE extended far beyond the intelligence his spies were supposed to gather. The relish with which he engaged in the actual mechanics of espionage suggests an interest born not just of military necessity but of genuine, if amateurish, fascination. For all that, espionage remained a life or death affair. The consequences of capture were terrifying. According to the accepted rules of war, spies could be pumped for intelligence—possibly tortured—and shot out of hand. Washington never countenanced torture, but he was willing to use almost any other means to gather information. (There are several accounts of teenage boys and girls in Philadelphia and elsewhere who worked as spies, but it is not known if any were ever captured.)

In 1778, two British spies were captured and prepared for execution. Learning that Presbyterian minister and army chaplain Alexander McWhorter would visit the condemned men to offer them the consolations of his office before their deaths, Washington decided to ask him to take on a more practical task—to try to gain information from them. "It is hardly to be doubted but that these unfortunate men are acquainted with many facts respecting the enemy's affairs," he instructed, "When you have collected in the course of your attendance such information as they can give you will transmit the whole to me." The men went to the gallows—but apparently without giving up any vital information.

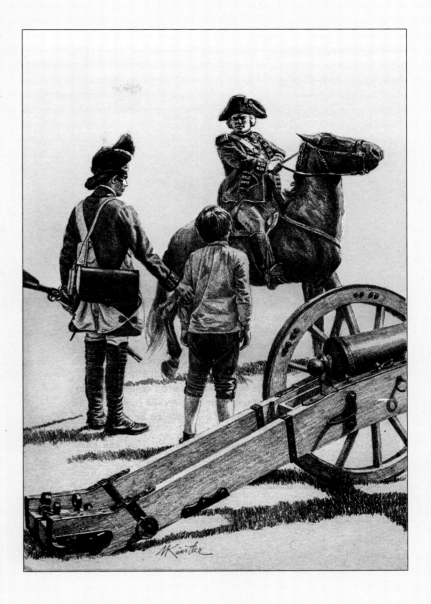

*"The **destructive evidences** of British cruelty are yet visible both in **Norwalk and Fairfield;** as there are the chimneys of **many burnt houses standing** in them yet."*

~George Washington diary entry,
October 16, 1789

The Spy
Fairfield, Connecticut, July 7–8, 1779

IN THE SUMMER OF 1779, BRITISH FORCES EMBARKED ON A SERIES of raids of coastal Connecticut. Their objective was to distract Washington from the militarily important Hudson River Valley, and to punish and terrify American civilians who had supported independence. The British certainly succeeded in the latter. On July 7, 1779, two thousand British and German soldiers landed at Fairfield. The people of that small town quickly hid their valuables and drove off their livestock, but there was little they could do to protect their homes. Over the following two days, the King's forces put the town to the torch and bayoneted a few civilians. Only a few buildings survived the calamity. It would take decades for Fairfield to recover. In 1789, Washington visited the town. "The destructive evidences of British cruelty are yet visible both in Norwalk and Fairfield," he wrote. "There are the chimneys of many burnt houses standing in them yet."

CHAPTER SEVEN

The Road to Victory

"A contemplation of the compleat attainment [at a period earlier than could have been expected] of the object for which we contended, against so formidable a power, cannot but inspire us with astonishment and gratitude——The disadvantageous circumstances on our part, under which the War was undertaken, can never be forgotten——The singular interpositions of Providence in our feeble condition were such, as could scarcely escape the attention of the most unobserving, while the unparallelled perseverence of the Armies of the United States, through almost every possible suffering and discouragement, for the space of eight long years, was little short of a standing Miracle."

— GEORGE WASHINGTON'S FAREWELL ORDERS TO THE
CONTINENTAL ARMY, NOVEMBER 2, 1783

AFTER THE BATTLE OF MONMOUTH IN June 1778, the primary scene of war shifted to the South. A British expedition captured Savannah, Georgia, in December 1778, and just under a year later a Franco-American attempt to retake the city failed miserably. In December 1779, General Sir Henry Clinton decided to open a major offensive aimed at taking Charleston, South Carolina, and then rolling up the southern colonies.

He achieved a major victory in May 1780 with the capture of Charleston, along with 5,000 Continental troops. After that Loyalists went on a rampage, swarming across the southern countryside and wrecking what remained of patriot authority in Georgia and South Carolina. The hero of Saratoga, General Horatio Gates, rode south to take over the reeling patriot armies, but he endured a catastrophic defeat at the Battle of Camden on August 16. Gates fled to escape capture, and his reputation collapsed in disgrace.

Another disgraceful event took place the following month in the North, when General Benedict Arnold unsuccessfully attempted to betray the patriot cause and surrender West Point to the British. Washington's general orders of September 26, 1780, proclaimed: "Treason of the blackest dye, was yesterday discovered! General Arnold, who commanded at West Point, lost to every sentiment of honor, of public and private obligation, was about to deliver that important post into the hands of the enemy." Horrified at such "treason of the blackest dye," the Americans would have happily executed Arnold—but he escaped. The Americans had to enact their vengeance instead on British Major John André, who had carried communications between Arnold and British headquarters and was caught in the act. André was no professional spy but a brave and handsome young officer who had simply been following the orders of his superiors—orders that forced him briefly to carry out the role of a spy in aiding Arnold's treason. By the rules of war he was subject to execution, but no one wanted responsibility for ordering his death—least of all Washington.

Washington proposed to exchange André for Arnold, but the British refused. Washington in turn had to refuse when the British appealed for clemency. Arnold threatened brutal retaliation on American prisoners if Washington harmed a hair on André's head but would not condescend to place his own head in the noose instead. Finally, after the determination of a board of officers, Washington submitted to grim duty and ordered the young officer's execution by hanging.

Marched to the gallows, André conducted himself to the last with bravery and composure. Dr. James Thacher, a Continental army surgeon at the scene, recorded the major's last minutes in his journal (published in 1823 as the *Military Journal of the American Revolution*). Thacher writes that as André "perceived that things were in readiness, he stepped quickly into the wagon, and at this moment he appeared to shrink, but instantly elevating his head with firmness, he said, 'it will be but a momentary pang'" and then "bandaged his

own eyes with perfect firmness, which melted the hearts and moistened the cheeks, not only of his servant, but of the throng of spectators." His final words: "I pray you to bear witness that I meet my fate like a brave man."

Arnold became a brigadier general in the British army, leading a force that captured Richmond, Virginia, in early January 1781, and went on to wreak havoc on much of coastal Virginia.

For a time, all seemed lost. Yet the southern patriots proved more resilient than anyone had anticipated. Inspired by dashing, innovative leaders such as Daniel Morgan, Francis "Swamp Fox" Marion, and Henry

"Light Horse Harry" Lee, patriots fought savagely to protect their farms, undermine the enemy, and reassert control in the South. Their enemies, including Loyalists and British officers such as Lieutenant Colonel Banastre Tarleton and Major Patrick Ferguson, fought back with equal fury and ruthlessness. The fighting spread everywhere, as bands of irregular cavalry, militia, Continental soldiers, redcoats, and even pitchfork-wielding farmers engaged in skirmishes and sharp engagements too numerous to count. Atrocities were common on both sides. By 1780 the war in the South had become a full-fledged civil war.

"They Are Crying for Quarter!"

Kings Mountain, South Carolina, October 7, 1780 (*opposite, bottom*)

THE TIDE BEGAN TO TURN IN THE AUTUMN OF 1780. After Camden, General Lord Charles Cornwallis pressed ahead to invade North Carolina. His army included the fearsome British Legion under Banastre Tarleton, and a strong formation of Loyalists under British Major Patrick Ferguson, who had fought Washington in the North with great success. Protecting Cornwallis's left flank, Ferguson roved along the Appalachian foothills, gathering Tories and warning patriots living in and across the mountains that he would "lay waste to their country with fire and sword" if they did not come to terms. His braggadocio backfired. Enraged by his threats, more than one thousand Overmountain ("Over-the-mountain") Men from southwestern Virginia and East Tennessee trudged over the Appalachians to teach him a lesson. Merging with bands of Virginia and North Carolina militia, they converged on Ferguson at a ridge called Kings Mountain, from where the major "defied God Almighty and all the rebels out of Hell to overcome him."

They did just that. Infiltrating through the dense woods, the patriots simultaneously attacked Ferguson and his Tories from all directions on October 7. As his men moved forward, patriot Colonel Isaac Shelby cried, "I will not stop till night, if I follow Ferguson into Cornwallis' lines!" The Tories fought savagely, with Ferguson vowing that he would "never yield to such a d—d ["damn'd"] banditti," but the patriots pushed them inexorably inward. Finally, the patriots heard the cry "Hurrah, my brave fellows! Advance! They are crying for quarter!" and pressed home their attack. Ferguson fell mortally wounded, and his command collapsed. Four hundred Tories were killed or wounded, and another seven hundred captured.

"Next morning, which was Sunday," recorded James Collins, a sixteen-year-old patriot who had fought in the battle, "the scene became really distressing; the wives and children of the poor Tories came in, in great numbers. Their husbands, fathers and brothers lay dead in heaps, while others lay wounded or dying—a melancholy sight indeed!" Cornwallis would fight on, but loyalism in North Carolina had been broken for good.

Lord Charles Cornwallis, First Marquess of Cornwallis, in a 1799 engraving by J. Ward from a painting by Sir William Beechey.

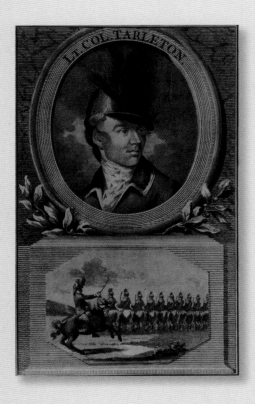

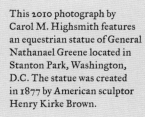

Lt. Col. Banastre Tarleton of the British Legion; this print is from the *Westminster Magazine,* March 1782.

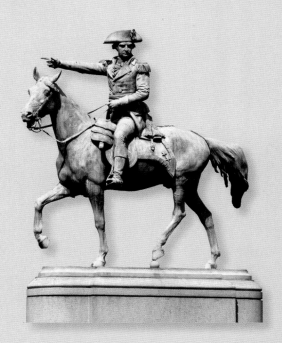

This 2010 photograph by Carol M. Highsmith features an equestrian statue of General Nathanael Greene located in Stanton Park, Washington, D.C. The statue was created in 1877 by American sculptor Henry Kirke Brown.

Hand to Hand

Cowpens, South Carolina, and Guilford Court House, North Carolina, January–March 1781

GENERAL NATHANAEL GREENE, WHO HAD BEEN trapped in the office of quartermaster general since Washington placed him there during the Valley Forge crisis in March 1778, happily took command of the southern army in December 1780. General Charles Cornwallis had withdrawn toward Camden in the wake of Kings Mountain, and Greene moved south in pursuit. Greene and Cornwallis—both superb tacticians—maneuvered back and forth until Cornwallis split his force, hoping to catch and destroy a detachment under the canny Virginian Daniel Morgan. The move blew up in his face when Morgan turned on Banastre Tarleton's British Legion at Cowpens on January 17, 1781, and won a stunning victory. "Such was the inferiority of our numbers," Morgan reported after the battle, "that our success must be attributed to the justice of our cause and the bravery of our troops."

Refusing to concede defeat, Cornwallis drove his entire army after Morgan, who successfully linked up with Greene in the hamlet of Guilford Court House (part of present-day Greensboro), North Carolina, near the Virginia border. Sensing an opportunity to change his fortunes once and for all, Cornwallis attacked. Greene placed his North Carolina militia in the first line and asked them to fire just two volleys at the advancing redcoats before falling back. The jittery militiamen did so, leaving the battle-hardened regulars to fight it out with the redcoats. "The battle was long, obstinate and bloody," said Greene. The redcoats pushed him back and took much of his artillery, but not before he had inflicted such losses that, as British politician Charles James Fox reported, "Another such victory would destroy the British army." Greene summed up the battle: "Except the ground and the artillery, they have gained no advantage. On the contrary, they are little short of being ruined." Bloodied and exhausted, Cornwallis and his army limped east to Wilmington, North Carolina—the first step on a road that would lead them to Yorktown.

"The battle was long, obstinate and bloody."

~General Nathanael Greene, describing the Battle of Guilford
Court House in a letter to Joseph Reed, president
of the Pennsylvania executive council, March 18, 1781

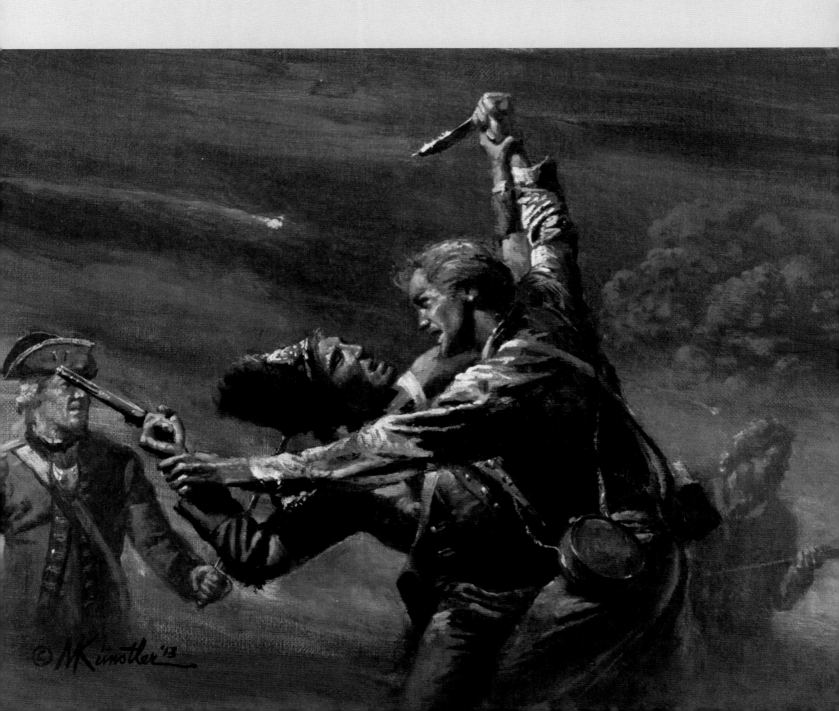

The Capture of Fort Motte
Fort Motte, South Carolina, May 8–12, 1781

WHILE GENERAL GEORGE CORNWALLIS MOVED east and north, patriot leaders gradually reasserted control farther south. In May, a patriot force jointly commanded by Lieutenant Colonel Henry "Light Horse Harry" Lee— Robert E. Lee's father—and General Francis "Swamp Fox" Marion moved toward Rebecca Brewton Motte's mansion, which had been garrisoned by about 175 British soldiers and dubbed "Fort Motte." Lee and Marion surrounded the house and prepared an assault, but the mansion was well defended, and the British commander, Captain Daniel McPherson, pronounced his intention of fighting to the last. A possible British relief force hovered nearby. Fort Motte had to be taken—and quickly.

With regret, because Mrs. Motte was a dedicated patriot, Lee and Marion decided to set the house afire with flaming arrows and so drive out its defenders. Lee sadly broke the news of their intended plans to Mrs. Motte— who had taken refuge with the patriots—"lamenting the sad necessity and assuring her of the deep regret which the unavoidable act excited in his and every breast." Instead of protesting, however, "with a smile of complacency this exemplary lady . . . declar[ed] that she was gratified with the opportunity of contributing to the good of her country. . . . Shortly after, seeing accidentally the bows and arrows which had been prepared, she sent for the lieutenant colonel, and presenting him with a bow and its apparatus imported from India, she requested his substitution of these, as probably better adapted for the object than those we had provided." Lee accepted, and Motte's mansion was duly set afire. Fortunately, McPherson raised the white flag before the structure was burned down. After the flames were extinguished, Mrs. Motte celebrated by inviting Lee, Marion, McPherson, and others on both sides to a "sumptuous dinner, soothing in the sweets of social intercourse the ire which the preceding conflict had engendered."

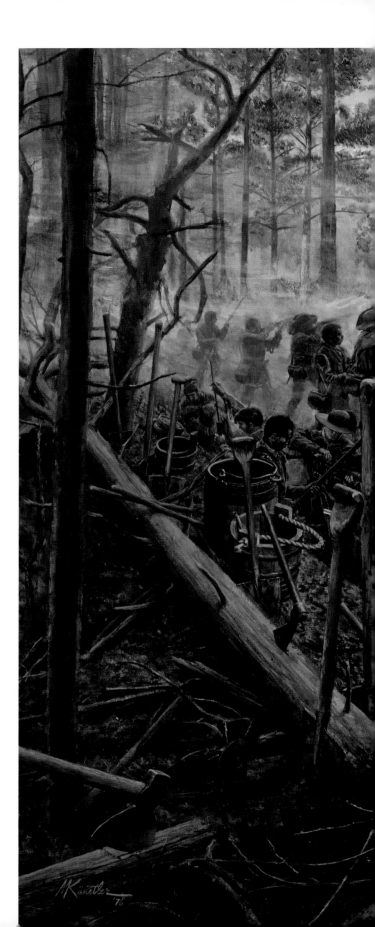

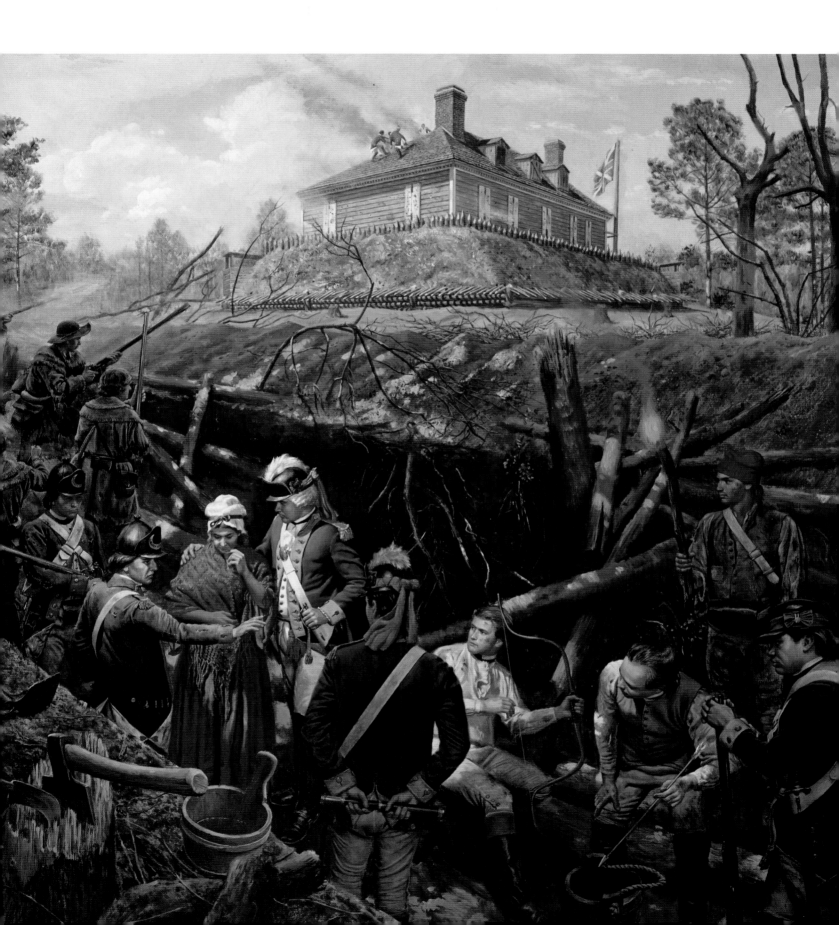

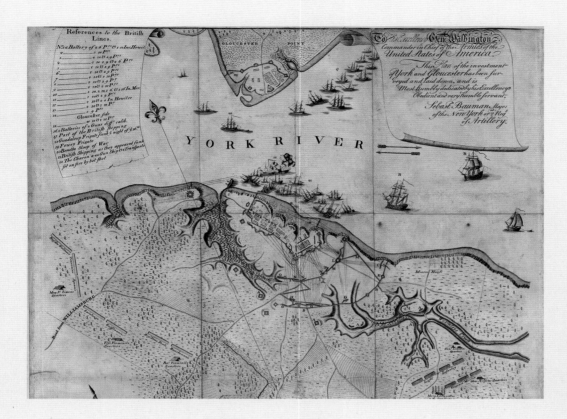

Digging the Trenches at Yorktown *(following pages)*
Le Soissonnais *(opposite top)*
Yorktown, Virginia, October 6, 1781

AS GENERAL CHARLES CORNWALLIS MARCHED toward Yorktown and General Nathanael Greene turned south, Washington watched developments from his encampment at New Windsor, New York. He remained preoccupied with attacking New York City, which seemed to him the most direct means of ending the war. A French army under the Comte de Rochambeau—whose assistance the Marquis de Lafayette had promised at Morristown the previous spring—stood by, ready to join the attack. (In July 1780, Rochambeau had arrived in Rhode Island with his French expeditionary force, which included four elite infantry regiments: the Bourbonnais, the Royal Deux-Ponts, the Saintonge, and the Soissonnais.) Events moved fast in that summer of 1781, however, leading Washington to engage in a campaign that he had not even begun to contemplate in the spring.

Seeking "a proper harbor and place of arms" to serve as a base of operations for his battered army, Cornwallis perused a map of the eastern United States and placed his finger on a point in southeastern Virginia. "I am inclined to think well of York," he mused in a letter to Henry Clinton, and took his soldiers by a roundabout route that led them to Yorktown in July. From there he proceeded to raid the countryside, defying the rebels to stop him. They couldn't, until a French fleet under Admiral François Joseph Paul de Grasse appeared off the Virginia Capes in August. Washington, who had hoped that de Grasse would help him assault New York, quickly readjusted his plans, and decided to march his entire army south to Virginia.

Washington's army began its trek on August 19 and surrounded Cornwallis's positions on September 28.

Expecting quick relief from British naval and land forces based in New York, Cornwallis decided to abandon his outer entrenchments and retract his army of nine thousand men into a close perimeter around Yorktown. It was a fatal error. Washington obligingly tightened the noose around Yorktown, and ordered the construction of entrenchments from which he could begin the siege. As his men prepared to begin work on the evening of October 6, the commander in chief appeared and "struck a few blows with a pickaxe, a mere ceremony, that it might be said, 'General Washington with his own hands broke first ground at the siege of Yorktown.'" Three days later, "His Excellency General Washington put the match to the first gun, and a furious discharge of cannon and mortars immediately followed."

Jean-Baptiste-Donatien de Vimeur, Comte de Rochambeau, in an engraving after an 1834 painting by French painter Charles-Philippe Larivière.

"*The troops of the line* **were** **there ready** ...
and began to entrench after **General Washington** *struck a few blows with a pickaxe,*

a mere ceremony,

that it might be said,

'*General Washington* **with his own hands** *broke first ground*

at the siege of Yorktown.'"

~Sergeant Joseph Plumb Martin,
*Memoir of a Revolutionary Soldier:
the Narrative of Joseph
Plumb Martin,* 1830

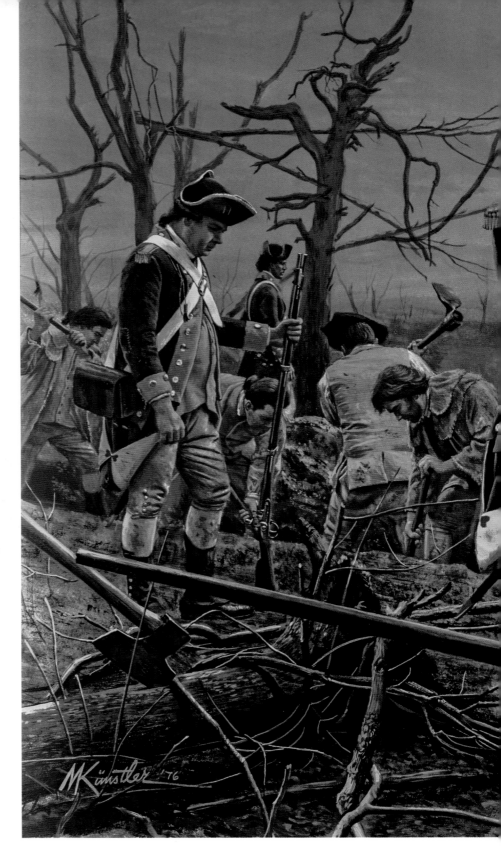

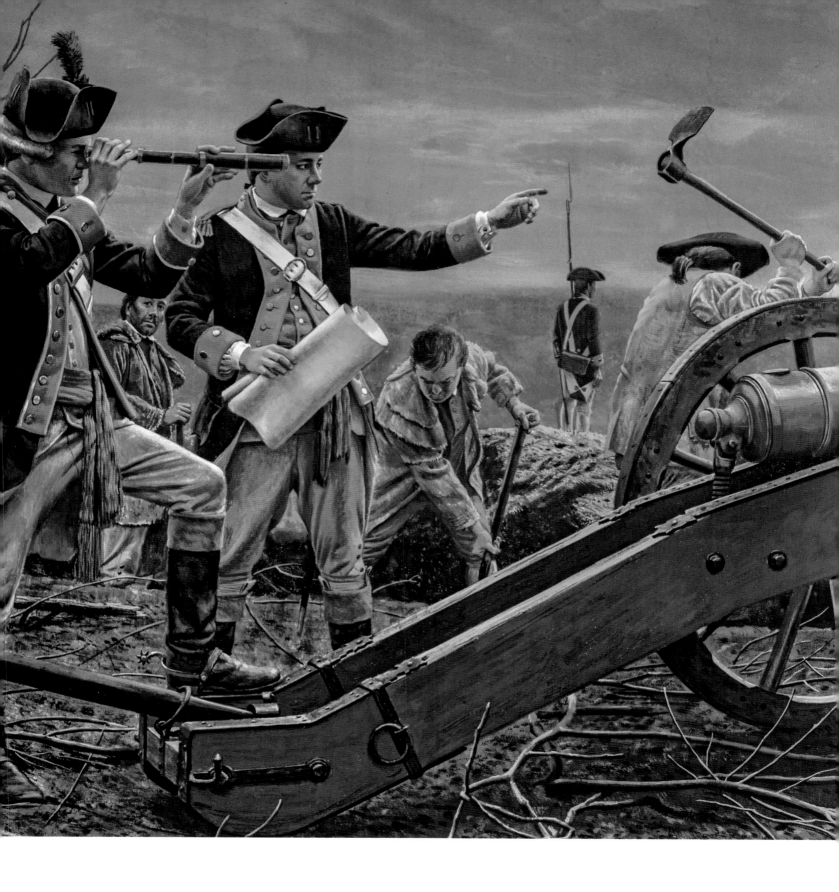

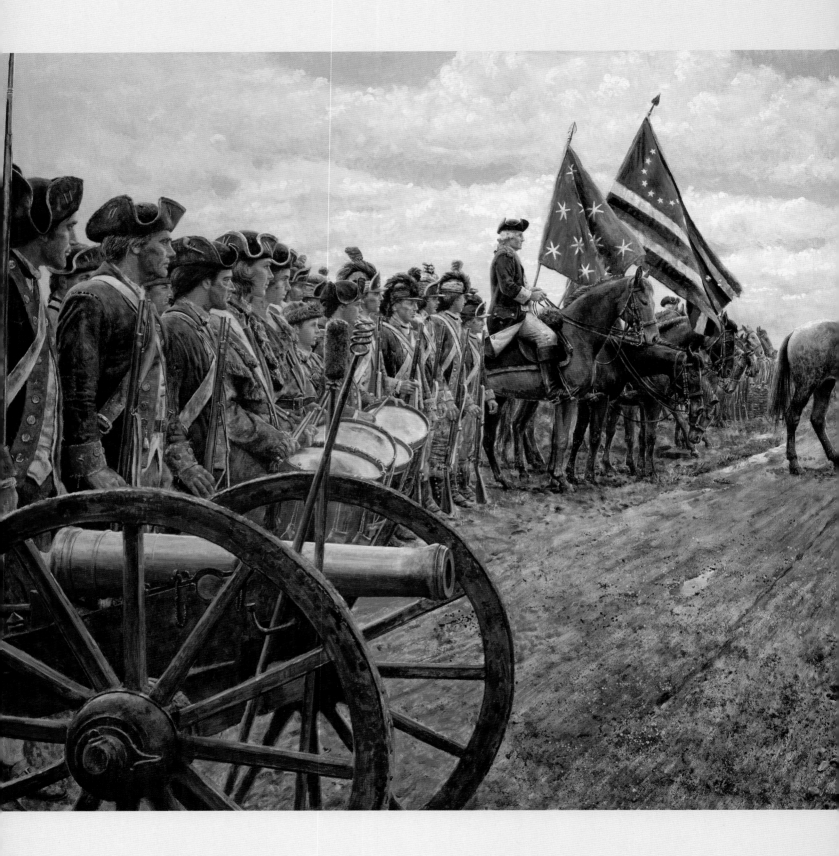

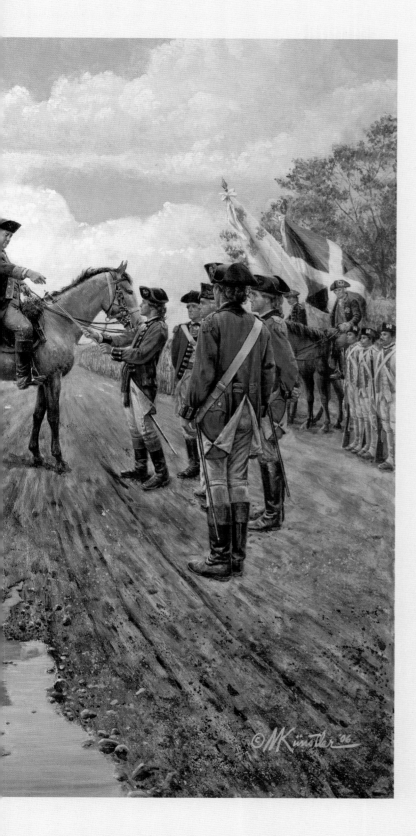

The World Turned Upside Down
Yorktown, Virginia, October 19, 1781

THE AMERICAN ENTRENCHMENTS CREPT closer to the British perimeter until, on October 14, they were within 150 yards of two British redoubts—dubbed numbers 9 and 10—which held the key to General Charles Cornwallis's defensive system. That evening Washington ordered two detachments—one French and one American, the latter under the command of Lieutenant Colonel Alexander Hamilton—to assault the redoubts. Before the attack began, Hamilton sat down to write a letter to his wife. "Five days more the enemy must capitulate or abandon their present position," he wrote hopefully, "and then I fly to you. Prepare to receive me decked in all your beauty, fondness, and goodness." Washington gave his troops a final speech as they prepared to attack. "I thought then that his Excellency's knees rather shook," wrote an American officer, Captain Stephen Olney, "but I have since doubted whether it was not mine." The Revolutionary War had reached its culminating moment.

Moving forward with quick efficiency, the French and American soldiers stormed the redoubts and overcame the defenders after bitter but brief hand-to-hand combat. With the fall of the redoubts, Cornwallis's position became hopeless. American artillery fire on his positions intensified, and the French naval cordon looked as strong as ever. The British had tried but failed to break through Admiral François de Grasse's fleet in September. On October 17, Cornwallis bowed to the inevitable.

American soldiers, including diarist Captain Ebenezer Denny, saw a British drummer "mount the enemy's parapet and beat a parley, and immediately an officer, holding a white handkerchief, made his appearance outside their works."

The officer brought a message from Cornwallis asking for a discussion of terms of surrender. Washington, expressing "[a]n Ardent Desire to spare the

further Effusion of blood," agreed. The negotiations took two days until the articles of capitulation were signed on October 19. Cornwallis and his entire army had become prisoners of war.

Cornwallis refused to turn over his sword personally, and instead remained skulking in his headquarters while Brigadier General Charles O'Hara performed the ceremony. He rode toward the allied commanders, who sat grimly astride their horses. O'Hara attempted to present his sword to the Comte de Rochambeau, but the Frenchman shook his head and silently pointed to Washington. The British general turned to offer his sword to the commander in chief, but Washington shook his head and pointed to General Benjamin Lincoln, who had been forced to surrender his own sword to the British at Charleston in May 1780. Lincoln accepted O'Hara's sword with grave dignity. With that the preliminaries ended, and the mass surrender got underway.

The Revolution Victorious [detail], Yorktown, Virginia, October 19, 1781

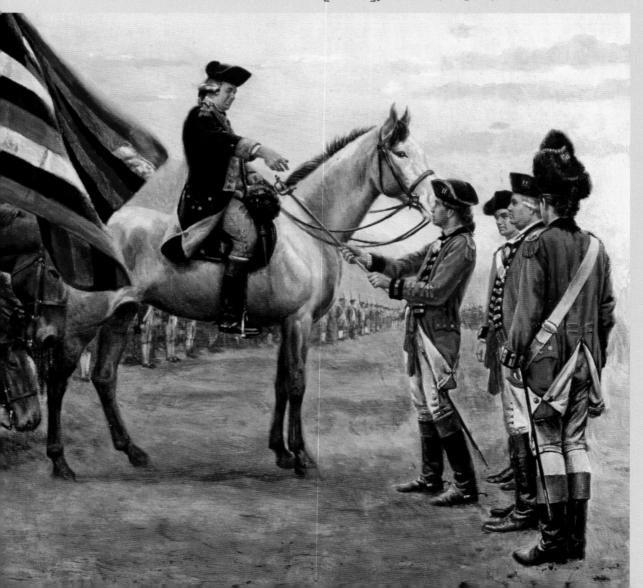

"Deny the best-disciplined soldiers of Europe what is due them and they will run away in droves. . . . But from this one can perceive what an enthusiasm——which these poor fellows call 'Liberty'——can do!"

~Hessian captain
Johann Ewald

Surrender at Yorktown

Yorktown, Virginia, October 19, 1781 (*following page*)

THAT AFTERNOON THE ALLIED FRANCO-AMERICAN ARMY entered the British positions and formed up lines with the Americans on the right and the French on the left. The British had hoped to march out in honor with shouldered muskets and flags waving, playing jaunty tunes. Washington denied them the honor, however, because they had refused similar honors to Lincoln's men at Charleston. Instead, Cornwallis's army kept their flags furled and muskets reversed in signs of shame while their drums beat a slow march. Later stories claimed that the British drummers and fifers played the English ballad "The World Turned Upside Down." Regardless of the tune, at the end of their march they hurled their muskets to the ground in anger and sneered scornfully at their tatterdemalion captors.

Battle-hardened Hessian captain Johann Ewald refused to share in the scorn. "I have seen many soldiers of this army without shoes, with tattered breeches and uniforms patched with all sorts of colored cloth, without neckband and only the lid of a hat, who marched and stood their guard as proudly as the best uniformed soldier in the world. With what soldiers in the world could one do what was done by these men, who go about nearly naked and in the greatest privation? Deny the best-disciplined soldiers of Europe what is due them and they will run away in droves. . . . But from this one can perceive what an enthusiasm—which these poor fellows call 'Liberty'—can do!"

George Washington, less than fifty years old, had won the greatest victory in the history of the fledgling United States, and set in motion the wheels that eventually would lead to independence. While the American officers and men "could scarcely talk for laughing, and they could scarcely walk for jumping and dancing and singing as they went about," the commander in chief took quiet satisfaction in his achievement. He treated the British officers—again not including the sullen Cornwallis—to a relaxed dinner in their honor, and in the following days and months he warned his countrymen not to relax their vigilance. A grand victory had been won, but the war was not yet over. At least one British leader, however, was convinced that the end had come. Learning of Yorktown, Prime Minister Lord Frederick North "opened his arms, exclaiming wildly, as he paced up and down the apartment during a few minutes, 'Oh God! It is all over!'"

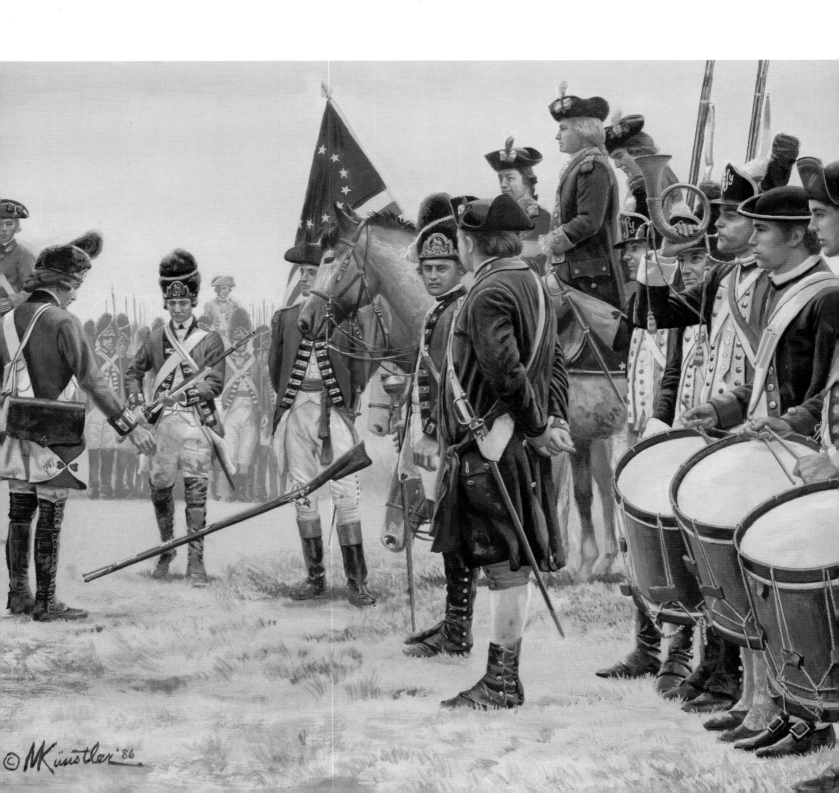

Brockholst Livingston Captured at Sea

Atlantic Ocean, April 25, 1782

GENERAL CHARLES CORNWALLIS'S SURRENDER at Yorktown did not end the Revolutionary War. Fighting continued in many parts of the continent. Congress struggled to establish central authority under the Articles of Confederation, ratified in 1781, that gave primary power to the states. The economy sputtered as the United States endeavored to remain on a war footing after seven long years of conflict. And although France, Spain, and the Netherlands had all entered the war, their recognition of the United States was not the same thing as granting the young nation the respect it deserved. For the country to survive, it needed men of quality to establish its first diplomatic corps overseas.

Henry Brockholst Livingston was one of those men. Born in New York City, the son of Governor William Livingston of New Jersey, Henry had served as a lieutenant colonel and aide-de-camp to General Benedict Arnold before leaving the army in January 1778 to study law. In the fall of 1779 he joined his brother-in-law John Jay on a journey to Madrid, where Jay had been appointed minister to Spain. It was a dangerous journey in wartime, but the men arrived safely. Livingston served as Jay's private secretary over the next three years as they worked slowly to build up regular diplomatic relations between Spain and the United States. On the return voyage in April 1782, however, a British privateer vessel captured Livingston's ship. Livingston quickly destroyed the diplomatic dispatches that had been entrusted to him, which so enraged the British that they tossed him in jail upon their arrival in New York City. Livingston's captors hoped that he would divulge the contents of the dispatches. Telling the British that they had lost "all hopes of distressing America into submission," he stubbornly refused to speak of his mission in Spain. The British released him on parole soon afterward.

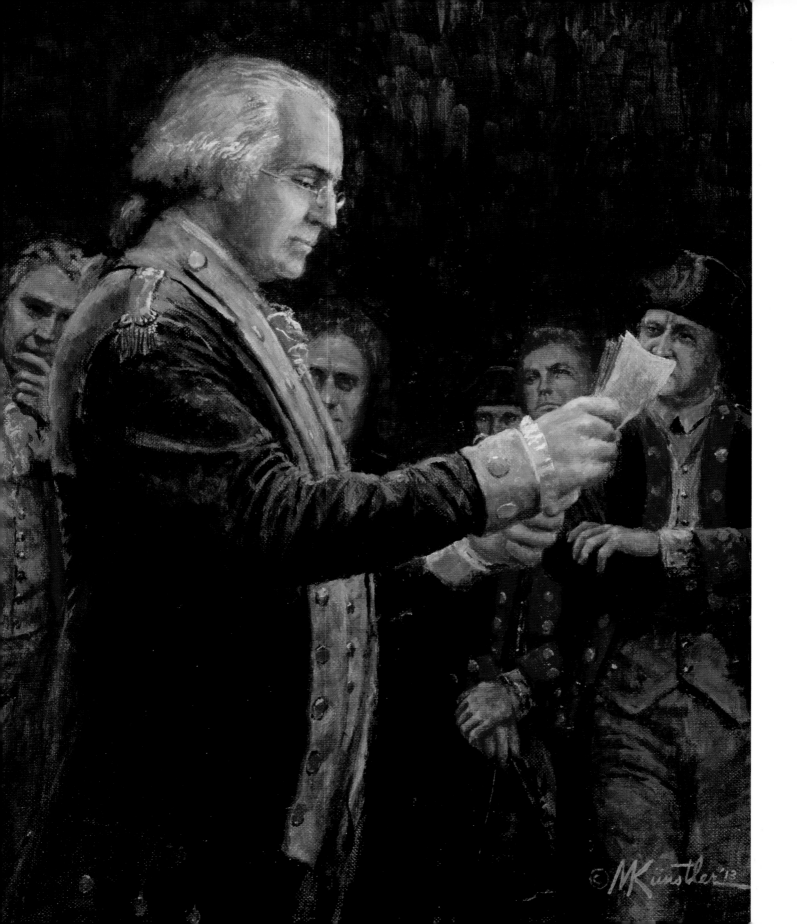

"Gentlemen, You Must Pardon Me"

Newburgh, New York, March 15, 1783

ONE FINAL TRIAL REMAINED. IN THE WINTER OF 1782–83, Washington's army was wracked by hardship and unrest as the American economy neared collapse. Money had almost entirely lost its value. Soldiers received news from home that their farms and businesses were failing, and that their wives and children faced the specter of poverty and starvation. Their only hope was that Congress would follow through on its earlier promise to provide veterans and their families with substantial pensions and back pay. But this Congress now refused to do. The government was out of money, and the states refused to supply the funds necessary to run the country, let alone to support veterans. Enraged, many soldiers and officers spoke of marching on Congress and enforcing their will on the nation at the points of bayonets. A manifesto spread through camp attacking "a country that tramples upon your rights, disdains your cries and insults your distresses," and called on Washington to spearhead a military rebellion. On the brink of total victory, democracy in America hung by a thread.

This was Washington's hour. No other man in America possessed the power to step into the gap that yawned between soldiers and civilians and pull the country back together. Had he sought personal power, Washington might easily have joined with his soldiers and taken over the country. Instead, on March 15 he appeared before his officers, assembled in a large wooden building at Newburgh, New York. His bearing was grave but firm. In a stirring speech, he begged the officers to convince their men to desist from talk of rebellion, and to trust him and Congress to do their duty. In doing so, he said, "You will give one more distinguished proof of unexampled patriotism & patient virtue, rising superior to the pressure of the most complicated sufferings; And you will, by the dignity of your Conduct, afford occasion for Posterity to say, when speaking of the glorious example you have exhibited to mankind, 'had this day been wanting, the World had never seen the last stage of perfection to which human nature is capable of attaining.'"

His speech completed, Washington paused. He glanced at his audience, which remained silent, and pulled out a letter—unfortunately rather dull—describing Congress's troubles in raising money. Before starting to read, Washington paused again, reached in his coat pocket, and pulled out a pair of spectacles. He had never worn them in public. By way of explanation, he gazed at his officers and said, "Gentlemen, you must pardon me. I have grown gray in your service and now find myself growing blind." It is unlikely that any of the officers heard a word that followed as he read the letter, but their eyes were cloudy with tears. Washington strode out of the room, and the officers voted unanimously to abandon all talk of rebellion and profess total obedience to Congress. With a simple gesture, Washington had saved democracy in America.

A Continental Officer

> *"With a heart full of love and gratitude,*
> *I now take leave of you."*
>
> ~General George Washington,
> Resignation Speech to Congress,
> December 23, 1783

Washington's Homecoming

Mount Vernon, Virginia, December 24, 1783 (*following pages*)

THE REVOLUTIONARY WAR OFFICIALLY ENDED on September 3, 1783, with the signing of the Treaty of Paris. British troops evacuated New York on November 25, and Washington marched triumphantly into the city. On December 4, in Fraunces Tavern in lower Manhattan, he bid farewell to his officers in a final toast. Colonel Benjamin Tallmadge, who had served under Washington for many years, later recorded the general's words. "With a heart full of love and gratitude, I now take leave of you," he said as he raised his glass. "I most devoutly wish that your later days may be as prosperous and happy as your former ones have been glorious and honorable." They drained their glasses and each embraced the general in turn, many weeping openly. Washington then "walked across the room, raised his arm in an all-inclusive silent farewell and passed through the door, out of the tavern, between the open ranks of a guard of honor, and then along the street to Whitehall."

Washington then rode south, visions of Mount Vernon, Martha, her grandchildren, Yuletide decorations, and a Christmas meal dancing before his eyes. He arrived in Baltimore on December 17, and rode to Annapolis six days later to resign his commission as commander in chief and deliver a farewell address to Congress. He spoke through tears, and his hands shook as he read. By the final sentences his voice had become firm and clear. "Having now finished the work assigned me," he said, "I retire from the great theatre of Action—and bidding an Affectionate farewell to this August body under whose orders I have so long acted, I here offer my commission, and take leave of all the employments of public life." He then handed over his commission to the delegates. They sat quietly and did not applaud, but removed their hats as he left the room. Upon hearing that Washington would not be exploiting his victorious, powerful position to become American monarch, King George III dubbed the general "the greatest man in the world" for doing so, and he was right.

The journey homeward began the next day, and Washington rode fast, determined to make Mount Vernon by evening. He reached the Potomac River, and must have welcomed it as an old friend as he stood gazing over its waters during the windy ferry passage. Continuing his ride, he caught sight of the boundary markers to his estate and passed beneath the mighty trees that marked the final approach. After that came the frosty lawn, the yard, and the doorway centered beneath gaily lit windows. Martha was there, waiting to embrace him, surrounded by servants and joyously shrieking grandchildren. In a moment they fell into each other's arms, and Washington enjoyed the richest reward of all: after a long, bitter war, he had come home for Christmas.

Sketch for *Washington's Homecoming*

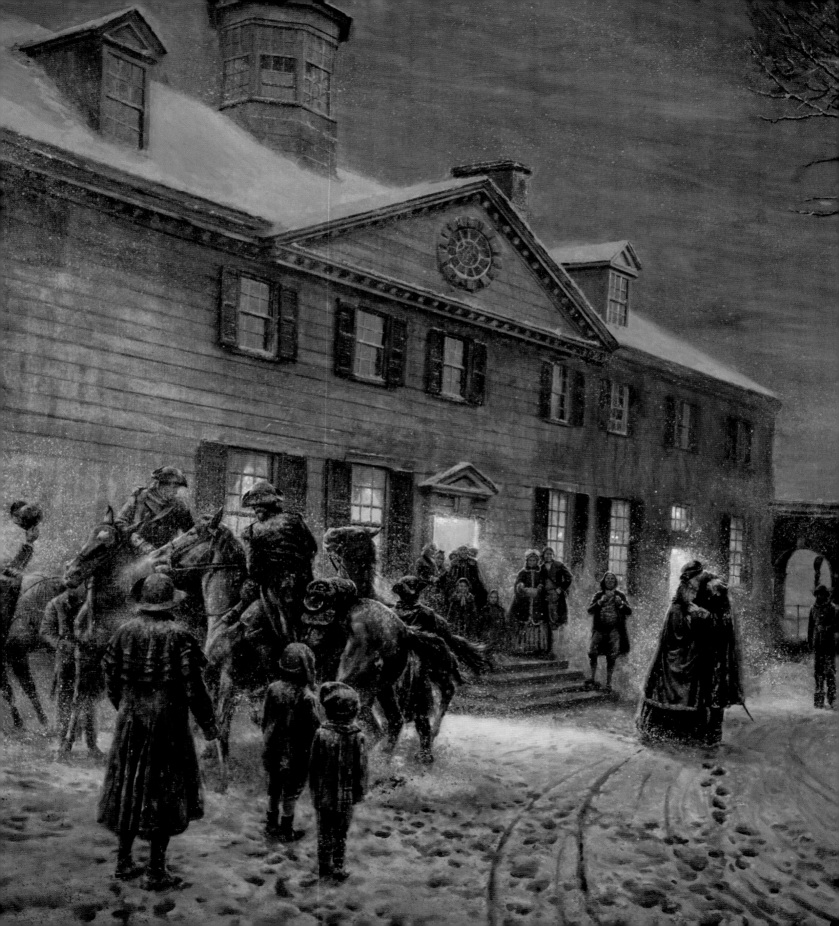

"*Having now finished the work assigned me* **I retire from the great theatre** *of Action——and bidding an Affectionate farewell to this August body under whose orders I have so long acted, I here* **offer my commission,** *and take leave of all the employments* **of public life.**"

~General George Washington,
Resignation Speech to Congress,
December 23, 1783

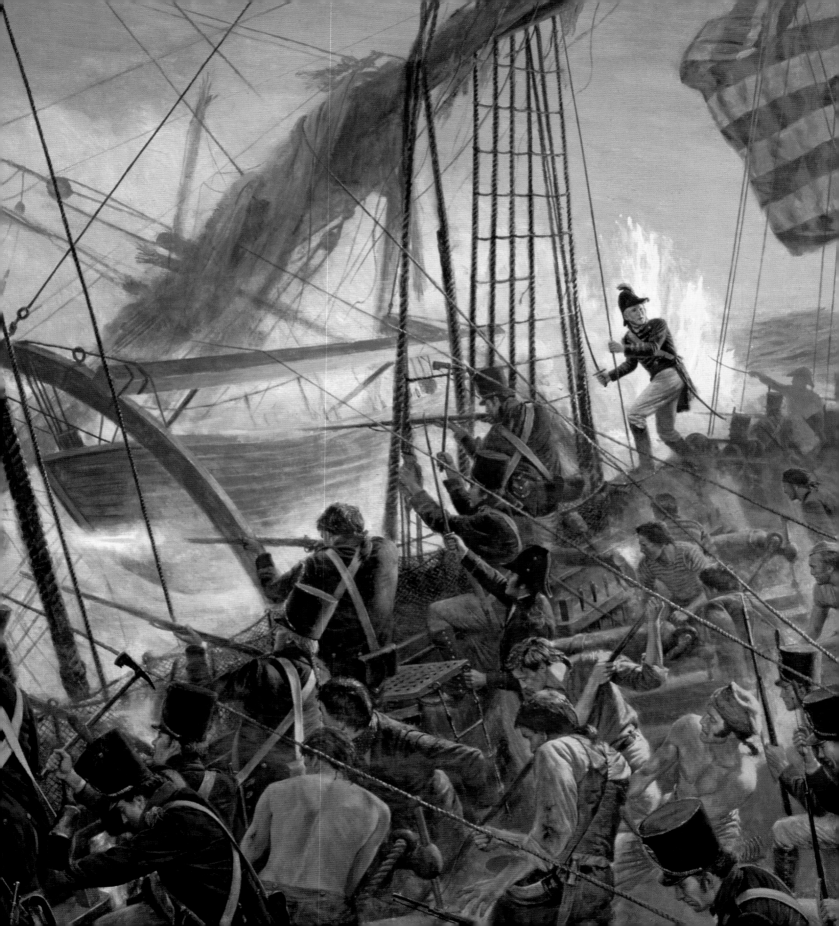

PART THREE

Constitution

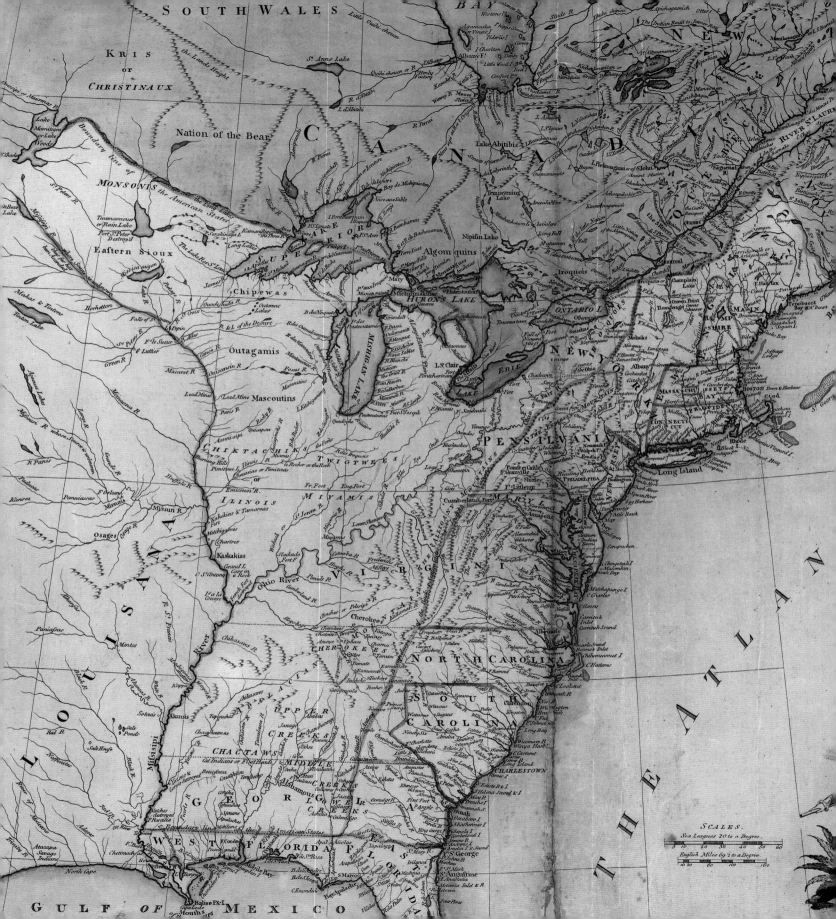

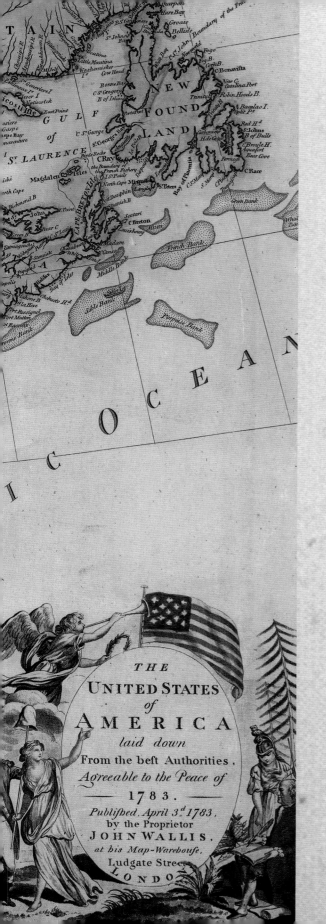

THE FIRST PART OF ANY REVOLUTION IS ALWAYS THE easiest. Often, the unity that comes from fighting a war against a common enemy crumbles as soon as revolutionaries attempt to craft a peace settlement that can satisfy all their aspirations. In many cases, as in France after 1789, successful popular revolutions have degenerated into bloody internal squabbles leading to massacre and military dictatorship.

The success of the American Revolution—not just in winning independence from Great Britain, but in founding a new nation with a stable government based on principles of freedom and equality—is one of the most remarkable achievements in history. It began in 1783 when Washington resigned his post as commander in chief and happily returned to his farm. But much hard work remained. The Articles of Confederation (1781), intended to unite the former thirteen colonies within a loose framework of alliance, didn't work effectively. In 1787, therefore, dozens of the greatest men in North America—and indeed the world—assembled at Philadelphia to frame a new form of government.

The convention delegates were brilliant but also, almost to a man, forceful and stubborn. Amazingly, they agreed to work together peacefully, to take risks—and to compromise. They knew that the Constitution they created was imperfect, but agreed that it was the best possible under the circumstances and were willing to fight to make it succeed. The Constitution did work, but only after a long battle for ratification, and an even longer battle to establish an effective, operational government. Here again, George Washington was the most pivotal figure.

Washington was elected as the first president of the fledging nation, serving for eight years (1789–97). He died in 1799. Meanwhile, the country institutionalized the smooth transfer of power; via closely contested elections, John Adams followed Washington in the top office, succeeded by his rival Thomas Jefferson. Despite continuing political controversy, the new nation began to expand in size and strength. The Louisiana Purchase and the expedition of Lewis and Clark set the country's sights westward, while the War of 1812 proved the United States could hold its own in a world of warring empires.

The United States of America Laid Down from the Best Authorities,
Agreeable to the Peace of 1783, John Wallis, London, 1783.

CHAPTER EIGHT

A New Government

"It now rests with the Confederated Powers, by the line of conduct they mean to adopt, to make this Country great, happy, & respectable; or to sink it into littleness——worse perhaps——into Anarchy & Confusion; for certain I am, that unless adequate Powers are given to Congress for the general purposes of the Federal Union that we shall soon moulder into dust and become contemptable in the Eyes of Europe, if we are not made the sport of their Politicks."

— GEORGE WASHINGTON TO REV. WILLIAM GORDON, JULY 8, 1783

GEORGE WASHINGTON HOPED THAT HIS homecoming at Christmas in 1783 would be his last. Just over fifty years old, he had fought in two major wars and had had a bellyful of politics. All he wanted was to work on restoring his estate and farm. There was much for him to do. During more than eight years of war, during which Washington had been able to visit home for only a few days and even his wife, Martha, had been frequently on the road, Mount Vernon had fallen into almost total disrepair. Shutters were sagging, the roof was leaking, and the rooms reeked of must. Vagabonds rampaged across Washington's property, poaching game and cutting down trees. His family finances were in disarray.

As Washington set to work getting his estate back in order, he continued to follow events elsewhere. He was intensely interested in the news, and spent much of every day reading the Alexandria newspapers. Unfortunately, each line he read left him feeling increasingly unsettled. The economy remained weak, and the Confederation government seemed powerless to do anything about it. Power remained almost wholly with the states, whose governments seemed equally inept. And the states could not agree with one another on anything. Regional rebellions broke out. More ominously, the great empires of Europe seemed inclined to treat the young United States as weak and insignificant. Sooner or later, Washington feared, one of them would pounce on the struggling young country like a wolf on a wounded calf. So strongly did he believe that something had to be done that he was willing to contemplate the unthinkable: leaving the retirement he had so long cherished and stepping once more onto the public stage. The events that impelled his decision to do so were not long in coming.

The Constitution Debated

Constitutional Convention, Philadelphia, May–September 1787

THE ARTICLES OF CONFEDERATION HAD SERVED WELL enough—if just barely—during wartime, but within a few years it had become obvious that they could not secure a lasting foundation for stable government. In February 1787, Congress called for a new convention of the states to meet in Philadelphia in May and "render the constitution of the Federal Government adequate to the exigencies of the Union." The convention opened on May 25, and the delegates promptly elected the imperturbable George Washington to preside over the proceedings. But he played little active role in the debates. Instead, James Madison of Virginia took the lead in advocating a proposal for a strong central government, as outlined in the Virginia Plan, which he had drafted.

Debate began and continued through the summer. Opponents of the Virginia Plan proposed an alternate New Jersey Plan, advocated by delegate William Paterson of that state, which would have severely limited federal powers. The arguments were sometimes polite and often bitter, but always creative. "Never was an assembly of men, charged with a great & arduous trust," wrote Madison, "who were more pure in their motives, or more exclusively or anxiously devoted . . . to the object of devising and proposing a constitutional system which would . . . best secure the permanent liberty and happiness of their country."

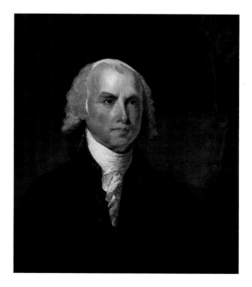

James Madison,
Gilbert Stuart, ca. 1821

We the People ... 1787

Philadelphia, September 17, 1787 (*opposite*)

AFTER LONG DEBATE, THE DELEGATES SETTLED on a draft Constitution. It established the government of the United States along a carefully devised system of checks and balances, with separate and independent executive, legislative, and judiciary branches of power. "Ambition must be made to counteract ambition," James Madison had proclaimed, and so the delegates enacted safeguards to protect political minorities and ensure both continuity and measured change. In mid-September, the delegates assembled to vote. Despite the hard-fought compromise, many delegates continued to resist the new form of government, and in the end just thirty-nine out of fifty-five delegates voted in favor—just enough to secure approval. Afterward, Washington wrote in his diary, the delegates "dined together and took a cordial leave of each other" at the City Tavern. "Well, Doctor," a lady supposedly asked Benjamin Franklin as he emerged from the State House, "what have we got, a republic or a monarchy?" "A republic," Franklin replied, "if you can keep it."

The campaign for ratification that followed tested the ability of the young nation to keep this republic. Well-respected men like George Mason and Patrick Henry opposed the plan. Henry, still a fiery orator, declared that he "smelt a rat" in Philadelphia that would reinstitute monarchy. At the Virginia Ratifying Convention of 1788 he refused to accept ratification, asking: "What right had they to say, We, the people? Who authorized them to speak the language of, We, the people, instead of, We, the states? . . . If the states be not the agents of this compact, it must be one great, consolidated, national government." Washington, however, quietly worked behind the scenes to ensure ratification, writing to undecided political leaders and urging them to support the new government, however imperfect. Delaware was the first state to ratify the Constitution, on December 7, 1787; but more than two years would pass before Rhode Island, by a narrow margin, gave the final vote for ratification on May 29, 1790. By then, the nation had already elected its first president.

The U.S. Constitution, September 17, 1787

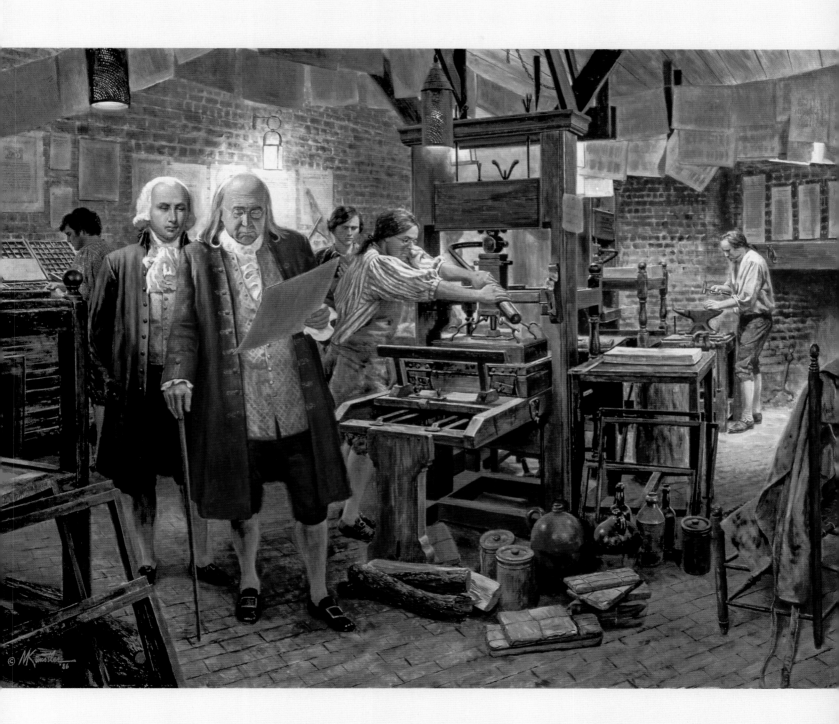

Washington's Inauguration
New York, April 30, 1789

GEORGE WASHINGTON WAS THE OBVIOUS choice for first president of the United States. The delegates who framed the Constitution had created the office with him in mind. Nevertheless, he did not enjoy the prospect of reentering public life so soon after leaving it. On April 16, he wrote in his diary: "I bade adieu to Mount Vernon, to private life, and to domestic felicity; and with a mind oppressed with more anxious and painful sensations than I have words to express, set out for New York . . . with the best dispositions to render service to my country in obedience to its call, but with less hope of answering its expectations."

Just after noon on April 30, Washington appeared on a balcony outside the Senate chamber at Federal Hall in New York, then the nation's capital. According to one Eliza Quincy, an eyewitness, he was "announced by universal shouts of joy and welcome. His appearance was most dignified and solemn. Advancing to the front of the balcony, he laid his hand on his heart, bowed several times, and then retreated to an arm-chair near the table." On this table was "a rich covering of red velvet; and upon this, on a crimson velvet cushion, lay a large and elegant Bible." He took the oath at one o'clock from Chancellor Robert R. Livingston of New York; Washington's secretary, Tobias Lear, noted that "the moment the chancellor proclaimed him president of the United States, the air was rent by repeated shouts and huzzas—'God bless our Washington! Long live our beloved President!'" Representative Fisher Ames of Massachusetts wrote that "it was a very touching scene, and quite of the solemn kind. His aspect grave, almost to sadness; his modesty, actually shaking; his voice deep, a little tremulous, and so low as to call for close attention." The world, Washington knew, was watching.

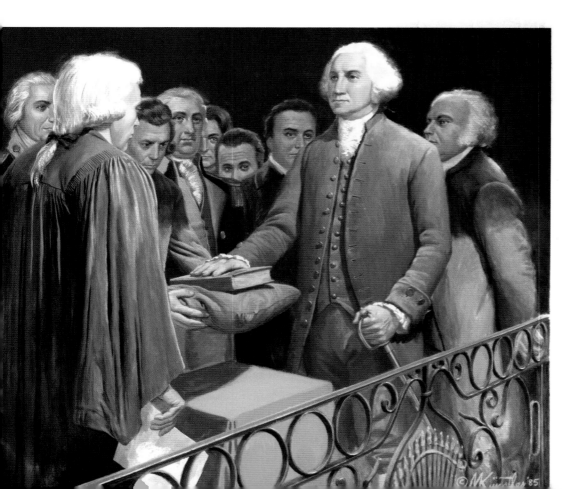

Opposite: *Washington Delivering His Inaugural Address April 30 1789, in the Old City Hall, New-York,* painted by T. H. Matteson; engraved by H. S. Sadd, 1849.

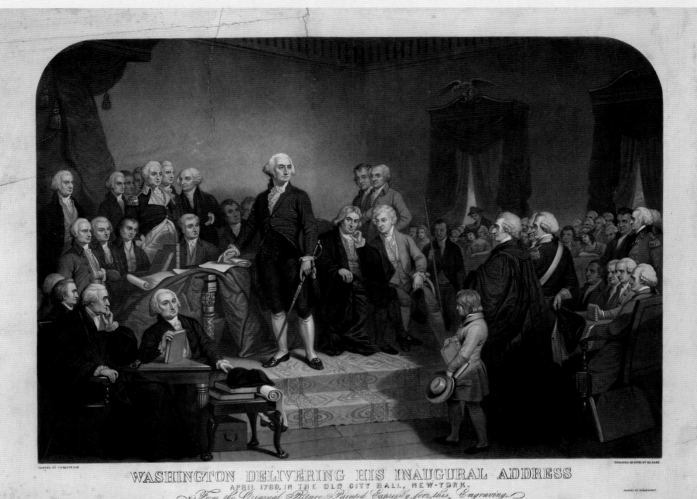

WASHINGTON DELIVERING HIS INAUGURAL ADDRESS
APRIL 1789, IN THE OLD CITY HALL, NEW-YORK.
From the Original Picture Painted Expressly for this Engraving
Published by John Noble

"It was *a very touching scene,* and quite *of the solemn kind.* His aspect grave, almost to sadness; his modesty, actually shaking; *his voice deep, a little tremulous,* and so low as to *call for close attention.*"

~Representative Fisher Ames of Massachusetts

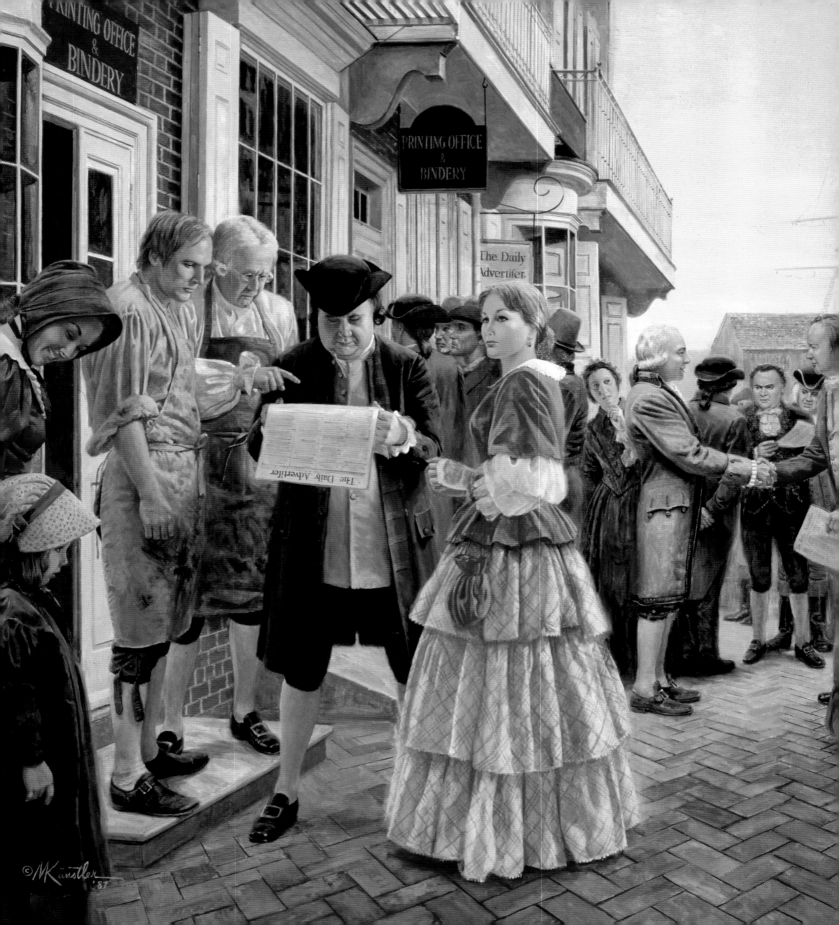

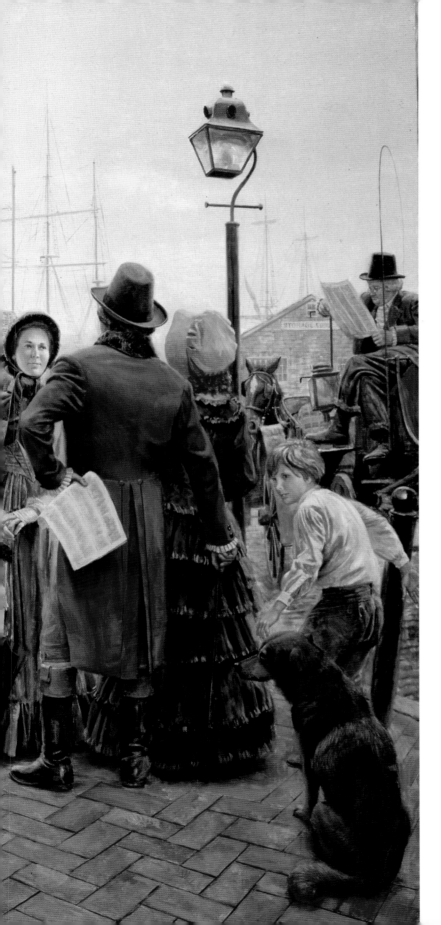

The First Amendment
New York, June 1789

AFTER HIS INAUGURATION, WASHINGTON proceeded to develop the office of the president of the United States. But it was up to other men to put the finishing touches on the form of government. As framed in Philadelphia, the Constitution had not included a Bill of Rights— even though Virginia had adopted one as early as 1776. As the states considered ratification, however, many Americans argued that specific guarantees of specific rights were necessary to secure their liberty under the new dispensation. "A bill of rights is what the people are entitled to against every government," said Thomas Jefferson, "and what no just government should refuse." James Madison concurred, and in 1789 introduced a draft Bill of Rights containing twelve articles. His speech of June 8 in the House of Representatives introducing the Bill of Rights was published four days later by the *Daily Advertiser* on Water Street in New York City. Among his arguments in support of it was the absolute necessity for "freedom of press and of conscience." American citizens read about the Bill of Rights through the medium of the very free press that Madison advocated in the First Amendment, and engaged in public debate. As the Founders had hoped and envisaged, democracy swung into action.

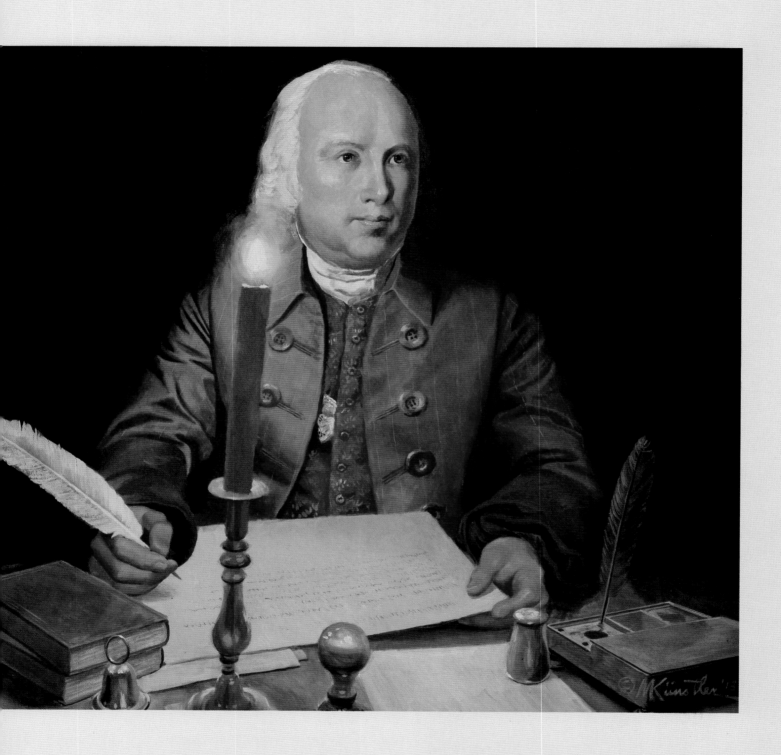

"My own opinion has always been in favor of a bill of rights. . . . In our Governments, the real power lies in the majority of the Community, and the invasion of private rights is chiefly to be apprehended."

~James Madison, in a letter to
Thomas Jefferson, October 17, 1788

Madison and the Bill of Rights, 1791

New York, June 1789

JAMES MADISON'S CAMPAIGN FOR A BILL OF Rights cemented his reputation as one of the most important founding fathers of the United States. Though suspicious, like his friend Thomas Jefferson, of government overreach, he proved a guiding inspiration for the creation of a constitution that assured stability. So did his long battle for ratification. In his drafting of the Bill of Rights, Madison ensured that basic liberties would never fall victim to the tyranny either of government power or of public opinion. "My own opinion has always been in favor of a bill of rights," he told Jefferson. "Wherever the real power in a Government lies, there is the danger of oppression. In our Governments, the real power lies in the majority of the Community, and the invasion of private rights is chiefly to be apprehended . . . from acts in which the Government is the mere instrument of the major number of the constituents." Madison's Bill of Rights also established a system of constitutional amendment that assured future flexibility of government according to changing circumstances without contravening the basic premises of the founders. Congress formally proposed Madison's draft Bill of Rights by a joint resolution on September 25, 1789, and ratification of ten of the twelve articles was won on December 15, 1791.

"*Were it* **left to me to decide** *whether we should have a government without newspapers or* **newspapers without a government,** *I should not hesitate a moment to* **prefer the latter.**"

~Thomas Jefferson, in a letter to Virginia delegate Edward Carrington, January 16, 1787

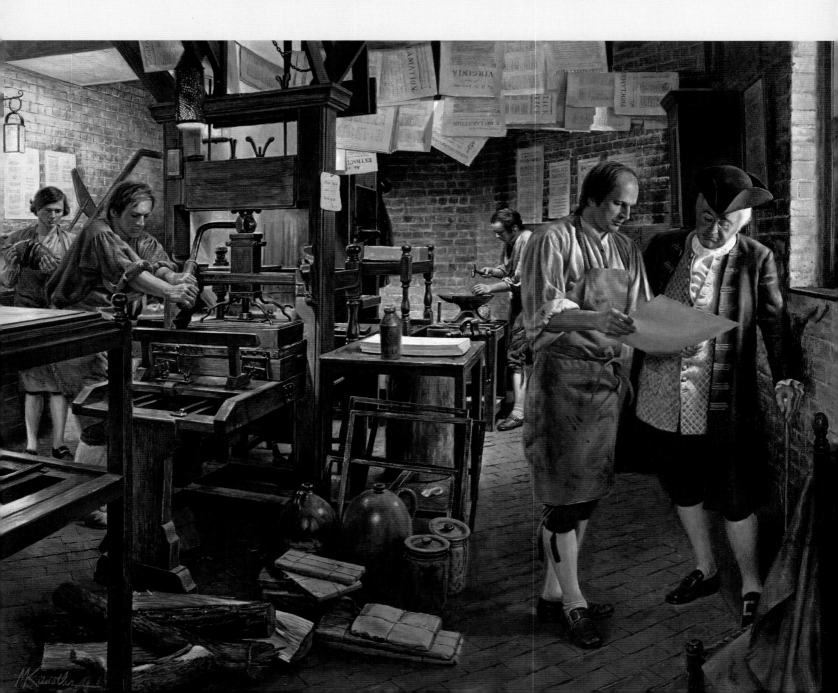

Freedom of the Press

Ratification of the Bill of Rights, December 15, 1791
(*opposite*)

ALTHOUGH ALL TEN OF THE AMENDMENTS TO the Constitution in the Bill of Rights had broad repercussions, the first was among the most important for its provision that "Congress shall make no law abridging the freedom of speech or of the press." These were not freedoms that any country could, or can, take for granted. Even in Great Britain—the most democratic country in the world before the American Revolution—the government routinely cracked down on journalists who presumed to criticize the king or Parliament. In other nations, freedom of speech and freedom of the press were never considered elementary rights. But in America, these freedoms had been at the very roots of the rebellion against British rule and the establishment of a democratic form of government.

Freedom of the press had no more passionate defender than Thomas Jefferson. "Our liberty cannot be guarded," he declared, "but by freedom of the press." In his view, the right was so fundamental that life was inconceivable without it. "Were it left to me to decide whether we should have a government without newspapers or newspapers without a government, I should not hesitate a moment to prefer the latter." George Washington too supported freedom of the press—even when it hurt. In 1796, when Jefferson's friends in the radical press attacked the president with scurrilous accusations of misconduct and even reprinted forged letters to undermine his reputation, Washington neither uttered a word of protest nor lifted a finger to stop them. His restraint helped establish the rights in which both he and his opponents believed.

Thomas Jefferson, Gilbert Stuart, ca. 1821

CHAPTER NINE

A New Nation

"A combination of circumstances, and events, seems to have rendered my embarking again on the ocean of publick affairs, inevitable. . . . For the rectitude of my intentions I appeal to the Great Searcher of hearts——and if I know myself, I can declare, that no prospects however flattering—— no personal advantage however great——no desire of fame however easily it might be acquired, could induce me to quit the private walks of life at my age and in my situation. But if, by any exertion, or services of mine, my Country can be benefitted, I shall feel more amply compensated for the sacrifices which I make, than I possibly could be by any other means."

— GEORGE WASHINGTON TO J. HECTOR ST. JOHN
DE CRÈVECOEUR, FRENCH AMERICAN
AUTHOR AND FRENCH CONSUL, APRIL 10, 1789

WASHINGTON'S EIGHT YEARS AS president were no joyride. From 1789 to 1797 he was probably more miserable than at any time in his life. Although he hoped idealistically that men would continue to work together whatever their differences, supporters of Thomas Jefferson and Alexander Hamilton split into violently competing factions. Washington, whose sympathies lay largely with Hamilton, tried but ultimately failed to stand above the controversy between his two talented colleagues. During his last years in office, Washington found himself in the unprecedented role of being cast as a villain and savagely excoriated by a large portion of the country: the Jeffersonians. The greatest triumph of the young United States is that it was able to contain this controversy within the context of a strong and democratic government.

Meanwhile, the French Revolution of 1789, which most Americans had welcomed, became a bloodbath as men like Robespierre sent tens of thousands to the guillotine. Events in France sparked fervent debate in America as citizens wondered whether the pursuit of liberty must inevitably lead to civil discord. The debate would continue for decades, but without Washington, who finally bowed out of public life at the conclusion of his presidency. His final years at Mount Vernon gave him a brief glimpse of that peace in tilling the land he had always sought throughout his years of service to his country. He passed away on December 14, 1799, with a sense of quiet acceptance, combined with hope for the future of the country he had done so much to create.

The United States now turned to men like John Adams, Alexander Hamilton, Thomas Jefferson, and James Madison to see it into the new century. None of these men were soldiers, but they were filled with ideas. Their visions for the future of their country often competed—but the brilliance of the democratic system they had created ensured that Americans would benefit from the best they had to offer while not suffering long from their missteps. While Hamilton played an important role in establishing the American economy on a firm basis and thus developing the resources for future growth, Jefferson gave momentum to the vision of a nation that would reach from ocean to ocean.

"*Government is set at defiance,* the contest being whether *a small portion* of the United States *shall dictate to the whole union,* and at the expence of those who desire peace, indulge a *desperate ambition.*"

~George Washington, Proclamation of September 25, 1794

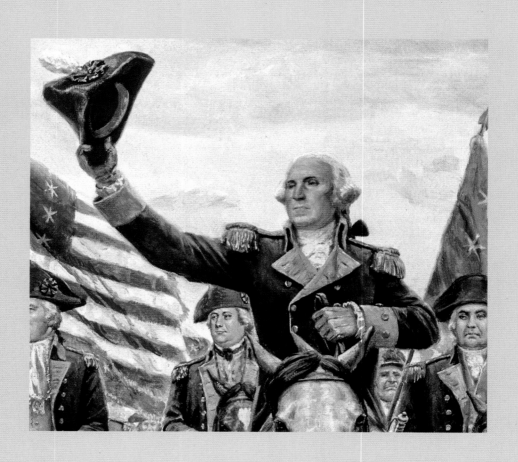

Washington at Carlisle, 1794
Carlisle, Pennsylvania, October 4, 1794 (*detail, opposite, and following pages*)

GEORGE WASHINGTON'S FEAR OF CIVIL DISCORD AND UNREST had helped motivate him to attend and then preside over the Constitutional Convention in May 1787. In the winter of 1786–87, an anti-government rebellion that had been fomenting for months broke out in western Massachusetts under the leadership of Revolutionary War veteran Daniel Shays. While Shays' Rebellion was largely crushed before the Constitutional Convention was convened, many feared that this revolt would instigate further unrest across the continent and destroy the United States. "The flames of internal insurrection were ready to burst out in every quarter," said Representative James Wilson of Pennsylvania, "and from one end to the other of the continent, we walked on ashes, concealing fire beneath our feet." Horrified at the spectacle of rebellion so soon after independence had been won, Washington asked, "What stronger evidence can be given of the want of energy in our governments than these disorders? If there exists not a power to check them, what security has a man to life, liberty or property?" As president, he was determined to prevent anything of the sort from happening again.

In 1791, Congress imposed an excise tax on distilled spirits. Memories of the anti-tax protests of the early 1770s were still strong, and in a similar spirit many farmers in western Pennsylvania opposed the new tax. In the summer of 1794 their resistance sprang into open rebellion as farmers assaulted government agents trying to crack down on illegal distilleries. Washington worked to find a peaceful solution to the so-called Whiskey Rebellion, but as unrest showed signs of spreading to other states, he proclaimed that "Government is set at defiance, the contest being whether a small portion of the United States shall dictate to the whole union, and at the expence of those who desire peace, indulge a desperate ambition." To the shock of many Americans, Washington not only decided to call out the militia to put down the rebellion, but chose to lead the troops in person. To this day, he remains the only sitting president to have marched at the head of an army. He arrived in Carlisle on October 4, 1794, and reviewed the troops. Afterward he was feted by the citizens at the courthouse under slogans reading "Washington is Ever Triumphant"; "The Reign of the Laws"; and "Woe to Anarchists." He turned the army over to Alexander Hamilton before it marched into western Pennsylvania, where the rebellion dispersed with hardly a shot being fired.

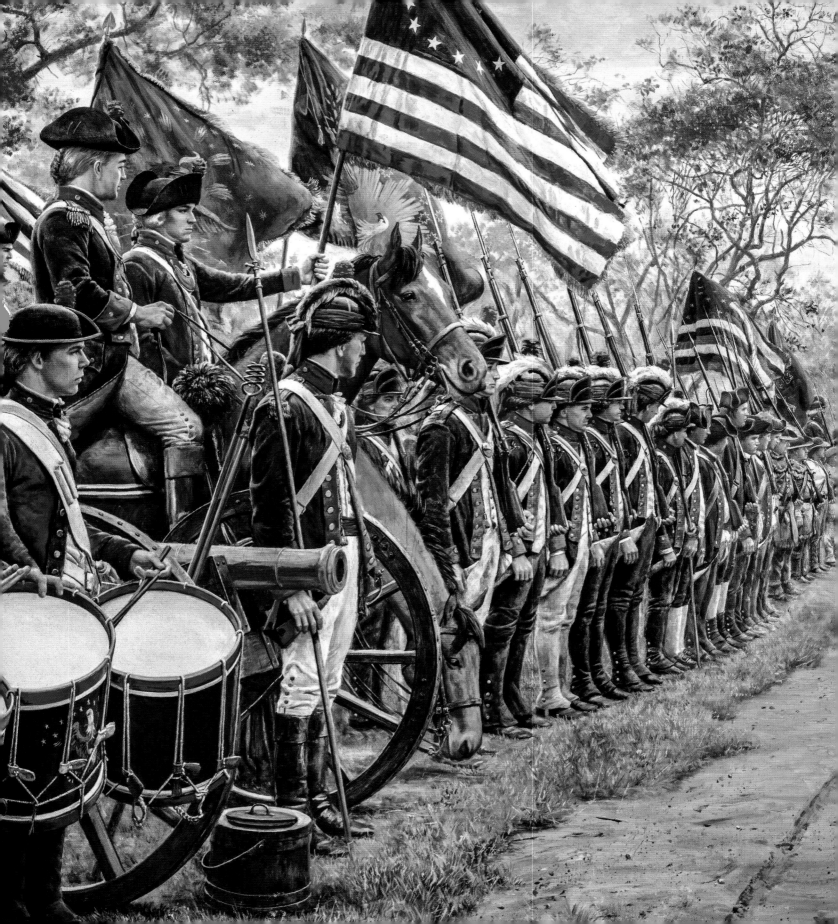

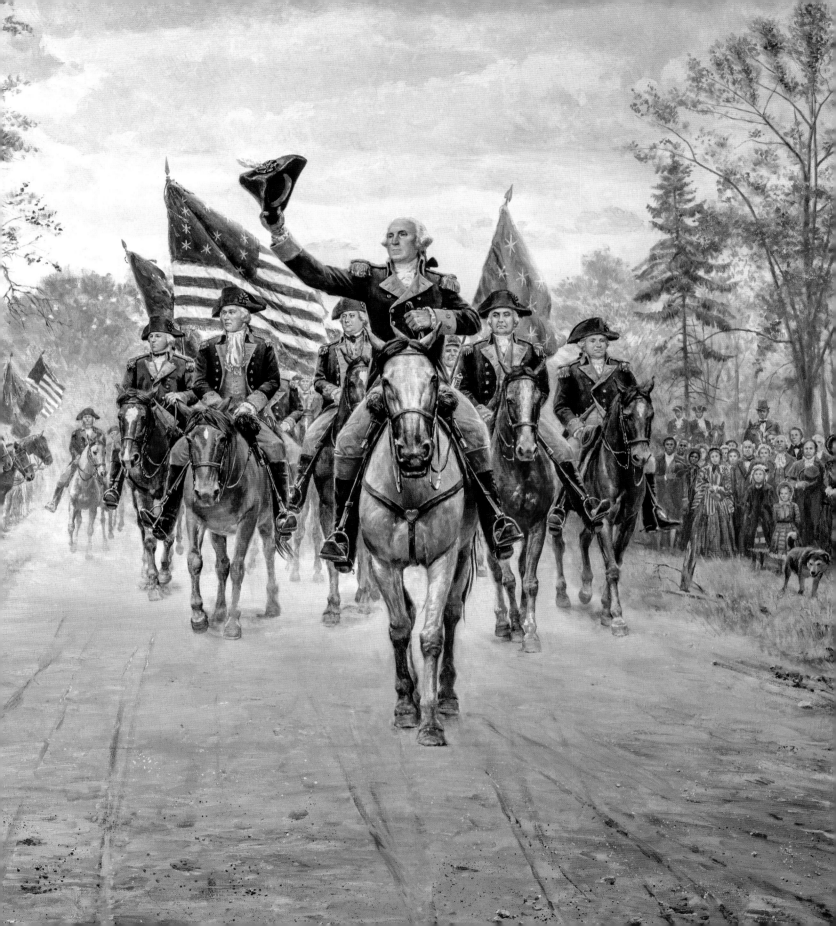

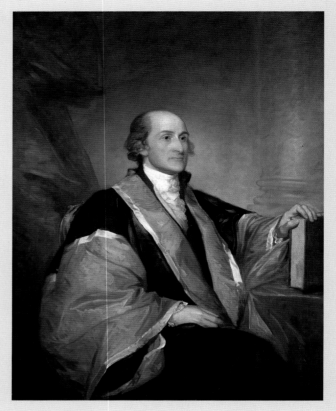

Portrait of John Jay, Gilbert Stuart, 1794

Negotiating the Jay Treaty
London, November 1794

THE FRENCH REVOLUTION OF 1789 DIVIDED
Europe and engulfed the world in almost three decades
of war. In time, it would also transform politics in the
United States. At first, most Americans agreed that the
overthrow of King Louis XVI and the apparent estab-
lishment of democratic rule in France was a good thing
that boded well for the United States. As the revolution
descended into the Reign of Terror after 1793, however,
Washington drew back in disgust from the violence and
bloodshed, even as Jefferson and his friends defended it
as a necessary step on the march toward liberty. Wash-
ington declared neutrality in the burgeoning contest
between Great Britain and France; his Farewell Address
of 1796 would provide the maxim that "the great rule of
conduct for us in regard to foreign nations is . . . to have
with them as little political connection as possible." Even
so, he thought it important to take steps toward normal-
izing relations with Great Britain, whose stable political
system he continued to admire. He accordingly sent
Chief Justice John Jay to London to negotiate a treaty
that, it was hoped, would settle some of the points of con-
tention remaining from the Revolutionary War.

Jay's long negotiations with the British resulted in
the signing of a treaty that declared an "inviolable and
universal peace"—commonly called the Jay Treaty—on
November 19, 1794. It decided several points, such as the
status of some western lands; and left others unsettled,
including the Royal Navy's practice of impressing Amer-
icans as sailors—that is, forcing them into service. In all,
it didn't amount to much. The treaty and its subsequent
approval by the Senate and President Washington in
the summer of 1795, however, infuriated Jefferson and
other French sympathizers across the United States.
For the first time, Washington was openly denounced
in speeches and in the press for "his cold, aloof, arro-
gant manner; his lack of intelligence and wisdom; and
his love of luxury and display." Thomas Paine, author of
the *Rights of Man,* cursed Washington as "treacherous"
and a "hypocrite." Washington and Hamilton broke all
ties with Jefferson and Madison. Their opposing camps
eventually developed into the so-called Federalists and
Republicans, progenitors of the two-party political
system in the United States. Washington's disgust with
the political fallout from the Jay Treaty was one of the
factors that convinced him to not seek a third term in
office after his second term as president expired on
March 4, 1797.

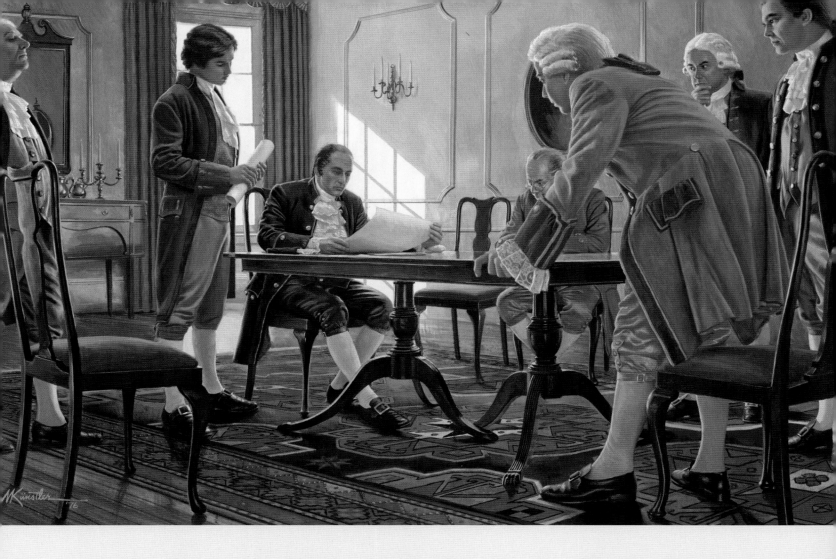

"There shall be a *firm, inviolable, and universal peace,* and a *true and sincere friendship* between his Britannic Majesty . . . and the United States of America."

~Article 1 of the Jay Treaty, November 19, 1794

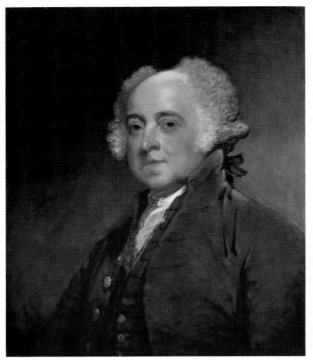

John Adams, Gilbert Stuart, ca. 1821

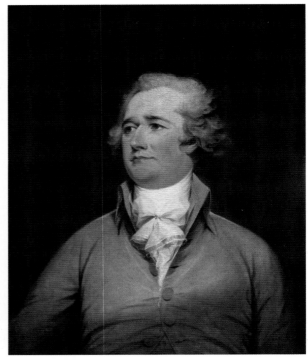

Alexander Hamilton, John Trumball, ca. 1792

Little Old New York
New York, September 1, 1799 (*opposite*)

ALTHOUGH POLITICAL AFFAIRS WERE UNSETTLED in the 1790s, the national economy continued to grow. The population doubled from 2.5 million just before the revolution to about 5 million in 1800. Cultivation spread rapidly across the land, and the first glimmerings of industrial development appeared as entrepreneurs experimented with new technologies in agriculture and manufacture. Helping to guide it all was a government under President George Washington, and then President John Adams (1797–1801) that was determined to exploit to the full its constitutional powers to guide the economy. Despite strong opposition from Thomas Jefferson and James Madison, Treasury Secretary Alexander Hamilton implemented his plan to reduce the national debt, create a national mint (1792), and establish the First Bank of the United States (1795). Jefferson denounced Hamilton's "corruption of the legislature" in appealing to what Jefferson regarded as personal greed, lamenting

that "with grief and shame it must be acknowledged . . . that even in this, the birth of our government, some members were found sordid enough to bend their duty to their interests, and to look after personal rather than public good." Whether because or in spite of Hamilton's policies, a well-developed system of banking and commerce began to flourish.

By the end of the decade, New York City needed a new water supply system. The state legislature accordingly chartered the Manhattan Company, founded by Aaron Burr, on April 2, 1799, in order to build it—and not incidentally to expand the state banking system. With the large excess funds from the water supply project, company directors elected to open an "office of discount and deposit." This office, the Bank of the Manhattan Company, officially opened at 40 Wall Street in New York on September 1, 1799. The bank survived until 1955, when it merged with Chase National Bank.

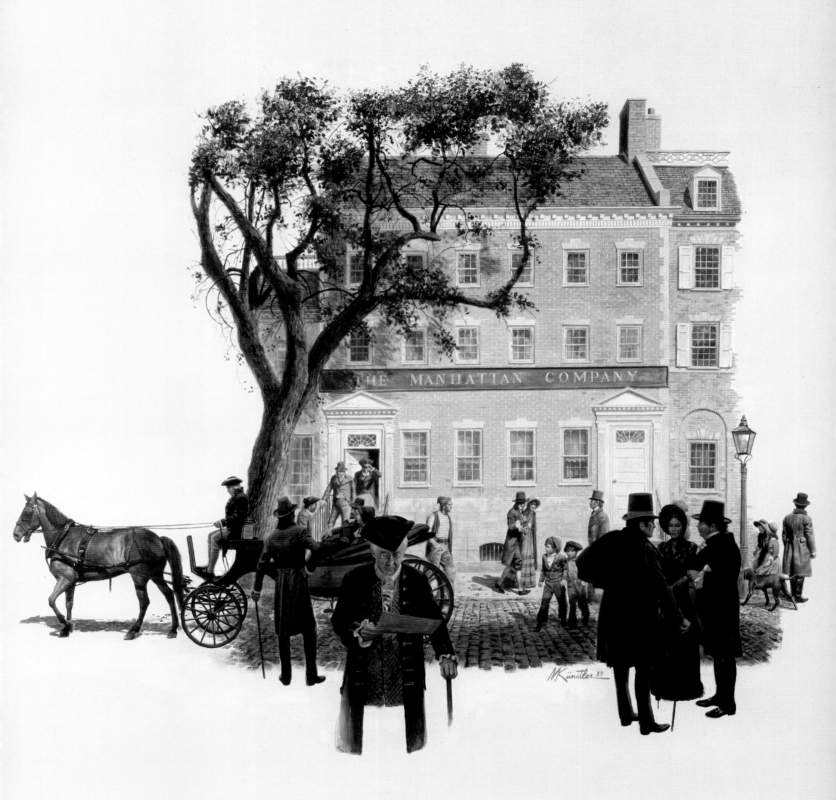

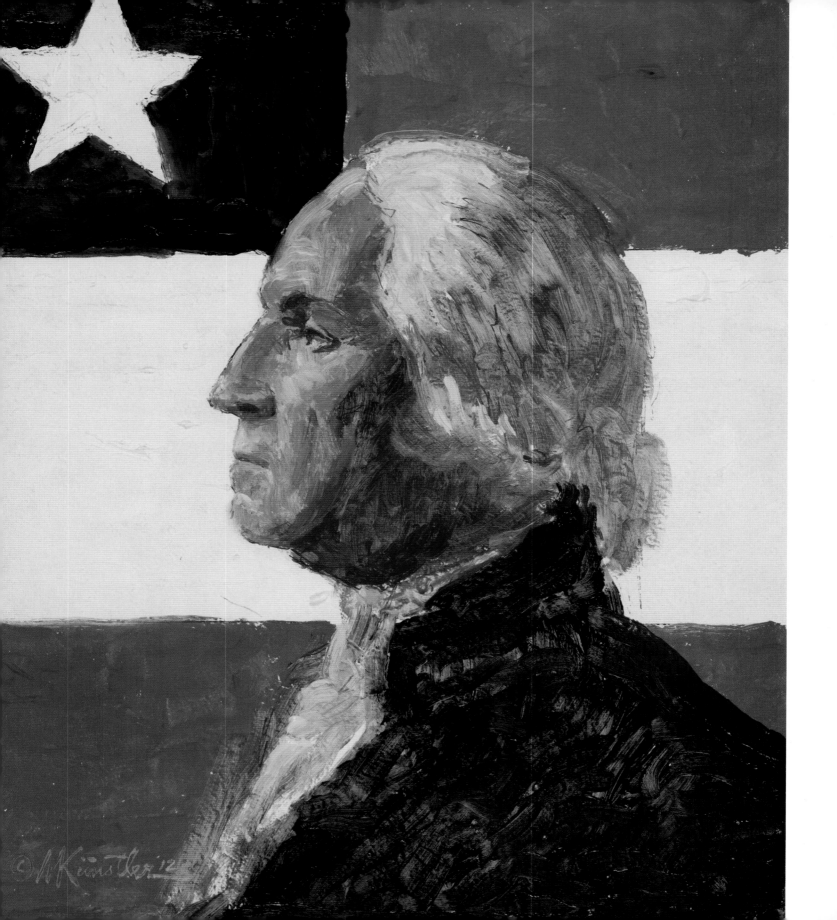

"To the memory of the man, first in war, first in peace, and first in the hearts of his countrymen."

~Henry Lee, Eulogy for George Washington, December 26, 1799

Washington Study

Mount Vernon, Virginia, December 14, 1799

AFTER HIS DEPARTURE FROM THE PRESIDENCY, GEORGE WASHINGTON retired to his estate at Mount Vernon, where he hoped finally to enjoy the "shade of my own vine and fig tree." But he never fully left public life. Members of President John Adams's cabinet continued to harass Washington with political affairs, and as American relations with France began deteriorating in 1798, Congress called him once more to take command of the army in case of a possible invasion from that country. For the most part, however, he spent his remaining months doing what he enjoyed most—farming.

Snow and hail pelted Mount Vernon on December 12, 1799, as Washington rode contentedly around his farms. He did not even notice the slush oozing down his collar until dinnertime, and by that time he decided that it was too late to change his clothes. That evening he sedately read the newspaper in the sitting room with Martha, and went to sleep as usual. He woke up in the morning with a sore throat, but rather than call for a doctor to treat his cold, he said he would "let it go as it came." Unfortunately, his condition worsened, and by the time he agreed to call a doctor that evening, his throat had nearly swollen shut. On the afternoon of December 14, after whispering final instructions to his family and secretary and expressing total resignation to his fate, Washington died peacefully in his bed at the age of sixty-seven.

Washington's death threw the country into anguish and mourning. Eulogists everywhere publicly lamented the loss of his guidance on the cusp of a new century. The greatest eulogist of them all, "Light Horse Harry" Lee, dubbed the fallen hero "first in war, first in peace, and first in the hearts of his countrymen." More than any other man, George Washington had brought the new nation into being. In some way, his spirit would remain with the United States as it faced the challenges ahead.

"This little event, of France's possessing herself of Louisiana, is the embryo of a tornado which will burst on the countries on both sides of the Atlantic, and involve in its effects their highest destinies."

~Thomas Jefferson, in a letter to French economist
Pierre Samuel du Pont de Nemours, April 25, 1802

The Louisiana Purchase
New Orleans, December 20, 1803

THOMAS JEFFERSON BECAME THE THIRD president of the United States on March 4, 1801. His earlier support for the French Revolution, strong opposition to the pro-British policies of Washington and John Adams, and condemnation of the Jay Treaty seemed to herald new amity in Franco-American relations. But there was a new leader in France, the emperor Napoleon Bonaparte. His campaign for dominance in Europe and perhaps the world left many Americans worried about his intentions in North America. In 1802, learning that Spain was planning to hand over its vast Louisiana Territory to France, Jefferson wrote that "[t]his little event, of France's possessing herself of Louisiana, is the embryo of a tornado which will burst on the countries on both sides of the Atlantic, and involve in its effects their highest destinies." With two vast warring empires—France and Great Britain—ensconced respectively in Louisiana and Canada, the United States seemed doomed to be situated between hammer and anvil, and

possible destruction. The Mississippi River was also increasingly vital to American trade, while French control of Louisiana seemed likely at the very least to block any future prospects for American westward expansion.

Jefferson sent Madison and James Monroe to Paris to negotiate a deal with the French to acquire the Louisiana Territory. Fortunately, they found Napoleon willing to talk. Preoccupied with his expensive campaigns in Europe, he had no desire for overseas distractions. For only $15 million, he agreed to turn over the huge Louisiana Territory—about 827,000 square miles—to the United States (in 2014 this would be equivalent to approximately $290 million, or $350 per square mile). Spain formally ceded territory to France on November 30, 1803. Only three weeks later, on December 20, France sold Louisiana to the United States. As the Stars and Stripes rose over the Place d'Armes (present-day Jackson Square) in New Orleans, the United States had doubled its territory and opened the road to continental power.

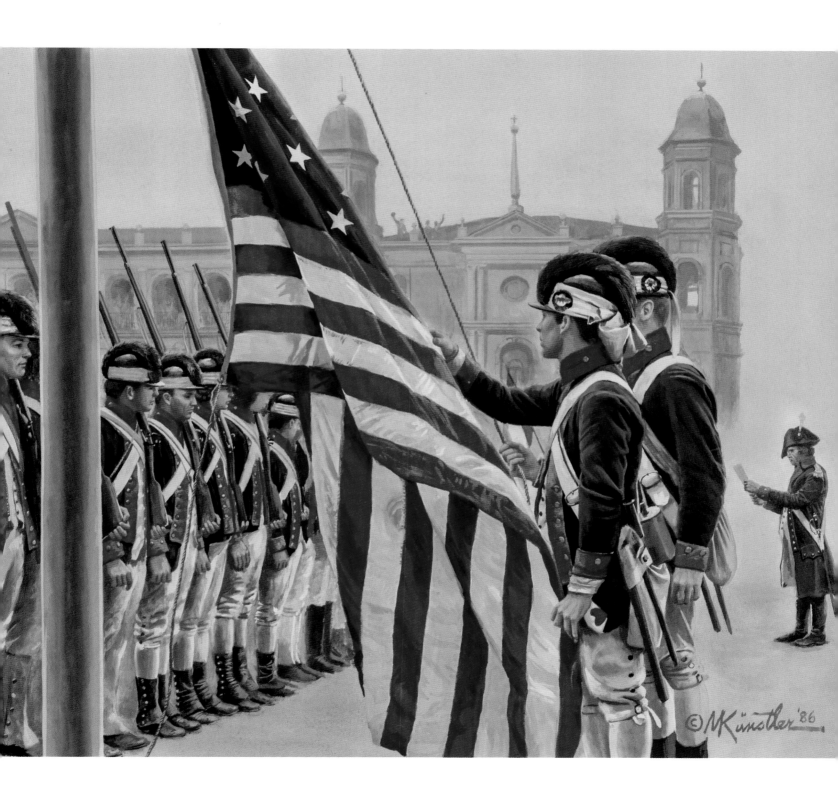

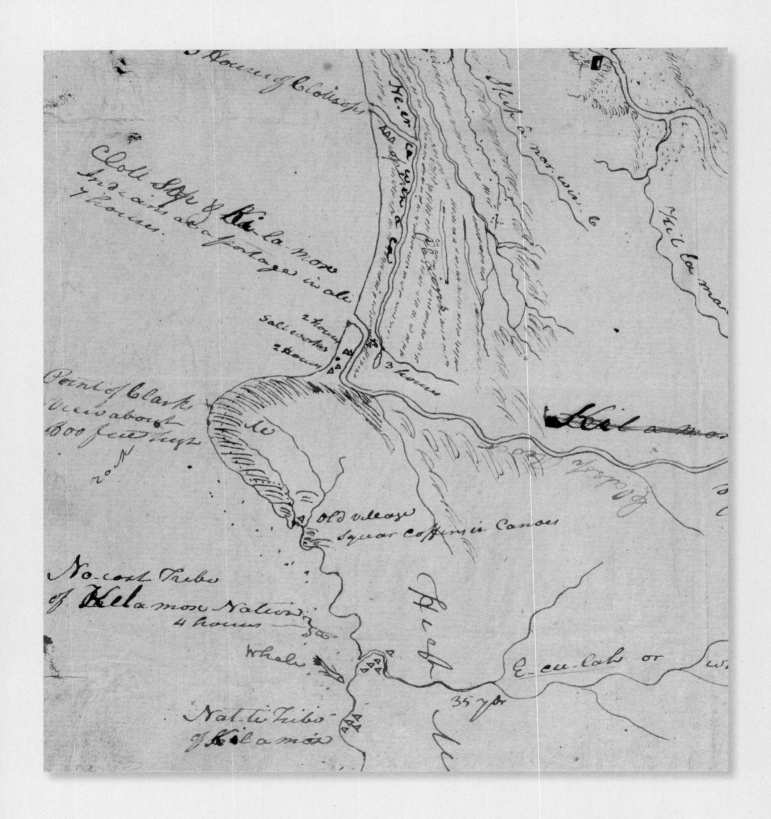

Meriwether Lewis, Charles Balthazar
Julien Févret de Saint-Mémin, ca. 1807

William Clark, Charles Balthazar
Julien Févret de Saint-Mémin, ca. 1807

Opposite: *Area of the Mouth of the Columbia River, Southern Side*
[detail], hand-drawn map by Lewis Clark, ca. 1806.

Lewis and Clark

Columbia River, November 1805 (*following pages*)

EVEN BEFORE THE LOUISIANA PURCHASE WAS completed, Jefferson sent a confidential message to Congress on January 18, 1803, with a proposal to send an expedition across that territory and beyond, even to the far reaches of the continent. "An intelligent officer," he wrote, "with ten or twelve chosen men, fit for the enterprise, and willing to undertake it . . . might explore the whole line, even to the Western Ocean, have conferences with the natives on the subject of commercial intercourse, get admission among them for our traders, as others are admitted, agree on convenient deposits for an interchange of articles, and return with the information acquired, in the course of two summers." He asked for an appropriation from Congress of $2,500; the delegates agreed, and the Corps of Discovery expedition was born.

The journey of Captain Meriwether Lewis and Lieutenant William Clark is one of the epic stories of the United States. Their small expedition left St. Charles, Missouri, on May 21, 1804. Traversing a vast expanse of some four thousand miles, they took careful records of geology, climate, flora and fauna, and the culture of the Native American tribes they encountered. They also endured incredible hardships. Had it not been for the friendly assistance of Native American tribes, the Corps of Discovery might well have perished. As the intrepid explorers journeyed down the Columbia River through the Cascade Range of the Rocky Mountains, they anticipated day by day their first view of the Pacific. Finally, on November 7, 1805, Clark wrote in his journal: "Ocean in view! O! the joy." Unfortunately, they had not sighted the Pacific but the estuary of the Columbia—about twenty miles from the actual coast. Within several days, however, Lewis and Clark finally reached the Pacific. With their journey, they had cast the first thread in the tapestry of the continental United States of America.

"*An intelligent officer,* with ten or twelve chosen men . . . *might* *explore the whole line,* even to the Western Ocean. . . . *While other civilized nations have* *encountered great expense to enlarge* *the boundaries of knowledge . . .* **our nation seems to owe to** **the same object,** *as well as* *to its own interests, to explore this,* *the only line of easy communication* **across the continent."**

~Thomas Jefferson,
message to Congress,
January 18, 1803

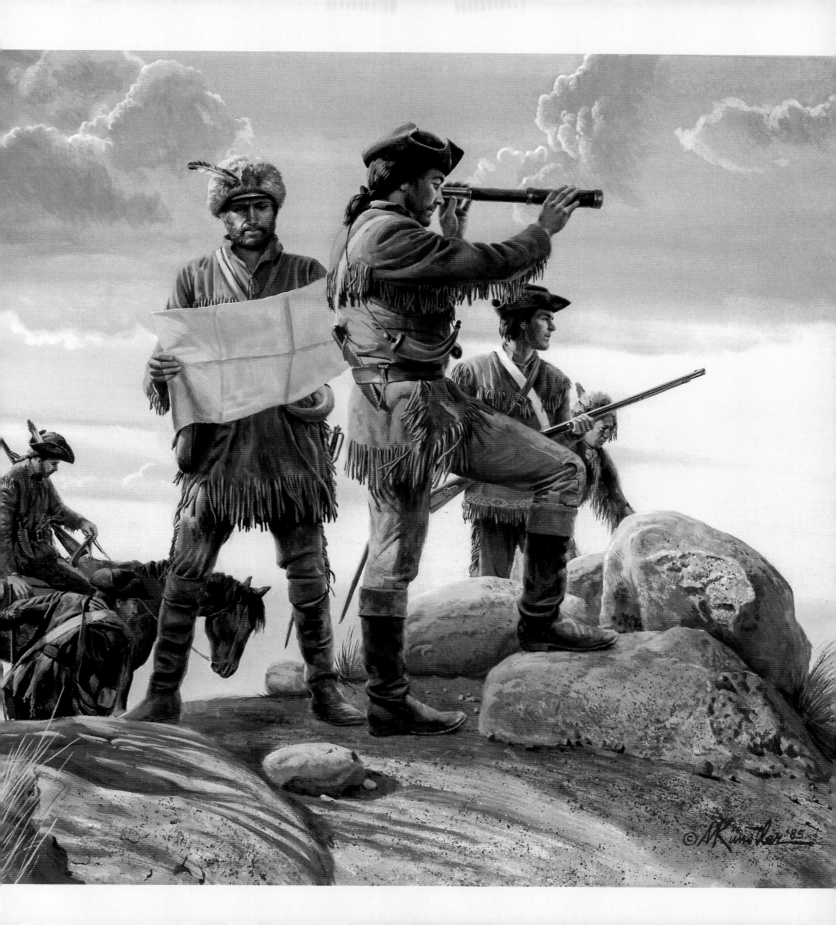

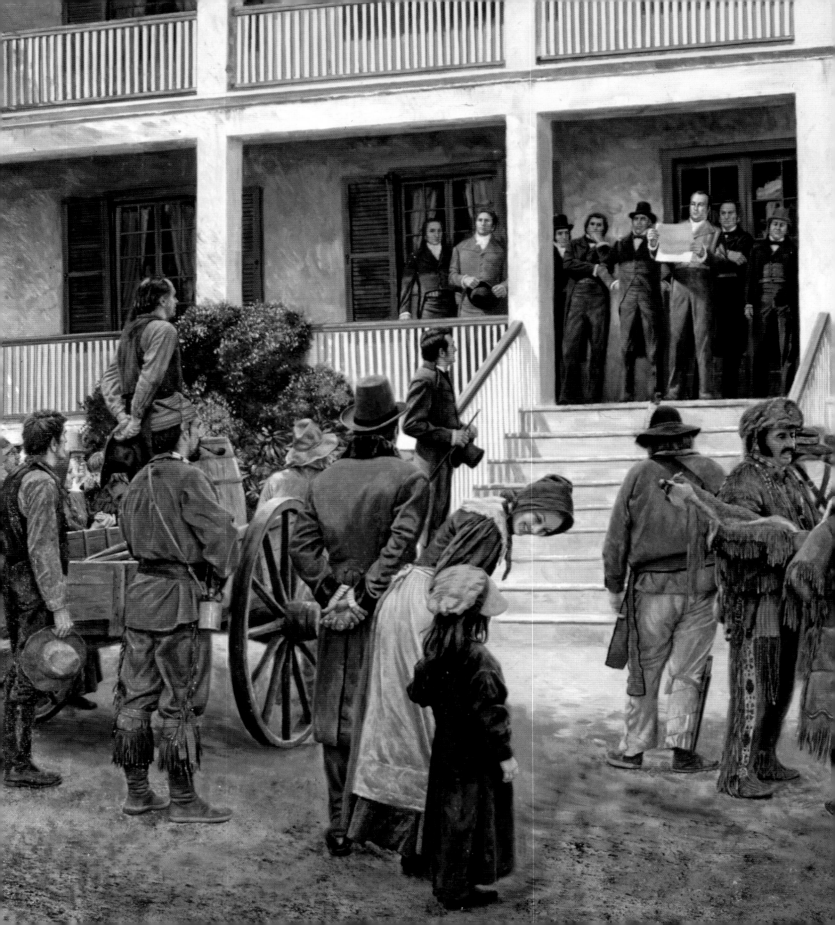

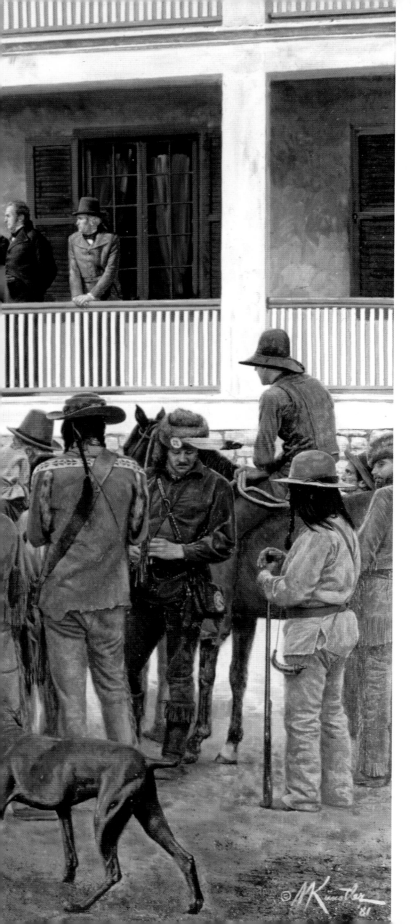

The First Bank Charter of Missouri
Announcing the Charter, St. Louis,
August 21, 1813

LEWIS AND CLARK HAD PAVED THE WAY. Millions would follow. In the first decades of the young nineteenth century, Americans began building the framework for society, economy, and government in the new western territories. Just before the Lewis and Clark expedition began, Captain Amos Stoddard, who had been commissioned as the first civil commandant of Upper Louisiana, arrived in St. Louis. There he found a town that "contains about 200 houses, mostly very large and built of stone; it is elevated and healthy, and the people are rich and hospitable; they live in style equal to those in the large seaport towns, and I find no want of education among them." St. Louis became the seat of the Louisiana Territory in 1805. From these humble beginnings would arise a great city, known in time as the "Gateway to the West."

On August 21, 1813, William Clark, then governor of the territory, participated in a ceremony to announce the first bank charter of Missouri. Presiding over the event was Auguste Chouteau, who read the charter from the front steps of his mansion. Chouteau represented the new brand of American entrepreneur. A native of New Orleans, he had sailed up the Mississippi River to Missouri, made his fortune in the fur trade, and become a founder of St. Louis. He would now head the commissioners of the new Bank of St. Louis. In hundreds of towns across the continent, events such as these heralded the coming of age of the United States.

CHAPTER TEN

The War of 1812

"It has become, indeed, sufficiently certain that the commerce of the United States is to be sacrificed, not as interfering with the belligerent rights of Great Britain; not as supplying the wants of her enemies, which she herself supplies; but as interfering with the monopoly which she covets for her own commerce and navigation. She carries on a war against the lawful commerce of a friend that she may the better carry on a commerce with an enemy——a commerce polluted by the forgeries and perjuries which are for the most part the only passports by which it can succeed."

— JAMES MADISON, WAR MESSAGE TO CONGRESS, JUNE 1, 1812

IN HIS INAUGURAL ADDRESS ON MARCH 4, 1801, Thomas Jefferson had spoken of his intention to pursue "peace, commerce, and honest friendship with all nations, entangling alliances with none." In truth, this was making a virtue of necessity. As a frail young democracy surrounded by empires, the United States could not afford to take sides in the continuing global conflict among the European juggernauts. The acquisition of the Louisiana Territory provided a modicum of safety and hope for expansion to the west, but the Atlantic United States—home to almost all of its major settlements—remained vulnerable to the threats and repercussions of war. As the nineteenth century progressed, Jefferson had his hands full managing conflicts with the Barbary pirates of North Africa, the depredations of the British Royal Navy, and the impact of the war between Great Britain and France on Atlantic commerce and trade. By the time James Madison became president of the United States in 1809, the Anglo-French conflict was at its height, and American involvement seemed increasingly inevitable.

As the year 1812 dawned, Great Britain and France had installed competing trade embargoes against each other, but only the British had the wherewithal to control the Atlantic. Even as American ships were prevented from trading with French-dominated continental Europe, the British navy ramped up its practice of impressing United States citizens as sailors. The British exacerbated these insults to American commerce and pride by offering open support to Native American attacks on the American Northwest frontier. An angry Congress goaded Madison to punish the British. On June 1, 1812, Madison addressed Congress, calling attention to "the spectacle of injuries and indignities which have been heaped on our country," and asking "whether the United States shall continue passive under these progressive usurpations and these accumulating wrongs, or, opposing force to force in defense of their national rights, shall commit a just cause into the hands of the Almighty Disposer of Events." Congress deliberated, and decided to declare war against Great Britain.

"I found that at the very moment when complete victory was in our hands, the Ardor *of the unengaged Troops had entirely* subsided. *I rode in all directions and* urged men by every Consideration *to pass over, but in vain."*

~General Stephen Van Rensselaer
of the New York Militia,
to General Henry Dearborn,
October 14, 1812

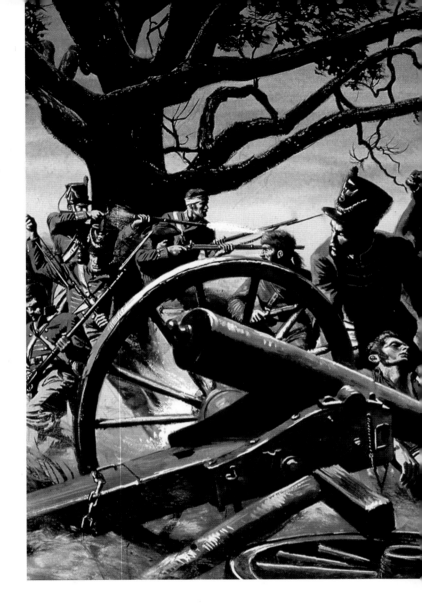

Surprise Attack, War of 1812
First Invasions of Canada, July–October, 1812

NEITHER SIDE WAS PREPARED FOR WAR. THE British were heavily engaged in the conflict in Europe. The Americans had no army or navy to speak of. The Revolutionary War had provided ample lessons on the weakness of the militia system, and George Washington had implored his countrymen to establish a strong standing army. Instead of heeding these warnings, Congress elected to depend almost exclusively on militia to prosecute the new war against Great Britain. Congress raised an army of 35,000 militiamen and endorsed an immediate invasion of Canada. Congressman John Randolph of Virginia, one of the few to remain adamantly opposed to the war, exclaimed: "We have heard but one word, like the whip-poor-will, but one eternal monotonous tone—Canada! Canada! Canada!" This obsession, and lack of preparation, would result in disaster.

On July 12, 1812, General William Hull had led an unsuccessful attempt to occupy the Canadian town

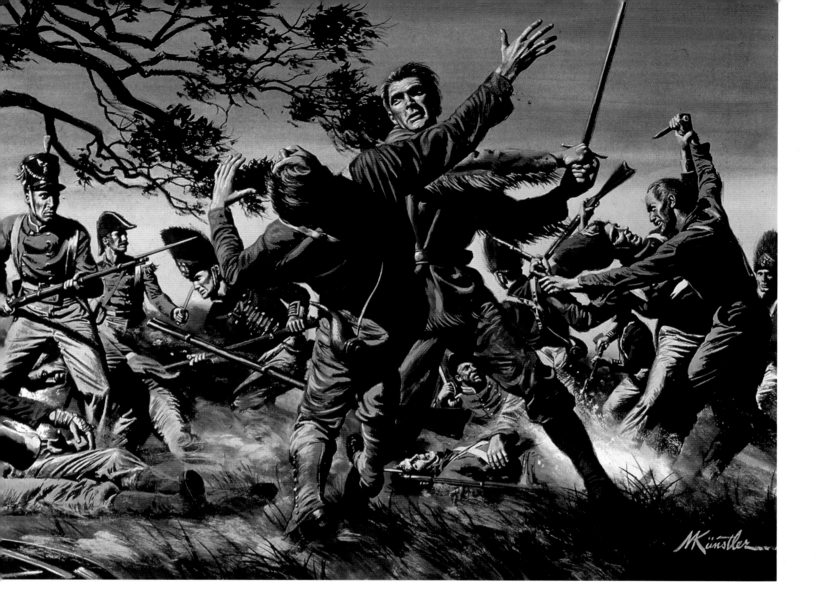

of Sandwich (part of present-day Windsor, Ontario) with 1,000 militiamen. Then, in early October, a force of more than 2,000 American militiamen and several hundred regulars under General Stephen Van Rensselaer tried to invade Canada by crossing the Niagara River. The regulars led the way across the river on the thirteenth, and quickly became involved in heavy combat with British soldier at the heights on the other side. General Van Rensselaer urged his large crowd of militiamen to cross the river and support the regulars, but they refused. "To my utter astonishment," the general reported, "I found that at the very moment when complete victory was in our hands, the Ardor of the unengaged Troops had entirely subsided. I rode in all directions and urged men by every Consideration to pass over, but in vain." While the militia stood by and watched, the British leisurely destroyed the better part of Van Rensselaer's army.

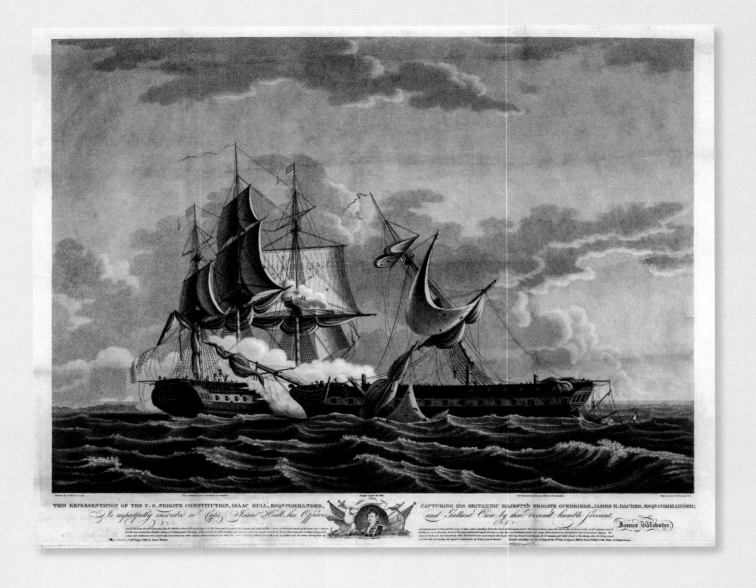

"There is a *Yankee frigate;*
in forty-five minutes she is certainly ours. *Take her in fifteen*
and I promise you *four months' pay.*"

~Captain James Richard Dacres of the HMS *Guerriere*

"Huzza, her sides are made of iron!"

~American sailor onboard the
USS *Constitution*, "Old Ironsides"

"Shall I Board Her, Sir?"

USS *Constitution* vs. HMS *Guerriere*, Atlantic Ocean off Nova Scotia, August 19, 1812
(following pages)

THE BRITISH NAVY VASTLY OUTNUMBERED ITS puny American counterpart. Once again it seemed, as in the Revolutionary War, that the United States would find itself entirely cut off by sea from the rest of the world. But the British did not anticipate men like Isaac Hull, captain of the 44-gun frigate USS *Constitution*. On August 19, 1812, about four hundred miles off coastal Nova Scotia, the *Constitution* encountered the 38-gun British frigate HMS *Guerriere*. Although slightly undergunned, the British were confident. "There is a Yankee frigate," James Richard Dacres, the British captain, told his sailors. "In forty-five minutes she is certainly ours. Take her in fifteen and I promise you four months' pay."

As close combat ensued, the British opened fire prematurely, and their cannon balls had little impact. Balls ricocheted off the *Constitution*, and an American sailor is said to have joyfully shouted, "Huzza, her sides are made of iron!" The ship would forever more be known by the nickname "Old Ironsides." Hull ordered his sailors to hold their fire until it could take effect, and as the British ship closed and the Americans opened up their guns, the effect was terrible indeed. In a matter of minutes, the *Guerriere* was almost totally demolished. "Huzza, my boys!" Hull shouted as he hustled about the deck. His sailors answered him with cheers and laughter—in equal parts because of the destruction of the *Guerriere* and the fact that their captain had unknowingly split the seam of his breeches. The fighting was nonetheless brutal on both sides. Lieutenant William S. Bush, who commanded the American marines tasked with boarding enemy vessels, leaped up, sword in hand, and turned toward Hull, shouting, "Shall I board her, sir?" At the next moment a British musket ball passed through his skull, killing him instantly. In the end, boarding proved unnecessary. With the scene on his deck a "perfect hell," the British captain struck his colors. "Ship for ship and crew for crew," wrote military historians R. Ernest Dupuy and Trevor Dupuy, "the superiority of American design, seamanship, and gunnery was proven."

Opposite: *This Representation of the* U.S. Frigate Constitution, *Isaac Hull, Esqr., Commander . . .* , painted by T. Birch, engraved by C. Tiebout, published in Philadelphia in 1813; the *Constitution*, in the background, fires on the wreckage of the HMS *Guerriere*, its last remaining mast falling.

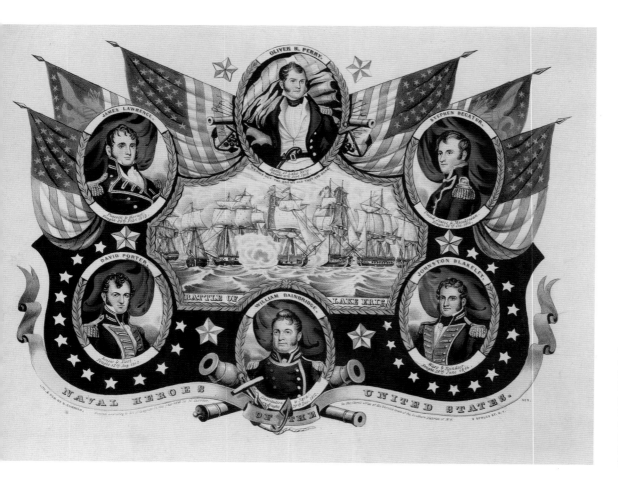

Naval Heroes of the United States, N. Currier, ca. 1846; this commemorative lithograph features portraits of noteworthy naval heroes from the War of 1812. Oliver H. Perry is featured at the top of the image, above a vignette of the battle of Lake Erie.

Perry Boards the *Niagara*

Battle of Lake Erie, September 10, 1813 (*opposite*)

DESPITE EARLY FAILURES, THE AMERICANS remained determined to conquer Canada. Through 1812 and 1813, fighting raged along the frontier. To a great extent, however, events on land depended on who maintained naval control on the Great Lakes. As on the Atlantic, the Americans had to make up for lost time. As the war began, the British maintained several vessels of war on the lakes against negligible American opposition. U.S. Commodore Isaac Chauncey supervised an immense building program that miraculously created substantial American flotillas on Lakes Ontario and Erie in time for combat in the pivotal summer of 1813.

On September 10, 1813, a British flotilla under Captain Robert Barclay approached the spanking new American flotilla on Lake Erie as it lay at anchor. Captain Oliver H. Perry went out to meet the British in his flagship, the brig USS *Lawrence*, but his vessel was quickly put out of action. Undaunted and under fire, Perry transferred by rowboat to the USS *Niagara* and resumed the battle. "If a victory is to be gained," he stolidly said, "I will gain it." The *Niagara* deftly broke the British line, and the remainder of Perry's flotilla engaged and shattered the enemy ships. The *Niagara* took on Barclay's flagship and won, forcing the entire British flotilla to surrender. It was the most stunning American naval victory of the war. "We have met the enemy," Perry reported, "and they are ours."

The Star-Spangled Banner, 1814

Fort McHenry, September 14, 1814

PERRY'S VICTORY ALLOWED THE AMERICAN forces fighting in the Northwest to recoup their early losses—including Detroit—but the contest for Canada ultimately ended in stalemate. On the Atlantic seaboard, meanwhile, the war was reaching its crisis. In August 1814, a British naval squadron put ashore more than five thousand British troops along the Patuxent River southeast of Washington, D.C. The seasoned British troops—veterans of the war with Napoleon—shattered an ill-trained force of militiamen at Bladensburg on August 24 and moved on to occupy and burn numerous public buildings, including the Capitol and the White House. Re-embarking, the British sailed north and attacked Baltimore. Here, however, things did not go their way.

As British land forces attacked the city defenses—unsuccessfully, as it turned out, thanks to stubborn American resistance—the British navy opened fire on Fort McHenry. This star fort, which dated from the turn of the century, was garrisoned by about one thousand men under Major George Armistead. The British bombardment began on September 13 and continued for just over twenty-four hours. Bombs, rockets, and carcass shells—a kind of incendiary device—rained on the fort all night and created a spectacular display. The fort endured. Inside, the defenders absorbed their casualties and waited for relief. As dawn broke, observers, including lawyer and aspiring poet Francis Scott Key, anxiously watched the fort. (Key, onboard a British troopship, had been on a diplomatic mission to negotiate the release of a friend who had been captured by the Royal Navy.) Had it surrendered? Or would the garrison hold, inspiring the Americans to fight on and raise new hope from the ashes of Washington, D.C.? The answer was immortalized in a poem Key wrote on the spot, "Defence of Fort M'Henry," which would be published soon after as "The Star-Spangled Banner." The lesser-known second stanza of the four-stanza poem—now the national anthem—follows:

On the shore, dimly seen through the mists of the deep,
Where the foe's haughty host in dread silence reposes,
What is that which the breeze, o'er the towering steep,
As it fitfully blows, half conceals, half discloses?
Now it catches the gleam of the mornings' first beam,
In full glory reflected now shines on the stream:
'Tis the star-spangled banner! O long may it wave
O'er the land of the free and the home of the brave!

In an act of defiance, the fort's defenders had raised the flag. The fight would go on.

The Lamplighter
American town, early nineteenth century

THE WAR OF 1812 WAS THE FINAL, DEFINING conflict in the creation of the United States. After Baltimore withstood the British assault on the city and Fort McHenry, peace negotiations led to the signing of the Treaty of Ghent on December 24, 1814. News of the treaty had not yet reached the United States when Andrew Jackson won an incredible victory against British redcoats at the Battle of New Orleans on January 8, 1815, putting a period to the conflict. Congress ratified the treaty on February 15, and the war came to an end. Neither side had gained anything from the conflict—Canada remained in British hands—but in time the main subjects of dispute, including impressment, would subside. At last, it seemed, the United States could grow in peace.

"Peace," of course, was relative. Native Americans knew no peace in the early nineteenth century as the Cherokee and other tribes faced extermination or exile from their ancestral lands. Soon the Mexican-American War would result in a massive expansion of the United States southwestward, and contribute to growing tensions over slavery that would lead to the bloody and catastrophic American Civil War. For many Americans, though, the new century presented new lights of hope for freedom, economic growth, and prosperity. The United States would no longer have to fight for independence from foreign domination. Americans could determine their own destiny.

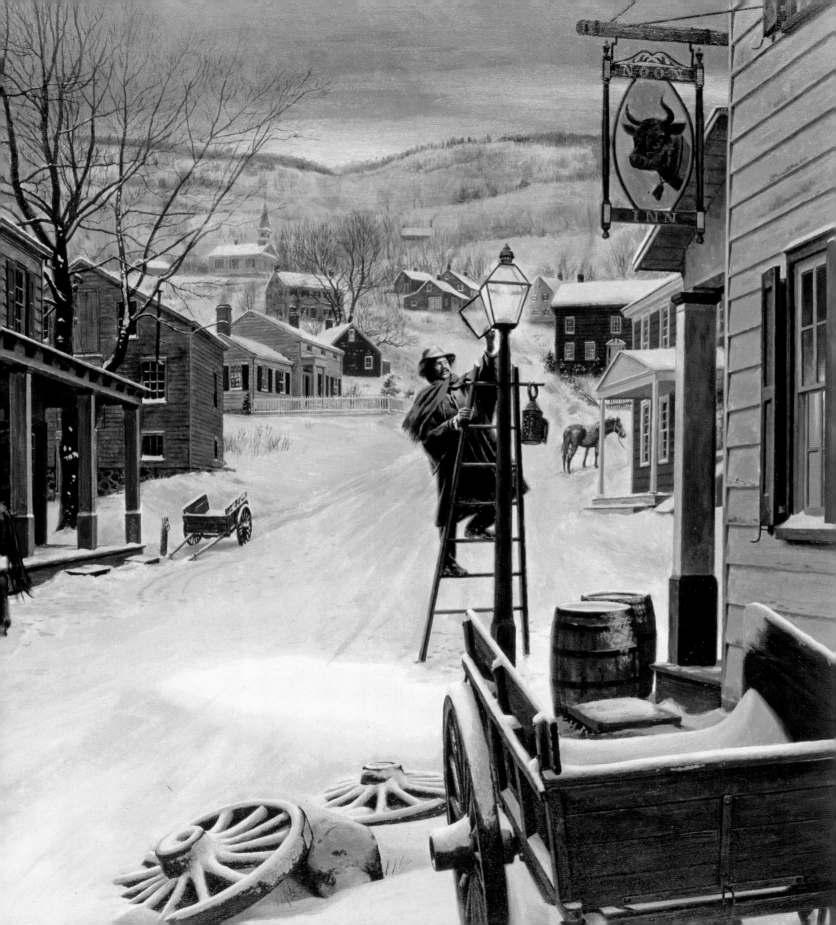

AFTERWORD

IT HAD BEEN A TREMENDOUS TWO HUNDRED years. From the landing at Jamestown in 1607 to the ratification of the Treaty of Ghent in 1815, North America had undergone a complete transformation. For Native Americans, change had been decidedly for the worse. Many of the Indian communities that had been vigorous when the first tanner in America set up shop had become extinct by the time Lewis and Clark embarked on their famous journey across the continent in 1804. The Corps of Discovery's explorations of the West heralded the future arrival of millions of settlers who would overwhelm and destroy traditional societies from Arizona to Montana, and from Missouri to California.

For many others, the achievements of exploration, settlement, revolution, and constitution brought only a hope for equality. During the same period that the original colonies were being settled and the United States was established, millions of Africans were forcibly taken from their homes and shipped as slaves to North America. Their children and grandchildren grew up in bondage. And while the Declaration of Independence promised that "all men are created equal," in practice they were not treated as such. When George Washington became president in 1789, the vast majority of his countrymen and women remained without the right to vote.

If the history of America from Jamestown to the War of 1812 taught anything, however, it was that good things come with time. The first settlers had little to offer at first except a willingness to work hard and a capacity to dream big. Struggling against enormous odds, they carved homes out of the wilderness and planted seeds that gave their children the resources to build a little more. As communities, towns, and cities appeared, the conviction grew that this new land must not just replicate the old. Americans sought not just prosperity, but a land unburdened by kings and wars. They hoped for something that no people on earth had ever achieved before: the freedom to speak, think, and live as they wished.

The cost of winning this freedom was high. At least 25,000 Americans died as a direct result of combat or disease during the Revolutionary War. Many more probably died indirectly as a result of hardships, such as famine and dislocation, that followed from the war. Perhaps another 15,000 Americans died in the War of 1812. And while these numbers seem small compared to the casualty tallies for the Civil War or World War II, the full toll of freedom should not be tallied only from wars. Many thousands of explorers, settlers, and others lost their lives during this period as a result of weather, physical hardships, disease, or Native American attacks. Each man or woman gave, in his or her own way, so that succeeding generations could be free.

George Washington anticipated some of the challenges that the country would face in later centuries. Writing to his friend Rev. William Gordon on July 8, 1783, about the troubles caused by political factionalism and self-interest, he quipped: "A hundred thousand men coming one after another cannot move a Ton weight—but the united strength of 50 would transport it with ease." All of the "blood & treasure" expended to secure independence, he continued, "has been lavished to little purpose, unless we can be better Cemented." What Washington would have thought about those times when political faction paralyzed the government's ability to function may well be envisioned. Now, as ever, he would have counseled Americans that they must be united in order to be free.

AMERICANS LIVING IN 1815 could not have imagined the trials that yet lay ahead before the United States of America could truly become secure, prosperous, and free. Fifty years later the nation would emerge half-ruined from a great Civil War that freed the slaves without entirely divesting them of their chains.

One hundred years later the United States—now straddling the continent coast to coast—would stand on the cusp of two massive world wars that threatened not just freedom in America, but across the globe. One hundred and fifty years after the end of the War of 1812, the nation stood on the brink of a tumultuous social revolution while mourning its first dead from war in a land that many of the founding fathers had probably never heard of.

Two hundred years after the day Commodore Perry announced, "We have met the enemy, and they are ours," the United States faces new enemies determined to destroy the dream of freedom that so many generations of Americans have struggled and fought to keep alive. Time will tell whether the same qualities that empowered the first Americans to overcome the challenges of their era will remain strong enough to carry future generations through the trials to come.

Detail of sketch for
Washington's Crossing

ENDNOTES

1. Abigail Adams I to Elizabeth Smith Shaw, March 4, 1786; Abigail Adams II to John Quincy Adams, January 2–24, 1786, Margaret A. Hogan and C. James Taylor et al., *The Adams Family Correspondence, January 1786–February 1787* (Cambridge, MA: Harvard University Press, 2005) 7:80–85, 402–7.

2. Joshua Reynolds, *Discourses on Art* (1778; ed. Robert Lavine, New York: Collier Books, 1961), 57–58, 66–67, 80–81.

3. James I. Robertson Jr., *For Us the Living: The Civil War in Paintings and Eyewitness Accounts* (New York: Sterling Publishing, 2010), xii.

BIBLIOGRAPHY

Abbot, W. W., et al., eds. *The Papers of George Washington*. 5 series, 66 vols. to date. Charlottesville: University of Virginia Press, 1983–.

Adair, James, and Kathryn E. Holland Braund, eds. *The History of the American Indians*. London: Edward and Charles Dilly, 1775.

Arnade, Charles W. *The Siege of St. Augustine in 1702*. Gainesville: University of Florida Press, 1959.

Borneman, Walter R. *1812: The War That Forged a Nation*. New York: HarperCollins, 2004.

Boyd, Mark F., trans. "The Siege of Saint Augustine by Governor Moore of South Carolina in 1702 as Reported to the King of Spain by Don Joseph De Zúñiga y Zerda, Governor of Florida." *Florida Historical Quarterly* 26, no. 4 (April 1948), 345–52.

Brumwell, Stephen. *White Devil: An Epic Story of Revenge from the Savage War That Inspired* The Last of the Mohicans. London: Weidenfeld & Nicolson, 2004.

Budiansky, Stephen. *Perilous Fight: America's Intrepid War with Britain on the High Seas, 1812–1815*. New York: Knopf, 2011.

Commager, Henry Steele, and Richard B. Morris, eds. *The Spirit of 'Seventy-Six: The Story of the American Revolution as Told by Participants*. New York: Harper & Row, 1967.

Cook, S. F. *The Aboriginal Population of Alameda and Contra Costa Counties, California*. Berkeley: University of California Press, 1957.

Díaz, Bernal. *The Conquest of New Spain*. Translated by J. M. Cohen. London: Penguin, 1963.

Dupuy, R. Ernest, and Trevor N. Dupuy. *The Encyclopedia of Military History, from 3500 B.C. to the Present*. New York: Harper & Row, 1970.

Ewald, Johann, and Joseph P. Tustin, eds. *Diary of the American War: A Hessian Journal*. New Haven: Yale University Press, 1979.

Fischer, David Hackett. *Washington's Crossing*. New York: Oxford University Press, 2004.

Founders Online. *Correspondence and Other Writings of Six Major Shapers of the United States*. National Archives. http://founders.archives.gov.

Gomez-Galisteo, M. Carmen. *Early Visions and Representations of America: Álvar Núñez Cabeza de Vaca's* Naufragios *and William Bradford's* Of Plymouth Plantation. New York: Bloomsbury Academic, 2013.

Horn, James. *A Land as God Made It: Jamestown and the Birth of America*. New York: Basic Books, 2005.

Horne, Field, ed. *The Diary of Mary Cooper: Life on a Long Island Farm 1768–1773*. New York: Oyster Bay Historical Society, 1981.

Hough, Franklin B., ed. *Journals of Major Robert Rogers: Containing an Account of the Several Excursions He Made Under the Generals Who Commanded upon the Continent of North America, During the Late War*. Albany, NY: Joel Munsell, 1883.

Kukla, John. "Patrick Henry." *Encyclopedia Virginia*. http://encyclopediavirginia.org/Henry_Patrick_1736-1799.

Lengel, Edward G., ed. *A Companion to George Washington*. New York: Wiley-Blackwell, 2012.

———. *General George Washington: A Military Life*. New York: Random House, 2005.

———, ed. *This Glorious Struggle: George Washington's Revolutionary War Letters*. New York: Smithsonian Books, 2007.

Lipscomb, Andrew A., and Albert Ellery Bergh, eds. *The Writings of Thomas Jefferson*. 20 vols. Washington, D.C.: Thomas Jefferson Memorial Foundation, 1904.

Lossing, Benson J., ed. "An Ancient Valentine." *The American Historical Record* 1, no. 2 (February 1872), 67–68.

Manucy, Albert. *The Building of Castillo San Marcos*. Interpretive Series, History 7. Washington, D.C.: U.S. Government Printing Office, 1942.

———. *Sixteenth-Century St. Augustine: The People and Their Homes*. Gainesville: University Press of Florida, 1997.

Percy, George. *Discourse of the Plantation of the Southern Colony in Virginia by the English, 1606*. London, 1608.

Philbrick, Nathaniel. *Mayflower: A Story of Courage, Community, and War*. New York: Viking, 2006.

Pory, John. "A Reporte of the Manner of Proceeding in the General Assembly Convened at James City." Richmond, VA, 1619.

Quimby, Robert S. *The U.S. Army in the War of 1812: An Operational and Command Study*. 2 vols. East Lansing: Michigan State University Press, 1997.

Ranck, George W. *Boonesborough: Its Founding, Pioneer Struggles, Indian Experiences, Transylvania Days, and Revolutionary Annals*. Louisville, KY: John P. Morton & Company, 1901.

Sheffield, Merle. "The Chain and Boom." http://www.hudsonrivervalley.org/links/pdfs/Chainandboom.pdf.

Southern, Ed, ed. *The Jamestown Adventure: Accounts of the Virginia Colony, 1605–1614*. Winston-Salem, NC: John Blair, 2004.

Taylor, Alan. *American Colonies: The Settling of North America*. New York: Viking, 2001.

INDEX OF ART

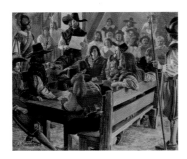

pp. ii and 68–69 (detail), 88–89:
Washington's "Watch Chain," West Point, November 30, 1779, 2011
Oil on canvas, 26 x 48 inches

pp. vi, p. 82:
The Guns of Monmouth, 2013
Mixed media, 15½ x 21 inches

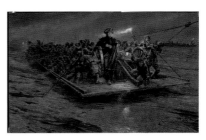

pp. xi and 42–43 (detail), 64–65:
Washington's Crossing, 2011
Oil on canvas, 33 x 50 inches

pp. xii–1, 6:
The New World, Jamestown, Virginia, May 14, 1607, 2006
Oil on canvas, 26 x 42 inches

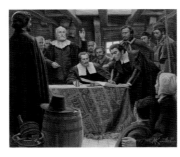

pp. 4–5 (detail), 11:
The Mayflower Compact, 1985
Gouache on board, 11⅞ x 14 inches

p. 6:
The New World (sketch), 2006
Charcoal and ink on paper, 18 x 29 inches

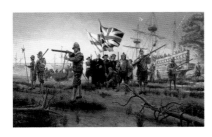

p. 8:
First Legislative Assembly, 1986
Gouache on board, 12 x 14 inches

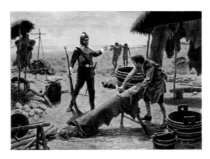

p. 12:
The First Tanner in America, 1972
Oil on board, 28 x 38 inches

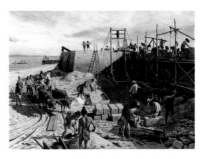

pp. 14–15: *Building of Castillo de San Marcos, St. Augustine, Florida*
Oil on board, 25 x 32½ inches

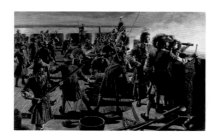

pp. 16–17: *Battle for St. Augustine,*
Agony of a Town Aflame–1703, 1965
Oil on board, 22 x 34 inches

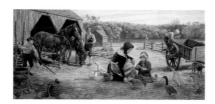

pp. 18–19:
Fox Hollow Farm, 1984
Oil on canvas, 24 x 48 inches

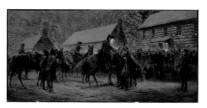

pp. 20–21 (detail), 24–25:
"Welcome to LeHewtown,
Col. Washington"—Winter 1755, 2013
Oil on canvas, 24 x 48 inches

p. 22: *"Welcome to LeHewtown,*
Col. Washington" (sketch), 2013
Charcoal on paper, 8½ x 10 inches

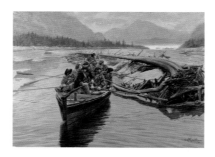

p. 26: *Rogers' Rangers—*
French and Indian War, 1982
Oil on canvas, 25 x 34 inches

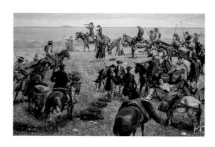

p. 27: *Portolá Discovers San Francisco*
Bay, November 4, 1769, 1987
Oil on canvas, 34 x 50 inches

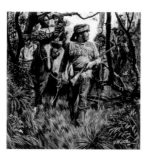

p. 28:
Daniel Boone, 1984
Gouache on board, 15 x 13½ inches

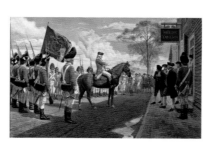

pp. 30–31 (detail), 40–41: *Benedict Arnold*
Demands the Powder House Key, New Haven,
April 22, 1775, 1991, Oil on canvas, 30 x 46 inches

p. 32:
Boston Massacre, March 5, 1770, 2013
Oil on canvas, 11⅜ x 10 inches

p. 33: *Boston Tea Party,*
December 16, 1773, 2013
Oil on canvas, 16 x 12 inches

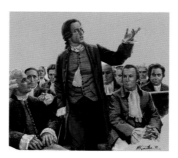

p. 34:
Patrick Henry's Speech, 1985
Gouache on board, 12½ x 14 inches

p. 35: *"The Regulars Are*
Coming Out!" (sketch), 2013
Pen on paper, 10½ x 8 inches

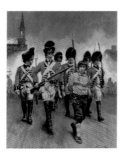

p. 105:
The Spy, 1974
Oil on board, 14 x 10½ inches

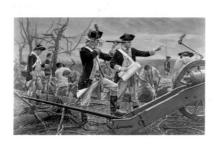

pp. 106–7 (detail), 116–17:
Digging the Trenches at Yorktown, 1976
Gouache on board, 14 x 22 inches

p. 108:
"They Are Crying for Quarter!," 2013
Mixed media, 17½ x 25½ inches

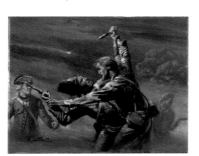

p. 111:
Hand to Hand, 2013
Oil on board, 11 x 14 inches

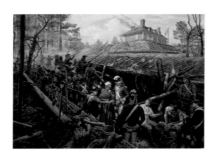

pp. 112–13:
The Capture of Fort Motte, 1976
Oil on board, 30 x 40 inches

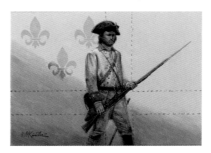

p. 115t:
Le Soissannais" to "Le Soissonnais, 2013
Oil on canvas, 12 x 16 inches

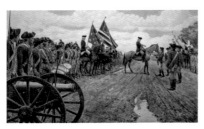

pp. 118–19: *The World Turned Upside Down,
Yorktown, Virginia, October 19, 1781*, 2006
Oil on canvas, 27 x 44 inches

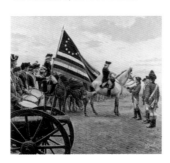

p. 120 (detail):
The Revolution Victorious, 1977
Oil on board, 18⅞ x 19⅝ inches

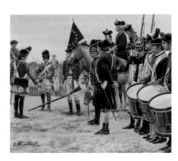

p. 122:
Surrender at Yorktown, 1986
Gouache on board, 12½ x 14 inches

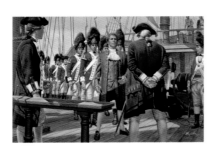

p. 123: *Brockholst Livingston
Captured at Sea*, 1976
Gouache on board, 15½ x 23½ inches

p. 124:
"Gentlemen, You Must Pardon Me," 2013
Oil on canvas, 14 x 11 inches

p. 125:
A Continental Officer, 2013
Mixed media, 17 x 10½ inches

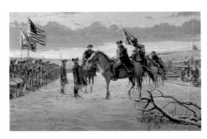

pp. 80–81: *Winds of Change, Washington
at Valley Forge, March 4, 1778, 2007*
Oil on canvas, 28 x 44 inches

p. 83:
The Scout, 2013
Oil on board, 12 x 10 inches

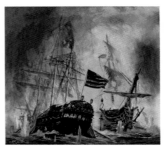

p. 85: *"I Have Not Yet Begun to Fight,"
September 23, 1779, the North Sea, 1977*
Oil on board, 17 x 17⅛ inches

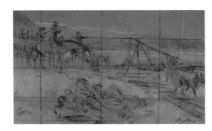

p. 86: *Washington's "Watch Chain"* (sketch),
2011, Charcoal and chalk on brown paper,
16 x 29½ inches

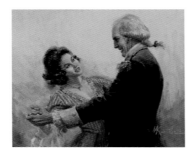

p. 90:
"Caty" Greene, 2013
Oil on canvas, 10 x 12 inches

p. 91:
"Caty" Greene (sketch), 2013
Charcoal on paper, 6 x 8 inches

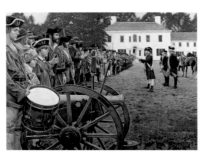

pp. 92–93:
Lafayette with Washington at Morristown, 1981
Oil on canvas, 36 x 48 inches

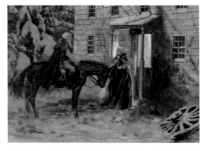

pp. 94–95 (detail), 100–101:
Sally's Valentine, 2013
Oil on canvas, 12 x 16 inches

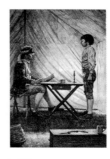

p. 97:
"I Want to be a Spy!," 1974
Pencil on board, 15½ x 10¾ inches

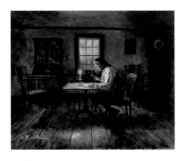

p. 98:
The Culper Spy Ring, 2013
Oil on canvas, 12 x 14 inches

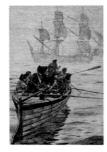

p. 102:
Spies on the Devil's Belt, 1974
Pencil on board, 15½ x 10 ¾ inches

p. 103:
"He's Just a Boy," 1974
Pencil on board, 15½ x 10¾ inches

p. 61l:
The Hessian, 2013
Mixed media, 17 x 10½ inches

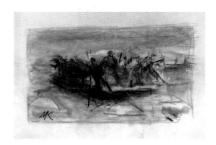

p. 64:
Washington's Crossing (sketch), 2011
Charcoal on paper, 4½ x 7¾ inches

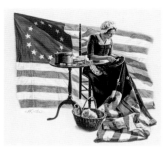

p. 66: *The Stars and Stripes Are Born,
June 14, 1777–Philadelphia, Pennsylvania,*
1977, Oil on board, 19⅝ x 20¾ inches

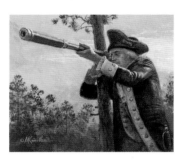

p. 70:
Washington's Spyglass, 2013
Oil on board, 10 x 11⅜ inches

p. 71: *The Casualty, Chadds Ford,
Pennsylvania, September 11, 1777,* 2013
Oil on board, 10 x 11⅜ inches

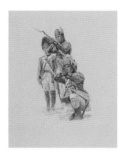

p. 72: *British at Germantown,
Pennsylvania, October 4, 1777,* 2013
Mixed media, 17 x 11 inches

p. 73:
Militia and Minutemen, 2013
Mixed media, 44 x 17 inches

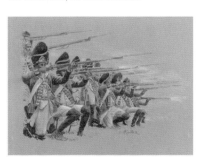

p. 74:
"Fire!," 2013
Mixed media, 16 x 22½ inches

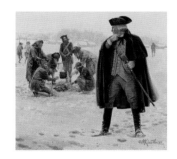

p. 76:
Washington at Valley Forge, 1985
Gouache on board, 13½ x 14 inches

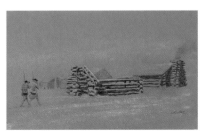

p. 78:
Crisis at Valley Forge, 2013
Mixed media, 15 x 29 inches

p. 79: *Winds of Change* (sketch), 2007
Charcoal, chalk, and crayon on brown
paper, 16½ x 27 inches

p. 80:
The Toast, 2013
Mixed media, 18½ x 13½ inches

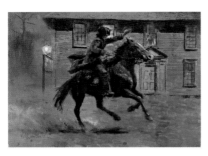

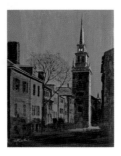

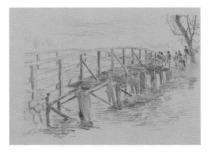

pp. 36–37: *"The Regulars Are Coming Out!"*
Lexington, Massachusetts, April 19, 1775,
2013, Oil on board, 11½ x 15½ inches

p. 38:
Two If By Sea, 2013
Oil on board, 16 x 12 inches

p. 39: *North Bridge, Concord,*
Massachusetts, April 19, 1775, 2013
Mixed media, 9¾ x 13½

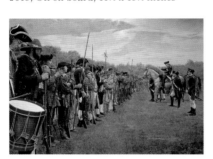

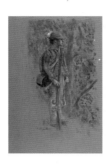

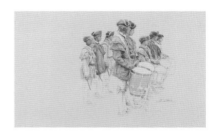

pp. 46–47 (detail), 58–59: *Reading the*
Declaration of Independence to the Troops,
July 9, 1776, 1975, Oil on canvas, 28 x 38 inches

p. 48:
The Patriot, 2013
Mixed media, 25 x 13 inches

p. 49bl:
Fife and Drum, 2013
Mixed media, 17½ x 17½ inches

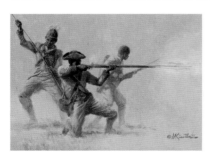

p. 50:
First Rhode Island, 2013
Oil on canvas, 12 x 16 inches

p. 51r:
Morgan's Rifles, 2013
Mixed media, 14 x 11 inches

p. 53:
The Loyalist, 2013
Mixed media, 17 x 10½ inches

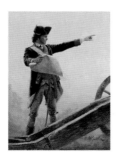

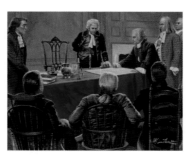

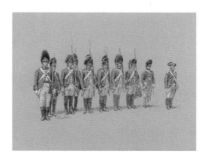

p. 54:
"Move the Guns Up," 2013
Oil on board, 16¾ x 12 inches

p. 56:
The Signing, 1986
Gouache on board, 11½ x 14 inches

p. 60:
The Redcoats, 2013
Mixed media, 14 x 20½ inches

p. 127: *Washington's Homecoming* (sketch), 2012, Charcoal and chalk on brown paper, 6⅛ x 9 inches

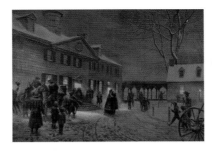

pp. 128–29: *Washington's Homecoming, Mount Vernon, December 24, 1783,* 2012 Oil on canvas, 32 x 44 inches

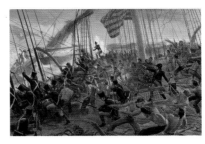

pp. 130–31 and 168–69 (detail), 174–75: *"Shall I Board Her, Sir?,"* USS *Constitution vs.* HMS *Guerriere, August 19, 1812,* 1989 Oil on canvas, 34 x 50 inches

pp. 134–35 (detail), 142–43: *The First Amendment, 1791,* 1987 Oil on canvas, 30 x 40 inches

pp. 136–37: *The Constitution Debated,* 1985 Gouache on board, 12½ x 14 inches

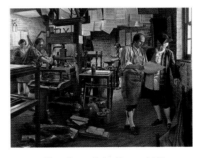

p. 139: *We, The People . . . 1787,* 1986 Oil on canvas, 30 x 40 inches

p. 140: *Washington's Inauguration,* 1985 Gouache on board, 12 x 14 inches

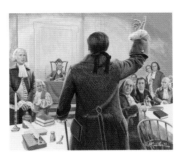

p. 144: *Madison and the Bill of Rights, 1791,* 1986, Oil on board, 12½ x 14 inches

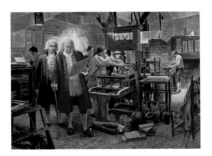

p. 146: *Freedom of the Press,* 1975 Oil on board, 20½ x 26 inches

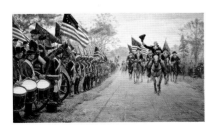

pp. 148–49 and 150 (detail), 152–53: *Washington at Carlisle, 1794,* 1989 Oil on canvas, 30 x 52 inches

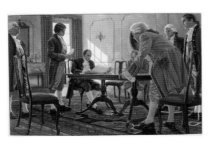

p. 155: *Negotiating the Jay Treaty,* 1976 Gouache on board, 14⅜ x 22⅛ inches

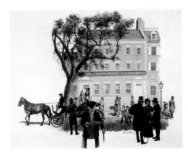

p. 157: *Little Old New York,* 1983 Oil on board, 28 x 34 inches

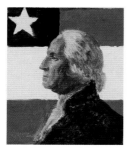

p. 158:
Washington Study, 2012
Oil on board, 13 x 11 inches

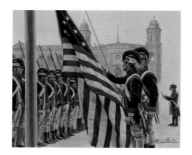

p. 161:
The Louisiana Purchase, 1986
Gouache on board, 12 x 14 inches

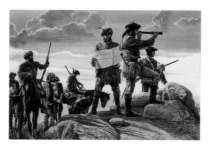

pp. 164–65:
Lewis and Clark, 1985
Gouache on board, 14½ x 20½ inches

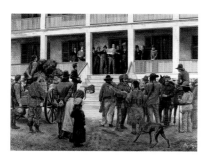

pp. 166–67: *The First Bank Charter of Missouri, Announcing the Charter*, 1981
Oil on canvas, 30 x 40 inches

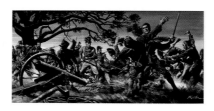

pp. 170–71:
Surprise Attack, War of 1812, 1958
Gouache on board, 13⅞ x 28 inches

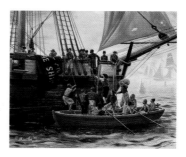

p. 177: *Perry Boards the* Niagara, *Battle of Lake Erie*, 1985
Gouache on board, 12 x 14 inches

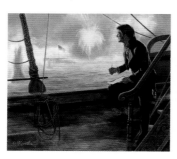

p. 178:
The Star-Spangled Banner, 1814, 1977
Gouache on board, 16⅛ x 18¼ inches

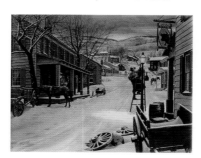

pp. 180–81:
The Lamplighter, 1975
Oil on board, 20½ x 26 inches

p. 183: *Washington's Crossing* (sketch, detail), 2011, Charcoal and chalk on brown paper, detail

INDEX

PICTURE CREDITS

49br: Photography by Christopher Bain, courtesy James C. Nannos
63: © Metropolitan Museum of Art, New York, USA / The Bridgeman Art Library
84: Courtesy U.S. Senate

Courtesy Beinecke Rare Book & Manuscript Library, Yale University, New Haven
p. 162: WA MSS 303

LIBRARY OF CONGRESS
COURTESY OF AMERICAN MEMORY
57: Declaration of Independence; 92: icufaw apc0022; 96: George Washington Papers

COURTESY OF GEOGRAPHY AND MAP DIVISION
2–3: g3290 ct000342; 44–45: g3764b ar303800; 61r, g3804n ar116200; 114:
g3884y ar147100; 132–33: g3700 ct000080

COURTESY OF PRINTS AND PHOTOGRAPHS DIVISION
32: LC-USZ62-45586; 52: LC-USZ62-45179; 67: rbpe.23902400; 75: LC-DIG-pga-00926; 76:
LC-USZ62-45258; 110l: LC-USZ62-45487; 110r: Carol M. Highsmith/LC-DIG-highsm-09851;
163t: LC-USZC4-2970; 163b: LC-USZ6-633; 170: LC-DIG-pga-02860; 176: LCDIG-ppmsca-35281

Courtesy the U.S. National Archives and Records Administration
115b: 512940; 109: 532901; 138: 1667751

Courtesy the National Gallery of Art, Washington, D.C.
137: 1979.4.2; 147: 1986.71.1; 154: 2009.132.1; 156l: 1979.4.1; 156r: 1952.1.1

Courtesy Wikipedia
51b: Independence National Historical Park, Philadelphia/courtesy Wikipedia; 10: Commonwealth
of Massachusetts/courtesy Wikipedia; 141: White House, Washington, D.C./courtesy Wikipedia

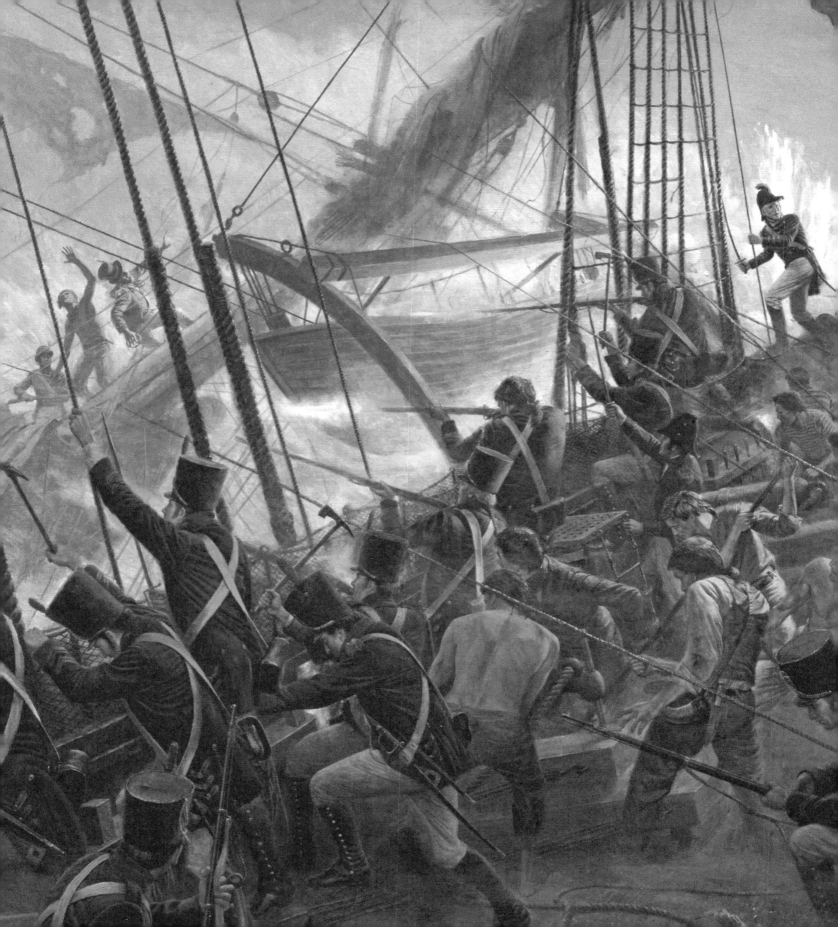